FILM NOIR PRODUCTION

Film Noir Production: The Whodunit of the Classic American Mystery Film reveals the fascinating facts behind how the classic film noir movies were actually made. Beginning with the mystery novel base material, studio executives' and staff writers' input, and talented contract cinematographers' imagery, learn why both studios and audiences loved noir films and why they are still popular today. Readers will discover many behind-the-scenes stories about the productions of certain classics and the prime players involved in their creation, from Darryl Zanuck and Raymond Chandler to John Seitz and Billy Wilder.

David Landau is an award-winning screenwriter and mystery playwright with seven works published by Samuel French, including his internationally produced play *Murder at Cafe Noir*, a comedy tribute to the film noir movies of the 1940s, which was so popular that multiple productions were performed every weekend across the United States and Canada for six years straight. The feature film version, for which David was the writer/director, won awards at several film festivals. His noir play *Deep Six Holiday*, inspired by the work of James Cain, won several theater awards, and the noir short film *Joker's Wild*, written and photographed by David, was featured on A&E's *Short Subjects* and Cinemax, and won several film festival awards. David holds a Masters of Fine Arts in screenwriting from Goddard College, and has published articles on screenwriting in such magazines as *Screenwriter's Monthly* and *Script Magazine* and on lighting in *HD Pro Guide* and *Student Filmmakers*. He is also an award-winning cinematographer and the author of the book *Lighting for Cinematography*. David is a full professor in the Fairleigh Dickinson University film program, a member of the Mystery Writers of America, the Dramatists Guild, the University Film & Video Association and IATSE Local 52 as a gaffer. (On a side note, David has also been widely recognized as the inventor of the interactive mystery play when he founded the traveling theater company Murder To Go in 1982, receiving international press.)

FILM NOIR PRODUCTION

The Whodunit of the Classic American Mystery Film

DAVID LANDAU

Routledge
Taylor & Francis Group
NEW YORK AND LONDON

First published 2017
by Routledge
711 Third Avenue, New York, NY 10017

and by Routledge
2 Park Square, Milton Park, Abingdon, Oxon OX14 4RN

Routledge is an imprint of the Taylor & Francis Group, an informa business

© 2017 David Landau

The right of David Landau to be identified as author of this work has been asserted by him in accordance with sections 77 and 78 of the Copyright, Designs and Patents Act 1988.

All rights reserved. No part of this book may be reprinted or reproduced or utilised in any form or by any electronic, mechanical, or other means, now known or hereafter invented, including photocopying and recording, or in any information storage or retrieval system, without permission in writing from the publishers.

Trademark notice: Product or corporate names may be trademarks or registered trademarks, and are used only for identification and explanation without intent to infringe.

Library of Congress Cataloging in Publication Data
Names: Landau, David, 1956–
Title: Film noir production: the whodunit of the classic American mystery film / David Landau.
Description: New York: Routledge, 2017. | Includes bibliographical references and index.
Identifiers: LCCN 2016021139 (print) | LCCN 2016032608 (ebook) | ISBN 9781138201477 (hardback) | ISBN 9781138201484 (pbk.) | ISBN 9781315511733 (ebk.) | ISBN 9781315511733 (e-Book)
Subjects: LCSH: Film noir—United States—History and criticism.
Classification: LCC PN1995.9.F54 L36 2017 (print) | LCC PN1995.9.F54 (ebook) | DDC 791.43/655—dc23
LC record available at https://lccn.loc.gov/2016021139

ISBN: 978-1-138-20147-7 (hbk)
ISBN: 978-1-138-20148-4 (pbk)
ISBN: 978-131-5511-73-3 (ebk)

Typeset in Joanna MT Std
by Keystroke, Neville Lodge, Tettenhall, Wolverhampton

Visit the eResources: www.routledge.com/9781138201484

I want to dedicate this book to my lovely wife Wendy for her continued selfless inspiration, support and suggestions – no guy could have a better femme fatale.

CONTENTS

Preface		ix
Acknowledgments		xi
1	Noir Comes to Light (*The Maltese Falcon*)	1
2	The Noir Hero (*Murder, My Sweet*)	17
3	The Noir Anti-Hero (*This Gun for Hire*)	29
4	The Femmes of Noir: They Aren't Always Fatale (*Double Indemnity*)	41
5	Directors and Studios: A Noir Relationship (*Laura*)	57
6	The Noir Cast (*The Big Sleep*)	69
7	Noir Themes (*Macao*)	85
8	Noir Style: Music, Costumes and Art Direction (*My Favorite Brunette*)	99
9	Noir Imagery: Lighting and Cinematography (*The Big Combo*)	111
10	Noir Speak: Dialog and First-Person Narrative (*Kiss Kiss Bang Bang*)	127

| 11 Noir's Rebirth and Neo-Noir (*House of Games*) | 139 |
| 12 Cross-Genre Noir and Noir Influence (*Brick*) | 151 |

Appendix: Notable Noir and Neo-Noir Films	157
Bibliography	161
Index	165

PREFACE

"The flash of the neon light through the Venetian blinds made her lips glow as she sat down. The next flash lit up just her eyes as she put the envelope of money on the desk. I didn't count it. I didn't really care. Those eyes were enough, even though I knew I couldn't trust them."

This book is for lovers of film noir, be they film fans, mystery lovers, filmmakers or film studies students and scholars. The fascinating facts behind how the classic film noir movies were actually made – beginning with the mystery novel base material, the studio executives' and staff writers' input, through the assigned directors and talented contract cinematographers' imagery – reveal much about why both the studios and audiences loved them and why they are still popular today.

Since there are so many scholarly writings on noir, there is no real need to take up pages detailing critical theories that have already been written and often written about (I have included in the Bibliography a number of fine academic works on the subject). Instead, this book can be seen as a companion piece to those academic studies, enlightening the reader on the mechanics of the movie-making process and what many of those people in the credits did.

This is a book meant for those who like a good story, as the noir films always delivered, concentrating on the characters more than anything else. Readers will find in these pages many behind-the-scenes stories (and much

gossip) about the productions of certain classics and the prime players involved in their creation, from Darryl Zanuck and Raymond Chandler to John Seitz and Billy Wilder. Every chapter will feature the production history of a significant noir film that exemplifies the topic under discussion, allowing the reader to enjoy the film in a new light. I have tried to avoid giving away too much of each centrally discussed film so that the reader can get the maximum enjoyment out of watching it if they haven't seen it before. Unfortunately, each chapter does contain plot spoilers of many other great noir films, which just couldn't be avoided. But they're still worth watching. Maybe you'll find in these pages films you never thought about or ones others haven't discussed much. They're all worth an investigation.

So welcome to a somewhat different and fascinating look into the shadows behind film noir. Dim lights, roll credits.

> *"As she walked out the door of my dingy office, she left behind a whiff of perfume and a case I knew would get more dangerous by the minute. But that was all part of the job, and I needed the money."*

ACKNOWLEDGMENTS

I want to thank all of those kind and dedicated people at the Marian Library at the Academy of Motion Picture Arts and Sciences for their generous research help, without whom this book wouldn't be nearly as interesting.

I would also like to thank my editor Emily McCloskey for believing in this project and helping to make it a reality, especially considering the unusual way we first met.

1

NOIR COMES TO LIGHT

"Don't be so sure I'm as crooked as I'm supposed to be."
(The Maltese Falcon)

Figure 1.1 Trailer for The Petrified Forest
Warner Bros, 1936

> "It's funny that some writers about pictures discovered Film Noir. I must tell you, I never heard of it until some years later."
>
> (Andre de Toth, director of Pitfall)[1]

> "When I was making these damn pictures, I never knew about Film Noir."
>
> (Samuel Fuller, director of Pick-Up on South Street)[2]

The term "film noir" was created by the French to describe certain American crime movies made during the 1940s that didn't make their way to France until after the end of the Second World War. The first use of the term has been credited to cineaste critic Nino Frank in 1946 in his article "A New Kind of Police Drama: The Criminal Adventure," published in L'Écran Français in August 1946. Jean-Pierre Chartier also used the term in his article in the November 1946 issue of La Revue du Cinéma entitled "Americans Also Make Noir Films." Other French critics picked up the term and began brandishing it about, culminating with the publication of Raymond Borde and Etienne Chaumeton's 1955 Panorama du Film Noir Americain.

What Frank and Chartier were referring to in their articles was the sudden influx of hard-boiled B movies based on many of the American mystery novels that were just being published in France as part of the immensely popular "Serie Noir" books. These were French translations of the pulp mystery novels of Raymond Chandler, Dashiell Hammett, James Cain, Cornell Woolrich and the other hard-boiled writers of the Black Mask era. The Black Mask was a popular mystery magazine that started in 1920 and ran until 1951, and published short stories and serialized novellas, many of which would be published as paperback books later. It gave many mystery authors their start and became a natural resource for Hollywood script material. So from its birth, film noir was referring to a subgenre of the American mystery story. Unlike the British mystery writers, the American mystery writers of the 1930s took murder out of the parlors and, as Chandler wrote, placed it back in the back alleys where it belonged. While Arthur Conan Doyle and Agatha Christie wrote about supersleuths such as Sherlock Holmes and Hercule Poirot, Raymond Chandler and Dashiell Hammett wrote about lone detectives for hire who needed the money and

weren't afraid of getting their hands dirty or being beaten up along the way. This change in the mystery story's characters was one of the primary things the French critics noticed and commented on.

Before the German occupation of France, the American films that were playing in Europe were the heartwarming Shirley Temple movies, the fast-talking romantic screwball comedies and the Depression-era big-budget musicals of Busby Berkeley. A reoccurring star of those extravagant musicals such as *42nd Street* and *Gold Diggers of 1937* was singer/dancer Dick Powell. One can only imagine the shock of the French audiences and critics when seven years later they saw their beloved optimist Powell playing a hard-boiled, sarcastic private eye who got beaten up and thrown around in the movie *Murder, My Sweet*. What happened to those happy-go-lucky feel-good films of Hollywood? Why were many of the films coming from America so "dark"? Frank referred to these stories and their characters as being more realistic and Chartier commented on how everyone in the films had their own underhanded schemes. No one trusted anyone anymore. And many of these stories featured private detectives, who worked outside the confines of the law. For Frank and Chartier, these films were reflecting the change in the moral outlook of postwar America, and indeed the world.

Thus, most film scholars seem to agree that film noir began in the early 1940s. It rose quickly, beginning through the production of mostly B pictures – the movies made to be the second film on the double-feature billing. Hollywood, desperate to get people back into the theaters during the war and needing to recoup the losses they suffered from a lack of foreign distribution, marketed the double feature as a movie theater standard. Two films for the price of one! The B picture was given to theaters for a flat rate rather than the percentage that the A picture carried with it. And theaters had to buy the B picture in order to get the A picture. A sort of extortion of theater owners, this system allowed the studios to produce a lot of smaller-budget films and maximize their profits. It was called "block booking" and continued up until the federal government sued Paramount Pictures in the Hollywood Anti-Trust Case of 1948.

The studio system was at its peak in the 1940s and writers, directors and actors were assigned to serve their time in the B-picture division, often against their will. The B-picture divisions of the studios had less money

and shorter schedules to churn out their films, which sometimes starred contract A talent as well. While these were lower-budget pictures, they were still complete studio endeavors with built sets, designed costumes and full experienced crews. Casts and crew were all hired by the studio for the term of their contract; they were virtually on staff so there was little difference for them, other than ego, of working on an A or a B picture and there was no savings on actors' pay to the studio. What made B pictures more economical to produce was that two films could be churned out in the time it often took to make just one A picture. Most B pictures had short shooting schedules of 15–20 days, with the cast and crew working straight five-day weeks, while A pictures would often have shooting schedules of 40–60 days. B pictures would have fewer sets or use ones redressed from other productions, saving money. It was also a great proving ground for new directors and a comeback avenue for those actors who had lost their "heat." These pictures were generally genre films – Westerns, horror and crime pictures: sure sellers filling the need for sheer entertainment.

Producer Val Lewton started the RKO B-movie unit in 1942. He had been at Universal making horror films and now was at RKO making film noir with less of a budget, pulling scripts from pulp novels to which the studio owned the film rights. Like Warner Bros and Fox, RKO already owned the movie rights to many plays and books. Scripts could be penned faster if the writers didn't have to worry about being creative. If the plot, characters, settings and even much of the dialog could be lifted directly from the source material, the script could be turned out faster and thus cheaper. The story had an already proven track record for working and it also had a ready-made audience of people who had read the book. The only thing the screenwriters had to do was cut it down from over 200 pages to under 90, condense a few characters and change a few locations to things that were on the backlot or could be easily made out of retrofitted standing sets. The B-division crews were fast and efficient professionals and the editorial department could cut the footage together in no time. Get a contract music composer to throw some melody behind it and you have a finished film ready to ship on the fast and relatively cheap.

Pulp novels were a goldmine for the B-picture divisions. Instead of being released in hardcover form, as literary novels were, these genre books,

which were meant to appeal to the masses, were printed in small paperback form and sold in such places as bus stations and at newsstands instead of just bookstores, thus earning the name "pulp" for the low-grade paper they were printed on.

The popular pulp mystery novels were the perfect fit for the B-picture financial model. They were short, spanned a really short time sequence — usually only days of story time — and had a limited number of main characters. They all took place in deserted alleyways, dive bars, cheap hotels, illegal gambling clubs and the occasional opulent mansion — which were all on the backlots, especially Warner's, which was one of the biggest. And their stories were often risqué and violent, about lust and betrayal, corruption and murder — which gave them box office appeal. The Hollywood trade paper *Variety* published a story in November 1943 stating:

> "Shortage of story materials and writers now has film companies seriously ogling the pulp mag scripts and scriptors. It marks the first time that Hollywood has initiated a concerted drive to replenish its dwindling library supplies and its scripter ranks from the 20 cent-a-word authors of the weird-snappy-breezy-argosy-spy-crime-detective-mag school."[3]

In a world that was becoming accustomed to death and the horrors of war from the radio, newspapers and newsreels that played before every movie, these stories allowed the viewer to see other people who might have things even worse off than they did. This was escapist entertainment, which often fulfilled a social need — a reassurance that sense will be made from chaos and that justice will be served in the end. In the midst of a long and devastating war, in a far-off place, these were ideals the American public needed to hold onto. The pulp mystery novels were a popular profit center for the publishing companies, so maybe they could be for the movie studios as well.

And they overwhelmingly were. Not only did they prove extremely popular with audiences and profitable for studios, they also gained recognition from the critics. The sudden explosion of film noir movies wasn't any kind of "movement" like Surrealism, where a group of like-minded artists

would socialize in cafes encouraging, inspiring and critiquing each other's work. For the most part, Hollywood producers, screenwriters, directors and actors each only worked on a few film noir movies between working on a wide variety of other genre films. It was the studio chiefs, who had to make money for their investors and make weekly payrolls for the thousands of people they employed, who escalated the production of what others would later call film noir movies. Their motives weren't artistic, philosophical or sociological. They were smart businessmen who knew that once you make something that proves successful and profitable, you quickly make more of it.

While audiences' love of film noir movies has never really gone away, writers about film noir often break down their production into three prolific time periods, or, as some say, "cycles."

THE WAR YEARS (1941–1946)

These movies were made during the war and, as discussed earlier, were often based on pulp mystery novels including the works of Raymond Chandler (such as *Murder, My Sweet* and *The Big Sleep*), Dashiell Hammett (such as *The Maltese Falcon* and *The Glass Key*), Cornell Woolrich (such as *Phantom Lady* and *The Woman in the Window*) and James Cain (such as *Double Indemnity* and *The Postman Always Rings Twice*). Chandler, Hammett and Cain were hired by the studios to write screenplays as well. Literary authors William Faulkner and John Steinbeck were also hired by the studios to write scripts, and Faulkner worked on the script for the movie version of Chandler's novel *The Big Sleep*. Chandler wrote the screenplay for Cain's novel *Double Indemnity* with writer/director Billy Wilder. These stories were crime stories, often about low-paid private detectives or run-of-the-mill working-class cops looking into a murder that linked into high-class society, exposing its dark side.

The gangster films of the 1930s had fallen out of favor with the Hays office as celebrating violence and immorality. Will Hays had been a former head of the Republican National Committee, and, with the endorsement of conservative US President Warren Harding, he took on the cleaning-up of the movie business. Hollywood didn't want government censorship intervention and thus formed its own Production Code office that would oversee and approve all film content. That independent censorship office,

from which Joseph Breen reviewed almost every noir screenplay before and during production as well as the film's finished edit, became the foundation for what is now the Motion Picture Association of America (MPAA), which administers the motion picture rating system. As the country entered the Second World War, many politicians wanted more uplifting entertainment. They thought it was more patriotic to keep people's spirits up. They encouraged the studios to give the public funny, romantic, escapist stories or something inspiring or patriotic. Ironically, in their own way the noir films did that. Under less scrutiny than the big A pictures, the noir films got away with more risqué subjects and filled the need the gangster picture use to fill. Most still ended on a positive note – that good triumphed over evil and that sense was made from chaos.

This was the period of the best of the film noir movies, as they were establishing a fresh new genre and exploring ideas and cinematic designs that hadn't become tried and true in the standard Hollywood system. Maybe because they were usually B pictures, they pushed the boundaries and thrilled the movie-going public with their suspenseful stories, strong characters and original imagery. They took risks and they usually paid off at the box office, so the studios let them do their thing and made more of them.

The Maltese Falcon, Murder, My Sweet, This Gun for Hire, Double Indemnity and *Laura* were all movies made during this period which opened in France in 1946 and which Nino Frank and Jean-Pierre Chartier wrote about when they coined the phrase "film noir."

THE POSTWAR YEARS (1946–1949)

The films produced during this period tended to be more negative in their outlook, a reflection of the disillusionment of postwar America where jobs weren't plentiful, many homes had lost their husbands and fathers, organized crime came back and nothing was as good as the end of the war had promised it would be. Often war veterans became major players in these tales. The Hollywood Anti-Trust Case freed up movie theater ownerships and allowed theaters to buy from anyone. More theaters sprung up in every

income area, all looking for product. The advent of lighter cameras and faster film allowed low-budget film companies, called Poverty Row, to churn out mysteries, horror films and Westerns in record short periods. These producers didn't have the luxury of backlots and warehouse inventories of film equipment. Because of the extremely low budget and short production period — sometimes as short as two weeks — they experimented with long single-take scenes and shooting on location. These companies had no one under contract, hiring as few people as possible on a per-film basis. Actors worked cheaply and their crews were the new guys working their way up into the big time or the craftsmen who wanted to try something new. It was the true beginning of independent film production. Criminals often figured in these stories, as well as mistaken identities that would lead the main character into big trouble. Since the big female stars were not available for these lower-budget non-studio companies, the actresses had no clout and the studio had no reason to glamorize them. The female characters often became more manipulative and hard-edged, more fatal femme fatales. The stories themselves often ended darkly for the main characters, a reflection of a pessimistic outlook slowly gripping America. But it was also possibly a reflection of the resentment of the filmmakers of Poverty Row, who dreamed of the big time but could only scrape together a living doing these very low-budget genre flicks.

During this period Hollywood had discovered a money-making genre that they would exploit more and more. Even though no one in the studios had yet heard of the term "film noir," the genre had become so recognizable that the studios even put out parodies of it. Bob Hope, the most famous and popular film comic of his day, produced a parody of film noir entitled *My Favorite Brunette*, in which he becomes mistaken for the PI whose office is next door to his and embarks on solving a mystery encompassing every standard noir element.

Meanwhile, non-noir films were made to resemble noir in order to capitalize on the genre's public popularity. Melodramas and gangster films were back and darker than before the war, often utilizing many of the images and dialog styles made popular by film noir.

THE RED SCARE PERIOD (1949–1953)

This was the period of the Republican House Un-American Activities Committee (HUAC) and political witch-hunter Senator Joseph McCarthy, who destroyed many people's lives, some even going to prison for contempt of court, as a result of being accused of being a communist or a member of a socialist group. He invaded Hollywood, accusing many films of being un-American and demanding the names of the subversive writers, directors and producers who made the films. Many people turned in names to the HUAC just as a way of complying and getting released themselves. Actor Ronald Reagan, then president of the Screen Actors Guild, turned in many names of innocent writers and actors, who were subpoenaed, without any due cause or proof, for being communist sympathizers, destroying their careers even after they were released. Many screenwriters became blacklisted in Hollywood and had to hide and write under false names using "fronts" – people who pretended to be writers and received a percentage of the script fee – in order to earn money writing. Often their scripts were sold cheaply to the low-budget independent companies who sold their movies to the low-rent working-class theaters that catered to lower-class audiences and rebellious youth.

Personal disintegration ruled the storylines that frequently ended with the protagonist dying or going to jail. Everyday middle-class nobodies who lost everything by a bad twist of fate or due to their own poor judgment were popular noir themes. Some noir critics include stories about psychotic characters and low-life criminals as part of this noir cycle, which is a considerable stretch. What is common is that often corruption was everywhere in the story. One might suspect these stories were the result of unfairly accused writers who lost everything through a poor twist of fate, being named a subversive by a superior in Hollywood who just said anything to save his or her own neck. The male characters often were losers and cowards who couldn't help themselves, giving in to greed or a bad woman. Even the detective stories of this period featured heartless PIs who were stone cold, such as the Mike Hammer PI character of the Mickey Spillane books in such films as *Kiss Me Deadly*.

This could also be called the "anything goes in noir" period. Everyone and anyone made low-budget "noir." The genre became more and more

diluted and warped while the visual quality often suffered greatly. There were some stand-out noir films made during this period, but it was the beginning of the end for the classic character-driven mystery, often giving way to forced, trite and melodramatic material.

While the period from 1941 to 1953 may be considered the heyday of noir, noir films have continued to be made, although sparingly, to this day and noir's influence has infiltrated TV, theater and feature films ever since its inception.

THE MALTESE FALCON (1941)

Most film scholars and historians agree that the 1941 film *The Maltese Falcon* marked the beginning of film noir and it is cited as the first major film noir movie in Borde and Chaumeton's *Panorama du Film Noir Americain*. This film opened in France in 1946 after the war and was one of the movies seen by the French film critics who turned the phrase "film noir."

Figure 1.2 Peter Lorre and Humphrey Bogart face off in *The Maltese Falcon*
Warner Bros, 1941

The Maltese Falcon was produced by Warner Bros and was a typical Hollywood film factory production. Written and directed by John Huston, it was based on the popular pulp mystery novel by private detective turned mystery writer Dashiell Hammett. While this was the third screen version of the book, it was this production that first presented the hard-nosed private eye Sam Spade to the public, setting a standard for the film noir hero and gaining international appeal.

The first version of *The Maltese Falcon* was made in 1931, also by Warner Bros, but was never released in the US, censored by the Production Code office for containing lewd content, which included a scene of a woman putting on her stockings before leaving the main detective character's office – implying they had just done something – and obvious references to one of the thugs being a homosexual. The main detective character was more of a Dapper Dan than the book's hard-edged Sam Spade. The studio waited until 1966 to re-edit the film and release it on TV as *Dangerous Female*.

In 1936, Warner Bros tried again, this time as a comedy entitled *Satan Met a Lady*, starring Bette Davis. It was assigned to staff writer Brown Holmes, who changed the falcon into a ram's horn, changed one of the bad guys into a female character and changed Sam Spade into PI Ted Shane. After reading the script, Davis refused to show up on set and instead stormed into Jack Warner's office to demand she be removed from the project and given better material more befitting her new stardom (which ironically she received from being in the film *The Petrified Forest*, which also featured Humphrey Bogart as a low-life, dangerous, killer gangster holding everyone hostage in a roadside diner). She was suspended without pay and three days later showed up on set and did the film. It was a terrible production.

In 1941, staff screenwriter John Huston begged Jack Warner to let him tackle *The Maltese Falcon* again since the movie rights were still owned by the studio. He wanted to not just be the screenwriter, but asked Warner to allow this to be his first directing project.

Huston's father had been a Hollywood actor and Huston was a magazine writer who landed a job as a script editor and then writer at Universal when his father worked there. But he became known as being a hard-drinking partier. After a car accident in which he killed a woman pedestrian, he became traumatized and moved to London and then Paris. At age 31, he

returned to Hollywood, got married and started writing for Warner Bros. He became well respected and wanted the chance to direct. Jack Warner told him he could if he wrote another hit picture first. The movie he wrote was *High Sierra*, directed by Raoul Walsh and starring Humphrey Bogart as a gun runner. It was a big success and started to make Bogart a potential star.

> *"They indulged me rather. They liked my work as a writer and they wanted to keep me on. If I wanted to direct, why, they'd give me a shot at it, and if it didn't come off all that well, they wouldn't be too disappointed as it was to be a very small picture."*
>
> *(John Huston)[4]*

Jack Warner agreed to let Huston write and direct *The Maltese Falcon*, even though the studio had lost money on it twice before, as one of their B pictures. Huston kept close to the book and retained a lot of Hammett's hard-nosed dialog. Veteran producers Hal Wallis and Henry Blanke were assigned to see the picture through and start the casting process.

Well-known actor George Raft refused to do the film, as Huston was a first-time director and Raft felt it wasn't an important picture. He wrote Jack Warner as much and Warner let him out. Raft had turned down the role Bogart played in *High Sierra*, which earned Bogart acclaim. It is ironic that Raft wrote Jack Warner a letter complaining that he was constantly being put up for the same roles as Bogart. When both he and Bogart were cast in the film *Out of the Fog*, he wrote Warner and asked that Bogart be removed, which he was. Bogart, who had always said he enjoyed playing the heavy parts, was hurt by this. At age 42, Bogart was happy to accept the role of Sam Spade, having liked Huston's work on the script for *High Sierra*. Bogart had accepted roles Raft had turned down before, including in the gangster film *Dead End* in 1937 and *It All Came True* in 1940. Raft is also believed to have turned down the part of Rick in *Casablanca*, also produced by Hal Wallis, which became Bogart's signature role.

For the female lead, the producers considered a variety of actresses under contract at Warner. Blanke sent the script to Mary Astor, who wrote back that she found the screenplay "a hum dinger" and would love to do it. Astor had acted in the 1938 movie *Dodsworth* with Walter Huston, John's father. As a

good luck gesture for his son, Walter Huston appeared in *The Maltese Falcon* in a small role as a cargo ship captain who got killed. Sydney Greenstreet was a theater actor who refused to do movies, until John Huston talked him into appearing in *The Maltese Falcon* after seeing the 61-year-old Greenstreet in a theater production of *There Shall Be No Night*. *The Maltese Falcon* would be the first of his many memorable character roles in films.

Huston preplanned everything in minute detail and decided to shoot the film in sequence, because he thought it would be easier for him and for the actors. He received memos on the dailies from both Wallis and Blanke, commenting on pacing and how certain characters were saying their lines. Not only was he on budget and on schedule, he often finished early and would take the entire cast to a local country club near the Warner backlot, where they would all lounge about the pool and drink.

Well-established studio cinematographer Arthur Edeson lensed the film, using low-key lighting as well as low and arresting angular compositions to add tension and mystery to the images. Some shots were very complicated, as commented on by Meta Wilde, Huston's longtime script supervisor:

"It was an incredible camera setup. We rehearsed two days. The camera followed Greenstreet and Bogart from one room into another, then down a long hallway and finally into a living room; there the camera moved up and down in what is referred to as a boom-up and boom-down shot, then panned from left to right and back to Bogart's drunken face; the next pan shot was to Greenstreet's massive stomach from Bogart's point of view . . . One miss and we had to begin all over again."[5]

Encompassing as much dialog and action into one long shot as possible would prove to be a way to speed up production, as long as it didn't require too many takes. The Mitchell Camera Company had come out with the BNC camera just before the war started, which was self-blimped, meaning that the camera was no longer weighted down with an enormous outside housing that had to be placed over the camera to deaden the mechanical noise of the gears to allow clean audio recording. Kodak had also come out with their new faster-speed black-and-white negative film, which allowed

Edeson to use fewer and smaller lights. These two things combined allowed him to create the low-key look and place the camera in unusual places that would become the visual standard for film noir.

After the first edit Jack Warner had a few changes he wanted. He wanted a new scene shot that showed the murder of Spade's partner via a subjective camera shot from the point of view of the killer. His murder was never shown in the original production, just referred to. He also was unhappy with the final scene of the film (which was the same as in the novel), which had Spade back in his office the next morning talking to his secretary Effie and going back to doing business as usual. Endings seem to have been one of Warner's strengths, knowing how to dramatize them and leave the audience satisfied and touched. His new ending did that much better than the one that had originally been filmed.

Warner's revised ending allows the audience to see Spade as a person who does what he feels he must, but isn't happy about it. His line "The stuff that dreams are made of" isn't in the book and wasn't in the version Huston first edited. This, combined with the expressiveness of Bogart's face, telegraphs to the viewer how much more disillusioned Spade has become, even though throughout the story he pretends to be stone cold.

This ending was one of the things that gained the film its "noir" reference. Unlike the classic European intellectual detective, this American private detective protagonist is rude, harsh and doesn't play by the rules. At the end, when he solves the crime, he isn't happy about it. He doesn't receive acclaim or get rich; it's all just part of the job.

After a preview screening, Warner wrote to the producers and Huston that he wanted the opening scene rewritten and reshot, as it was too confusing for the audience. Huston rewrote the scene and Bogart and Astor were pulled off movies they were acting in to report to Stage 6 for the reshoot. Cinematographer Ernest Haller shot seven camera setups, as Arthur Edeson was on another picture. They finished reshooting in less than an eight-hour day.

The Maltese Falcon was a gamble. The book had failed twice before as a film and Huston was an untried director who needed and was given a lot of help. Bogart had been playing thugs and anti-heroes up until then and there were a few unknowns in the cast, mainly Greenstreet. Warner Bros hadn't spent a

lot on the film even for a B picture, so Jack Warner went on vacation instead of going to the New York City opening.

The film received great reviews and was a tremendous financial success for Warner Bros. It launched John Huston's career as a director and propelled Bogart to stardom. The film was nominated for three Academy Awards including Best Picture, Best Screenplay and Best Supporting Actor (for Sydney Greenstreet). Huston and Bogart became friends and Huston would go on to use Bogart on many of his most famous films including *The Treasure of the Sierra Madre*, *Key Largo* and *The African Queen*.

In 1975, the book was bought again to be made into a movie, this time produced by Ray Stark for Columbia Pictures as a sequel titled *The Black Bird*, starring George Segal as Sam Spade Jr who inherits his father's PI business. Stark hired writer David Giler to adapt the book, but he had a falling-out with his co-writer on the project, John Milius. Giler changed the script into a comedy and Stark allowed him to direct it. On set there were many fights between director and star. The film was more of a slapstick 1970s comedy than a film noir parody and was a critical and financial disaster. It wasn't the stuff dreams were made of.

The Maltese Falcon is now recognized as a film classic. While audiences are different today, the film still holds the attention and has impact. Dashiell Hammett's book is equally recognized today as a classic work of American literature, not just a genre pulp novel. It was the beginning of something new that would sweep theaters across the country.

NOTES

1 Silver, Alain, Porfirio, Robert and Ursini, James, *Film Noir Reader 3: Interviews with Filmmakers of the Classic Noir Period*, New York: Limelight Editions, 2002, p. 12.
2 Ibid., p. 42.
3 Lyons, Arthur, *Death on the Cheap: The Lost B Movies of Film Noir*, New York: Da Capo Press, p. 18.
4 Pratley, Gerald, *The Cinema of John Huston*, New York: A. S. Barnes, 1977, p. 38.
5 Grobel, Lawrence, *The Hustons*, New York: Cooper Square Press, 1989, p. 220.

2

THE NOIR HERO

"You're a tough guy. You've been sapped twice, choked, beaten silly with a gun, shot in the arm until you're crazy as a couple of waltzing mice. Now let's see you do something really tough – like putting your pants on."

(Murder, My Sweet)

Film noir producer Dore Schary said he believed that the writers had the most liberal influence on film noir. Raymond Chandler and Dashiell Hammett were perhaps the most influential people in what was to become the film noir "movement." Their private detective pulp novels were made into films and Chandler wrote the screenplays for several others. But most significantly they established a new style of character which was very well received by the film-going public, the hard-boiled wise guy.

From 1942 to 1947, four of Chandler's novels became movies and he worked on four screenplays for Paramount. Eventually all of his books would become movies, many more than once, and he would go on to write the first draft of *Strangers on a Train* for Alfred Hitchcock and two other screenplays that were never shot. Chandler's private eye character Philip Marlowe is the very image of the noir protagonist, never giving a straight answer; sarcasm, dark wit and hard-boiled talk are his natural state of being. Chandler carried this art over into his screenplay work for *Double Indemnity* for the Walter Neff

character and his voice-over narration lines. Co-writer and director of *Double Indemnity* Billy Wilder learned from Chandler on this project and wrote similar hard-edged lines for the William Holden character for his shared screenplay of *Sunset Boulevard* years later. (More on this in Chapter 4.)

The protagonists of these noir stories are men with their own code of ethics, anti-social loners who are quick-witted and sarcastic with a cynical outlook on life. Chandler said in his essay "The Simple Art of Murder" that American detectives differ from the classic European detectives in that they are common men in uncommon situations, who are resourceful, if not the smartest or strongest. They use their wits and their brains and say whatever they like to whomever they like. They pull no punches, and when they swing with their fists, they often miss. They are not afraid of taking a beating or being alone. Chandler wrote: "He talks as a man of his age talks – that is, with rude wit, a lively sense of the grotesque, a disgust for sham, and a contempt for pettiness."[1] In other words, the noir protagonist has been disillusioned by life – perhaps because of all of the cheating and dishonesty he has seen as a private eye or police detective, or perhaps just because of something in his personal past. For whatever reason, never specified, he is not an optimist.

Hammett's cynically witty private eye Sam Spade, the main character in the first true film noir movie *The Maltese Falcon*, has everything that was to become the standard for the film noir hero. Played by Humphrey Bogart, who would build a career out of playing hard-boiled leads in movies, Spade is a private detective with a questionable amount of honesty. He is having an affair with his partner's wife and has a loyal gal Friday in love with him whom he virtually ignores. Still, he has his own code of ethics that he will not waiver from. Once his partner is murdered, he tells the cops that once your partner is dead it doesn't matter if you liked him or not, you were supposed to do something about it.

Not all noir heroes are detectives. Sometimes they are men who are forced to become detectives because they have been wrongly accused of murder and must clear their name. In the movie *Dark Passage* (1947), based on the book by David Goodis, a man wrongfully convicted of killing his wife escapes and tries to find the real killer. In *The Dark Corner* (1946), based on the short story by Leo Rosten, a private eye gets released from jail after

being framed for a murder by his ex-partner. In *The Big Clock* (1948), based on the novel by Kenneth Fearing, a crime magazine editor is framed for murder by his boss and must clear his name. These are true noir heroes as they are innocent loners who stick to their ethics and are out to clear themselves by taking on the role of detective.

After the war, often veterans became noir heroes. In *The Blue Dahlia* (1946), written for the screen by Chandler, an ex-soldier must clear his name after being accused of murdering his unfaithful wife. In *Cornered* (1945), written by John Paxton and based on an unpublished story by John Wexley, a Canadian pilot released from a prisoner-of-war camp tracks down the men who murdered his French war bride. In *The Unsuspected* (1947), based on the mystery novel by Charlotte Armstrong, a vet comes home to discover his fiancée has been murdered and sets out to uncover the killer, who is a wealthy noted radio personality. In *Dead Reckoning* (1947), written by Oliver Garrett and Steve Fisher and based on a story by Gerald Adams and Sydney Biddell, a veteran wants to clear his dead combat friend's name and tracks down his widow, who is working for, and possibly involved with, a dangerous gangster casino owner.

The typical noir hero is an outsider, a loner, a man with his own code of ethics that he will not break – no matter who pressures or bribes him. He is neither above nor afraid of violence, but, like the average viewer, would rather avoid it when possible. He is smarter and cleverer than others give him credit for, but never tips his hand or brags about it and has a self-deprecating sense of humor. He is an average, common man – neither wealthy nor famous nor very successful, but he gets by. He is neither greedy nor powerful, but he is persistent and resourceful. He treats everyone equally, whether they like it or not, and has a healthy disrespect for the rich and the powerful. He is a simple man, which makes him all the more complex a character.

It is these characteristics that draws the audience to like him. The majority of the movie-going public is neither rich nor powerful. Movie-goers can identify with this everyman hero. They might wish to be him – to have his dedication, his wit, his ability to take a beating and still stand on his own two feet. This is one of the reasons, if not the primary reason, that noir films are still popular today. The noir movies were and are character based, not

whodunit based. The audience becomes invested in the characters more than the plot. This was actually something recognized and pointed out by Nino Frank in his 1946 essay in which the term "noir" first appeared.

The noir hero also allows himself to become no one's fool. While he might make wrong choices at times, they are his choices, and thus he must suffer the consequences. Because of his ethics, he also has a sense of obligation and commitment, which often gets him into more trouble. He insists on following things through, even after there is no longer anything in it for him. The noir PI can have been paid off or his client can be dead and yet he still continues on the case. Once he makes a decision to do something, he'll do it no matter where it will take him or who it might hurt, including himself. This can be seen as one of his major flaws: his obsession with going on even when told not to, which he often does simply *because* he has been told not to. This makes the noir hero someone to admire. Not everyone will make good on their promises and the fact that he does, even if it makes things worse for him, shows that he is a rather noble person. The noir hero has traits that most of us wish we had. These are all reasons why the noir hero was and is so popular.

The 1946 film Nocturne, written by Jonathan Latimer and based on the novel by Frank Fenton and Rowland Brown, features police detective Joe Wayne looking into the death of a playboy songwriter that the police had branded a suicide – even though the audience has witnessed the murder through a subjective camera. Like the famous movie Laura that came two years before it, the detective is just a working-class everyday man doing his job, which happens to bring him into a lifestyle he's never been part of: the nightclub scene and the wealthy crowd. Played by George Raft (who became well known for turning down the most famous hard-nosed hero roles in film, including Rick in Casablanca, Sam Spade in The Maltese Falcon and Detective McPherson in Laura), the detective becomes obsessed with interviewing all of the lovers of the dead composer, intrigued in particular by a femme fatale club singer whom he knows is lying to him. Our hero continues on the case even after he is removed from it, eventually finding the killer.

Nocturne was another film from the RKO B-movie division, which also produced the noir classic Murder, My Sweet and was given a similar noir shadows-and-glamour mix by the same cinematographer Harry Wild. This

film's detective displays all of the traits of the typical film noir hero. He solves the crime despite others telling him not to, enduring beatings and uncovering lies even from those he wants to trust. But as is often the case in noir, the lies from the one closest to our hero are to protect someone else, so these lies the noir hero not only forgives, but often finds admirable.

A well-developed protagonist is one who has flaws. One of the primary flaws of the noir hero is that he usually manages to get himself in over his head. This is another thing that makes him so identifiable to the audience, as who has never felt they've gotten themselves into something they shouldn't have? We see and experience everything with him as the noir story is almost always told from the point of view of the noir hero. It is his journey and we go on it with him. We are along for his ride and when he gets knocked out, the screen goes black. We only learn what he learns as the story unfolds and thus we feel more for him.

The noir hero has other faults, the most commonly recurring one being how susceptible he can be to the charms of the female sex. A woman can bring out both the best and the worst in him. He never does anything to impress women, but often feels like helping or shielding them. He might become infatuated or even lustful, but remains honorable, if not always treating them totally respectfully. And while a femme fatale will make him change his mind, make him make bad decisions or take chances, he will never be her fool, servant, plaything or pawn. If she is guilty, even if he loves her, his ethics will force him to turn her in. He can live without a woman – but not his personal ethics. This often causes him to remain a loner. But that is something he can live with and is yet another admirable trait, as most of us hate the idea of being alone.

While the typical film noir hero is a man, there have been female noir heroes. The 1944 noir film *Phantom Lady*, based on the pulp novel by mystery writer Cornell Woolrich, features a strong female lead taking on the investigation of a murder. Kansas is a country gal who is now a secretary in the big city. When her boss is wrongfully convicted of murdering his unfaithful wife, she sets out to the find the mysterious woman who is his alibi. As in all noir tales, this femme protagonist now ventures into the dangerous underbelly of society. While she is aided by a local police detective, she is the main hero of the story.

In the 1945 comedy noir mystery *Lady on a Train*, written by Edmund Belion and Robert O'Brien and based on a story by Leslie Charteris, hardboiled mystery novel-loving debutante Nikki sees a man murdered from her train window as she arrives in the city. When no one believes her, she enlists the help of a mystery writer to help solve the case. Many critics have said that this is almost a parody of a Woolrich-type story. Interestingly, the film was photographed by Woody Bredell who also shot *Phantom Lady*, which actually *was* a Woolrich story.

Woman on the Run (1950), written by Alan Campbell and Norman Foster (who also directed) and based on a short story by Sylvia Tate, features a woman searching for her husband who has witnessed a murder and falls into danger herself. *The Blue Gardenia* (1953), written by Charles Hoffman and based on a short story by Vera Casper (the same author of the noir classic *Laura*), features a female protagonist who goes out on a blind date after receiving a "Dear Jane" letter from her beau off in the Korean War and ends up involved in a murder she thinks she may have committed. But, as in *Lady on a Train*, both of these strong independent-acting female characters need men to help them both solve their mysteries and save them.

The most famous female noir hero is the title character in the 1945 classic *Mildred Pierce*. Based on the pulp novel by James Cain but rewritten for the screen by Ranald MacDougall, the film begins with a murder and uses voice-over narration by Mildred to tell the story. When Jack Warner first decided to produce a film based on the book in 1944, inspired by the box office success of the film version of James Cain's *Double Indemnity*, he received a letter from the Production Code office stating:

> "the story contains so many sordid and repellent elements that we feel the finished picture would not only be highly questionable from the standpoint of the Code, but would, likewise, meet with a great deal of difficulty in its release."[2]

Many writers contributed to reworking the novel to appease the Production Code office, including the famous novelist William Faulkner, whose work was ultimately never used, as it concentrated on making Mildred look more

ruthless, with a history of underhand dealings that catapulted her to success in her restaurant business.

Jerry Wild became the producer and is credited with envisioning the idea of beginning the movie with a murder, which wasn't in the book, and using flashbacks to reconstruct the story. It is these elements that transform the story from melodrama to noir. Michael Curtz, who had directed the B movie *Casablanca*, was assigned to direct it. Curtz didn't want "washed-up" star Joan Crawford as his leading lady, due to her poor onset reputation and a series of flops she had recently done while under contract at MGM. But she was now signed with Warner and B pictures were a good place for the studio chiefs to get their money's worth out of falling stars still under contract. Crawford was assigned the project, took the part gracefully and worked so professionally that Curtz changed his opinion of her. Crawford was very much like the character she was playing: strong-willed, hard-working and professional, but also troubled.

Mildred is a strong and determined woman who is more of a loner even though she is married and has kids. Her femme fatale is her daughter Veda, whom she loves and will do anything for, even though Veda is a truly rotten person obsessed with money and sex. Veda even has an affair with Mildred's playboy second husband, her own stepfather, who becomes the murder victim. Like her male counterparts, Mildred has her own code of ethics and does the noble thing – which in her mind is to take the blame for the murder. But justice does prevail in the end. The film also has the traditional noir look, created by talented cinematographer Ernest Haller.

The film was nominated for five Academy Awards and Joan Crawford won for Best Actress. James Cain sent Crawford an autographed copy of the novel and inside wrote: "To Joan Crawford, who brought Mildred to life just as I had always hoped she would be and who has my lifelong gratitude." Crawford often said that her role as Mildred Pierce was her favorite.

While Sam Spade was the first draft of the noir hero, Chandler's Philip Marlowe would become the prototype for the hard-nosed, wise-cracking PI that everyone liked and wanted to be like. He would be first introduced to the public through the B picture *Murder, My Sweet*.

MURDER, MY SWEET (1944)

Figure 2.1 Dick Powell as Philip Marlowe meets his client Moose via the reflection in Murder, My Sweet
RKO, 1944

Murder, My Sweet was the second filmed version of the Raymond Chandler novel Farewell, My Lovely, the first book to introduce PI Philip Marlowe. The film was produced by RKO, which owned the film rights. The first production was in 1942 and released as The Falcon Takes Over, the third in a series of films about the adventures of a mysterious gentleman detective called the Falcon. The Philip Marlowe hard-nosed detective character was abandoned and film historians have panned the film, but it actually did just fine with the movie-going public, who loved the Falcon series.

Producer Adrian Scott, who was on staff at RKO's B-pictures division in 1943, needed a project to justify his weekly salary, one that wouldn't cost the studio much money. He pulled the book from the properties RKO owned. Since the previous version was a Falcon picture, he reasoned no one would associate the two. He hired John Paxton to write the screenplay.

Paxton kept a lot of Chandler's original dialog in the film and stayed close to the novel but made changes to keep it shootable on the backlot. Scott told Paxton to use first-person voice-over narration in the screenplay, to keep the tone and texture of the Chandler novel, which was written in the first person. Since both Scott and Paxton came from theater, they had much more respect and regard for the original author's work – a rarity in Hollywood, where the writer was often replaced and replaced again. In theater, the play's the thing and no one can change a word of it without the playwright's approval. Thus, the screenplay was very much just the novel set in a new format, but with some things combined, condensed or cut out in order to shorten it.

Edward Dmytryk was assigned to direct the film, even though he was hoping to move out of B pictures and into A pictures. Dmytryk liked the script and agreed. He also respected Chandler's writing and wanted to retain the essence of it in the movie.

In 1947 Dmytryk would direct another John Paxton B-picture noir script, *Crossfire*, which would win him the Academy Award for Best Director. But also in 1947 he became one of the Hollywood Ten, a group of backlisted film directors and writers who refused to give names or answer the question as to whether they were ever members of a socialist or communist party to the Republican House Un-American Activities Committee (HUAC). Dmytryk moved to London to escape prison for contempt of court and to make films. When he returned to the US in the 1950s, he was sent to prison for contempt of court for less than a year. After his release, his career restarted slowly until he regained some fame in 1955 when he directed *The Caine Mutiny*, which won the Academy Award for Best Picture.

The studio wanted actor John Garfield to play PI Philip Marlowe, but because so many male leading men had been called into the war, those left behind were in high demand and Garfield was now doing A pictures. Song-and-dance man Dick Powell was classified "4F," which meant not suitable for some reason for the army – possibly his short height. Powell had gained popularity playing singer/dancer parts in musicals such as *42nd Street* and in romantic comedies. Powell wanted to change his image. Scott was against hiring him, but Dmytryk wasn't.

> *"I wanted Marlowe played as I believed Chandler visualized him – really an Eagle Scout, a do-gooder, with the patina of toughness only skin-deep. This good-guy characterization is implicit in many of the things Chandler had him say, and that is the way Powell played him. Not because that was what I wanted, but because that's what he was – an Arkansas farmboy who got into showbusiness because his voice was too sweet for calling hogs, and who never quite got all the hay out of his hair."[3]*

Powell was cast as Philip Marlowe. Some critics felt he was too much of a "Boy Scout" for the part, while others hailed him as perfect for Marlowe. The film changed Powell's career and sent him into many more hard-boiled leading roles. Imagine the average French movie-goer's surprise to see one of their favorite American musical comedy stars, Dick Powell, in a film about murder, deceit and betrayal, with their smiling Mr. Optimistic playing a sarcastic loner who gets beaten up repeatedly and can't even pay the rent.

Actress Claire Trevor came on board as the femme fatale and earned the nickname "Queen of Film Noir" after this film. Ironically, she appeared in the film *Dead End* with Humphrey Bogart in 1939, which led to a nomination for an Oscar for Best Supporting Actress, but she didn't win. She would win that same Oscar in 1948 for her role in the hard-boiled crime drama *Key Largo*, directed by John Huston and starring Humphrey Bogart and fellow femme fatale star Lauren Bacall. Mike Mazurki was cast as the fresh-out-of-prison thug Moose Malloy. He played the character with a wonderful mix of intimidation and innocence that allowed viewers to care about him without fearing or hating him. In order to make Moose appear even larger next to Marlowe, Dmytryk had Powell walk in the gutter as he and Mazurki would walk down the sidewalk together.

Murder, My Sweet was photographed by veteran cinematographer Harry Wild, who had been shooting B-picture Westerns for RKO. He was known for working fast and efficiently. Dmytyrk claims he made Wild into the low-key cinematographer that later gained him a reputation within the industry. Wild became actress Jane Russell's favorite cameraman and worked on many of her pictures, including her noir films *Macao* and *His Kind of Woman* (both with noir actor Robert Mitchum, who would later star in the 1975

remake of Farewell, My Lovely), and also photographed Russell in the musical comedy Gentlemen Prefer Blondes, which also featured Marilyn Monroe.

Murder, My Sweet was first released under the title of the novel, Farewell, My Lovely, but audiences expected it to be a musical because it starred Dick Powell. The film was pulled and retitled Murder, My Sweet to make it clear it was a mystery film. It was given a new ad campaign stating "Dick Powell in a role you've never seen him in." Chandler liked the film and sent a note to Paxton saying so. The film was a box office success and received high praise from most film critics, though some lamented that the mystery was so complicated it was impossible to follow (a typical trait of a film noir).

Murder, My Sweet has everything that typifies a film noir, even more so than The Maltese Falcon. The PI character is a little more audience-likable, has more wit and goes through more troubles such as getting beaten up and drugged. What truly sets Marlowe apart from Sam Spade is the fact that he insists on completing the case even after his client dies. As he says in one of his narrations, "He gave me a hundred bucks to take care of him and I didn't. I'm just a small-town businessman in a very messy business, but I like to follow through on a sale." Powell succeeded in playing the character Marlowe the way director Dmytryk wanted. He comes across as a more average Joe, a bit hard-edged, but not as granite-hard as Bogart's Sam Spade.

In 1975 Farewell, My Lovely, starring noir actor Robert Mitchum as a much older and more world-weary Marlowe, was released to mixed reviews but strong box office numbers. While Mitchum was great at the sarcastic one-liners, many Chandler enthusiasts hated the film because they felt Mitchum was too old to play Marlowe and the film has a scene that suggests he sleeps with Mrs. Grayle, which is something Chandler's Marlowe would never do. The color cinematography by John Alonzo, who photographed the film rebirth of noir Chinatown, adds another level of sleaziness to the dark streets of LA.

Interestingly, the stepdaughter character from the first film is omitted and Marlowe is made into a nicer person in general, which made him more endearing to the film's modern audiences. Also to sell to the 1970s audience, the location where Marlowe is being held and injected with drugs by the bad guys is changed to a whorehouse, with some gratuitous nudity thrown in for box office appeal. Nevertheless, this version of Chandler's

novel, written by screenwriter David Goodman, helped to renew the public's interest in film noir and the hard-boiled mystery genre with a refreshed view of the loner noir hero who does the right thing, even if it hurts him.

The working-class detective may not have been the only noir hero character, but he was probably the most multifaceted and most enjoyable to audiences, which explains this genre's massive success at the box office and in film history.

NOTES

1 Chandler, Raymond, *The Simple Art of Murder*, New York: Ballantine Books, 1977, p. 20.
2 Letter in the document files for *Double Indemnity* at the Marian Library, Academy of Motion Picture Arts and Sciences, Hollywood, CA.
3 Clarke, Al, *Raymond Chandler in Hollywood*, Beverly Hills: Silman-James Press, p. 69.

3

THE NOIR ANTI-HERO

"You're trying to make me go soft. Well, you can save your oil, I don't go soft for anybody."

(This Gun for Hire)

Not all protagonists in noir films are detectives or nice guys. There are a group of noir films in which the protagonist kills someone or becomes involved in crime. These are the noir genre's anti-heroes. While the anti-hero is usually defined in standard storytelling as a protagonist who has more of the traits of a "bad guy," the noir anti-hero usually isn't a gangster or a psychopath (although there have been some). Instead, he's more often a character who eventually falls into becoming a murderer or criminal as a result of his decisions and actions rather than circumstances beyond his control.

One of the most common noir anti-heroes is the man who breaks his own code of ethics and ends up becoming involved in murder. Insurance salesman turned murderer Walter Neff in *Double Indemnity* (1944), based on the James Cain novel, is the classic prototype of the noir anti-hero. He becomes obsessed with planning the perfect murder, which begins as an infatuation with a femme fatale. But soon his obsession with the plan becomes all-consuming and means more to him than the woman who sparked it. What drives Neff, who originally warns the femme fatale against

trying to get away with murder, is actually neither sex nor money. Neff is consumed with the idea that since he's on the inside, he's the only one who can be clever enough to beat the system. It's the idea of getting away with the impossible that overcomes him.

In *Pitfall* (1948), based on the novel by Jay Dratler, a married insurance salesman, bored with life, becomes obsessed with a femme fatale while recovering embezzled money that his company insured, thus getting involved in murder. In *The Woman in the Window* (1945), based on a novel by J. H. Wallis entitled *Once Off Guard*, a happily married man sends his family off on vacation but on the way to his club sees the portrait of a woman in a window which mesmerizes him. When he bumps into her on the street, his obsession to see what kind of life she leads brings him to her apartment at night and a run-in with her wealthy boyfriend, whom he kills in self-defense. Now he must continue to cover up his crimes. In *The Big Clock* (1948), based on the novel by Kenneth Fearing, a married overworked magazine editor quits his job and picks up a woman in a bar. After spending a wild night on the town with her, he leaves her apartment to meet his wife rather than staying the night. But the woman's jealous lover sees them, kills her and frames him for the murder.

These are self-imposed anti-heroes, men who give in to temptation and fall from innocence. The danger they put themselves in doesn't come to them by accident or a cruel turn of fate. Rather, these are intelligent men with well-paying jobs who stray due to a lack of contentment with what has become to them ordinary. They long for a bit of adventure and flirtatious stimulation and when they find it, it turns out to be much more dangerous than they bargained for. They don't know how to handle it because, unlike the noir heroes, they aren't that tough. They are average Joes who are out of place in a part of society they have only read about in newspapers or pulp novels.

These noir anti-hero characters are people the viewer can sympathize with or relate to easily. Who hasn't felt bored in life at some point? Who hasn't wondered what it would be like to spend a day or night with someone who would normally be out of their grasp, to visit someone else's exciting world? If we understand how they got into the jam, we can root for them to get out of it. This kind of noir anti-hero is an ordinary person who finds himself in extraordinary situations. He is neither detective nor criminal, and

has never met those types before, but will now meet and conflict with those very people.

In all of these stories there is a femme fatale – a strong female character whom the anti-hero follows into the shadows. Another often appearing secondary character is a detective, either a private eye, an insurance investigator or a police officer, who is working on the murder the anti-hero was involved in, thus adding tension and a ticking clock. The mystery in these stories is how the anti-hero will get out of this mess. And in noir he sometimes doesn't; sometimes he pays the price for straying from the ethical. In all true noir stories, justice is served at the end – in one way or another.

Another noir anti-hero is the loser who falls into the problems that become the story. While he would like to claim it was a raw deal of fate, it is he who allows himself to become part of the underbelly of society. Early in these stories, the main character chances upon an opportunity, an unethical one that could lead to money or money and a dame. Unlike the comfortable but bored anti-heroes in films like *Double Indemnity*, *Pitfall* and *The Woman in the Window*, these protagonists have nothing and therefore nothing to lose, except ethics and perhaps their lives.

In *The Postman Always Rings Twice* (1946), based on the novel by James Cain, the protagonist is a drifter who takes a job at a roadside diner mainly because the owner's younger wife is a flirt. They end up having a wild affair and she asks him to help her murder her husband so they can get the insurance money and run away together. Unlike *Double Indemnity*, the anti-hero isn't intrigued with the idea of how to get away with it. He doesn't become obsessed with the plan; rather, he becomes the pawn of the femme fatale. He is a character who crashes before our eyes and will pay the price for giving in to desire and making a poor decision. Columbia and Warner Bros were both originally interested in the rights to the book back in 1934, but were deterred by the Production Code. MGM then bought the rights, but was also persuaded against developing the film by the demands of the Production Code office, which called the story "unwholesome and thoroughly objectionable." Twelve years later, after the success of Cain's other "immoral" book *Double Indemnity*, MGM decided to revive the project. Writers Harry Ruskin and Niven Busch changed the narrative structure to have it told in flashback with narration, imitating the success of Raymond

Chandler and Billy Wilder's change to Double Indemnity. This made the film a true noir rather than just a melodrama. The film, starring Lana Turner and John Garfield and directed by Tay Garnett, was both critically and financially successful.

The movie Detour, written by Martin Goldsmith and based on his own novel, is another prime example of the nothing-to-lose protagonist. Al, a musician down on his luck, hitchhikes to LA from New York City to see his old girlfriend and along the way is picked up by a wealthy stranger – a bookie – who keeps popping pills. As Al drives during the night, the bookie dies from what could be a heart attack. When Al opens the car door to see if he's okay, the body falls out and the bookie's head hits a rock. Instead of doing the right thing, the loser Al dumps the body in the desert and takes the dead man's clothes, his wallet with lots of cash and his car. He plans on dumping the car once in LA but picks up a female hitchhiker, Vera, who after a short time turns to him and says "What did you do with the body?" Al becomes a blackmailed pawn in Vera's schemes for getting money.

The low-class, down-on-their-luck characters and story of Detour is emphasized by the extremely shoddy production values of this Poverty Row movie. Shot in four weeks on a very low budget, a third of the film is just two people sitting silently in a car against rear projection as the narration drums on and on. While Ann Savage creates an authentic low-class schemer, Tom Neal as the protagonist alternates between overacting and just grimacing. The film is claustrophobic, which may have been director Edgar Ulmer's intention, but there is no doubt that Ulmer, who fled Nazi Germany, did just as shoddy a job directing. The film's only likable character is the sparingly used singer girlfriend, who viewers can't help but feel is better off without negative sad-sack Al.

The loser noir anti-hero is weak and often becomes the pawn of a woman who makes him venture further into danger. Our feelings for him are not the same as those we feel for the anti-hero who strayed, although both got themselves into the jams they find themselves in. Rather, audiences watch the noir loser with the same interest that they watch a boxer getting the life beaten out of him. We feel sorry for him, but also feel like he set himself up for it and can't believe someone could be so stupid. He's not a tough guy, and gets what's coming to him for pretending to be tough. Perhaps to some

this signals a pessimistic outlook on life, mirrored in film noir. But the loser protagonist in film noir is really a cautionary figure telling the viewer not to wallow in self-pity and take the easy way out, but rather to stand up and do what is right, even if it's the tougher thing to do.

Mike Hammer, the private eye invented by pulp mystery writer Mickey Spillane, is overly tough – so tough, in fact, that he's more of an anti-hero even though he's a "good" guy. He's violent and disrespectful and treats women very poorly. He usually kills a few people along the way while working on his case. He truly believes in doing whatever it takes, no matter whom it might hurt, including the unfortunate or weak – something a true noir hero such a Sam Spade or Philip Marlowe would never allow. Ruthless obsession is what characterizes this noir anti-hero. Spillane's hard-edged novels were men's paperbacks with lurid covers. They were cheap and appealed to the working-class male and teenage boy. Several of his novels became films that obviously qualify as film noir and feature the main character's bloodthirsty brand of vigilante justice. He's an unlikable character who is someone we root for only because the people he's up against are worse. But unlike his fellow noir PIs, who actually respect the law but just prefer to work without involving the police, Mike Hammer despises the law and goes out of his way to break it. He is not a good role model – the opposite of the noir hero, who is noble in his personal ethics. The reason audiences like watching Mike Hammer is because we all sometimes wish we could dish out revenge and take justice into our own hands. That is what Mike Hammer does.

While the first Mike Hammer novel *I, the Jury* was published in 1948, the first film version reached theaters in 1953 – the Red Scare period of noir. Written and directed by Harry Essex and photographed by John Alton, who did a number of the 1950s noir films, *I, The Jury* was a low-budget production from Parklane Productions. It features shooting and punching galore and was originally released in 3D. The excessive violence, overt sexuality and 3D projection were all part of getting viewers away from the TV and back into the theater. But for all of its attempts, it was Alton's cinematography that got the good reviews. The *New York Times* wrote:

> *"Denied a harvest of sadism and sex by the screen's censorship code, Mike Hammer emerges as a pretty dull operator . . . The photography*

34 THE NOIR ANTI-HERO

> *is excellent, heightened throughout by the endeavor's sole surprise, a sensible, unobtrusive use of three dimensions as an angular canvas that rarely nudges the text out of focus. Franz Waxman's moody, atonal jazz background also rates a nod. These technicalities, however, are squandered."*[1]

Variety wrote:

> *"The suspense element is not too strong, but such ingredients as brutal mob strong boys, effete art collectors with criminal tendencies, sexy femmes with more basic tendencies, and a series of unsolved killings, are mixed together in satisfactory quantities. The raw sex that is a prime feature of Spillane's book characters is less forthright on film. . . The stereo lensing by John Alton is good, and without obvious 3D trickery."*[2]

This didn't stop film producers from using the Mike Hammer anti-hero to try and lure male viewers away from the TV set. *Kiss Me Deadly* was made in 1955 and film critic Nick Schager wrote:

> *"Never was Mike Hammer's name more fitting than in* Kiss Me Deadly, *Robert Aldrich's blisteringly nihilistic noir in which star Ralph Meeker embodies Mickey Spillane's legendary PI with brute force savagery . . . The gumshoe's subsequent investigation into the woman's death doubles as a lacerating indictment of modern society's dissolution into physical/moral/spiritual degeneracy – a reversion that ultimately leads to nuclear apocalypse and man's return to the primordial sea – with the director's knuckle-sandwich cynicism pummeling the genre's romantic fatalism into a bloody pulp. Aldrich's sadistic, fatalistic masterpiece is impossible to forget."*[3]

In 1957, the next Mike Hammer PI film *My Gun Is Quick* was released in theaters but quickly Mike Hammer sold out to television and became a series from 1958 to 1960, which took out much of the sex and violence. All of that came roaring back in *The Girl Hunters* in 1963, with Spillane playing his own creation in a British production that proved that most writers can't

act. The character quickly retreated back to TV on CBS from 1984 to 1987. Mike Hammer can be easily viewed as the epitome of 1950s noir.

The noir anti-hero doesn't have to be a man, although classically it almost always was. Women's domination in the workplace during the war may be responsible for promoting the female of the species to the level of cold-blooded killer. It's not that there weren't women in the earlier noir films who committed murder or were ruthless, but those were the femme fatales and not the main characters. But the 1949 film *Too Late for Tears* stars Lizabeth Scott, who appeared as the femme fatale with Bogart in the 1947 movie *Dead Reckoning*, as a married woman who refuses to surrender a mysterious suitcase of cash and spirals deeper and deeper into murder over her obsession with keeping it. Roy Higgins (who would go on to produce the hit PI TV series *The Rockford Files*) penned the screenplay based on his own serialized novel and Byron Haskin directed the movie as a low-budget Poverty Row film produced by Hunt Stromberg through his own company. To get Scott, who was considered Paramount's answer to Lauren Bacall at the time, the director and cinematographer William Mellor found ways to shave $40,000 off the budget. It was well worth it, as Scott carries the picture as a femme fatale who smiles while she shoots. As in other noir films, there is also a good girl to offset the corruption of Scott's character – in this case, the character of her husband's sister. What makes this film noteworthy is that it is rare that a femme fatale is the protagonist of this kind of story. Like her male counterparts, her taking the opportunity to keep ill-gotten gains leads to her demise, thus becoming a morality tale pleasing both the Production Code office and the box office.

Gangsters, psychopaths and career criminals are not generally noir story protagonists. They each have their own film genre to call home, yet they all can and often do appear in film noir stories as supporting or extenuating characters. Occasionally, criminals fresh out of prison and professional killers have become noir anti-heroes. The distinction is in the story and theme of the film. In the 1953 film *Pick-Up on South Street*, written and directed by Samuel Fuller, based on an unpublished story by Dwight Taylor and produced by the Poverty Row independent film company Jules Schermer Productions, a fresh-out-of-jail pickpocket nabs the contents of a woman's purse, unaware that he's stolen secret military microfilm that she was

unknowingly being used to deliver to a communist spy. The anti-heroes of this patriotic tale are a low-life criminal, a suggested prostitute and a police snitch. The cops and FBI need them to fight the evil communists, even though they don't give them any respect. But between them there is their own code of ethics and "honor among thieves." These are people whom audiences can both feel they are better than and identify with at the same time. Their lives are common and a struggle, yet they hold their own and remain patriotic, even against the threat of death.

Eleven years earlier, the film noir classic *This Gun for Hire* (1942) has an equally dubious character, the loner professional hitman Raven, who would became one of film noir's favorite anti-heroes, in a film that also incorporates patriotism and espionage into its noir storyline.

THIS GUN FOR HIRE (1942)

British mystery writer Graham Greene's novel *A Gun for Sale* was first bought by Paramount to be made into a movie in 1936. Producer A. M. Botsford

Figure 3.1 Veronica Lake and Alan Ladd in the train yard scene from *This Gun for Hire*
Paramount, 1942

assigned Dore Schary (who would later become a producer) to write it into a screenplay. After the first two directors decided against doing the film, Botsford brought other writers onto the project. But directors kept backing out and the project was put on hold. In 1940, another script was written and then rejected. In 1941, Albert Maltz wrote a screenplay outline that was approved and worked with W. R. Burnett to finish the script. Frank Tuttle was assigned to direct it as a B picture under the title *The Redemption of Raven*. This would have made it clear that the protagonist was an anti-hero, which the Production Code office didn't approve of as they didn't want to glamorize criminals. They had many other objections to the screenplay, including the henchman Tommy's description as to how he planned on killing someone and even the last line of the film. While most of the things the Production Code office objected to the studio refused to change, one of the things they did change was the last line of the film – sort of: they just reassigned who said it. The writers also changed the location from London to LA and added a patriotic anti-fascist element, which wasn't in the original book, because America was at war. Cinematographer John Seitz, who truly helped establish the famous noir look, was assigned to photograph the film and the soon-to-become-legendary Edith Head designed the costumes for lead actress Veronica Lake. Head went on to be nominated for 25 Academy Awards, more than any other person in film history, and won eight. The gowns and look she established for Lake became another standard in the film noir tradition. (More on this in Chapter 8.)

The film was rushed into production because the studio wanted to capitalize on Lake, its newest ingénue actress, who had been a hit with audiences in *I Married a Witch* – the comedy that would later inspire the popular TV show *Bewitched* in 1964, which ran for many years. Actor Alan Ladd, who was virtually unknown, was cast as the cold hitman Raven and the name of the film was changed to *This Gun for Hire*, which allowed the studio to advertise Lake as the star. Both of the film's stars were very short, which allowed them to play against each other without the need to dig trenches for other actors or place them up on apple boxes for two-shots, as had been done in some of the other films they acted in. They were both total professionals and rather quiet – or, as Lake stated in her biography, "Both of us were very aloof . . . It enabled us to work together very easily and without friction or temperament."[4]

The film broke new ground in shooting on locations at night, something afforded to cinematographer Seitz by the new more light-sensitive film stock from Kodak and the smaller, lower-wattage and more easily transportable Solar Spot lighting units recently released by Mole-Richardson. This was one of the first, if not the first, films to shoot a scene that has become standard in virtually every modern cop, gangster or spy movie or TV show: a chase through a huge empty industrial complex at night. The production notes include several nights shooting at the complex and then another morning shoot at a real train yard. The film was shot in only 36 days with three pick-up shoot days. However, there was also a Raven dream sequence that shot for four days but never made it into the finished film.

What really set the film apart from other noir, crime or espionage movies was the fact that the writers refused to put into the film any sexual tension between the male and female leads. This was, and in many ways still is, rather novel, especially since Lake's character, Ellen Graham, is a sexy nightclub singer engaged to a police detective who is after Raven.

Raven's character is someone we can respect and eventually understand, but although he changes, he remains true to his ethics — which aren't all that righteous. Another thing that makes this film important is its invention of the often prescribed rule of Hollywood scriptwriting called the "save the cat moment," a brief act of kindness the main character does which comes early and helps endear the viewer to the main character. In the opening scene, the hitman Raven literally saves a cat.

The success of the film led to stardom for Ladd, who said it was his favorite role. The scene in the train yard is perhaps one of the best in film noir and really showed Ladd's talents as an actor. As Raven hides out with his captive, the audience learns more about the pitiful childhood that led him into the hard and lonely life he has now. We see a more complicated character and not just a standard Hollywood bad guy. This is one of the things that made noir stand out: for the first time in movies, the viewer could see that the bad guy had a reason for being bad and the good guys sometimes did not-so-nice things. In *This Gun for Hire*, we root for Raven to get away. He's not the standard gangster after power and money; rather, he's a man wronged who is obsessed with dispensing his own kind of justice — and revenge.

Also true to noir, and good screenwriting, is how Raven changes. He does this because for the first time someone has been nice to him, the very gal he was going to kill earlier and holds hostage. This good girl changes him and is his femme fatale – without any sexual overtones. The ending also dispenses justice in more ways than one, which is in keeping with the noir tradition and pleased the Production Code office. *This Gun for Hire* was another film screened in France after the war and is a true pioneering noir classic.

NOTES

1 "*I, the Jury*, Spillane Whodunit, Is Transformed into 3-D to Screen at Criterion Theater," *New York Times*, 22 August 1953. Available at: www.nytimes.com/movie/review?res=9E03E5DB153EE53BBC4A51DFBE668388649EDE (accessed 28 April 2016).
2 "Review: *I, the Jury*," *Variety*, 31 December 1952. Available at: http://variety.com/1952/film/reviews/i-the-jury-1200417488 (accessed 28 April 2016).
3 Schager, Nick, "Review: *Kiss Me Deadly*," *Slant Magazine*, 2006. Available at: https://en.wikipedia.org/wiki/Kiss_Me_Deadly (accessed 28 April 2016).
4 Stafford, Jeff, "*This Gun for Hire*," Turner Classic Movies. Available at: www.tcm.com/this-month/article/44686%7C436785/This-Gun-for-Hire.html (accessed 28 April 2006).

4

THE FEMMES OF NOIR
They Aren't Always Fatale

"She looked like a very special kind of dynamite, neatly wrapped in nylon and silk. Only I wasn't having any. I'd been too close to an explosion already. I was powder-shy."

(They Won't Believe Me)

During the Second World War, women took over the jobs of men. They worked in the factories, drove cabs and even had a baseball league. They were left to make it on their own, becoming more confident, resourceful and self-reliant. For the men at home, this was a very different society, dominated by strong women who were out of the kitchen and fending for themselves. When the GIs returned, nothing was the same. While many women retreated from the workforce to the family home, others pursued careers. At the same time, the GIs came back having met and having had relations with exotic women: French, Italian and Asian women and prostitutes. When the GIs came home, many looked at women in a new light. And having lived for years without young men, many women at home became more open about what they wanted from the homecoming GIs. Women were no longer afraid to speak up, say what they wanted and show what they had. All of these experiences changed the status quo of the American relationship between male and female.

Noir films held up a mirror to this new confusion. They also elevated and brought female characters who were prostitutes, barmaids, strippers and drunks into their stories. This was a view of women almost always avoided in popular cinema. Other than background extras or under-five-line walk-ons, the female roles in most movies were either wives and ingénues or women working honorable jobs such as secretaries, teachers, nurses and waitresses. Noir films had stories that often filled out their minor roles with women who worked in the shadows. Gone was the innocent, naïve female who needed a man to fulfill her life, both in the noir films and in the reality of wartime America.

One thing all film noir stories have in common is very strong, resourceful and independent-minded women who are aware of and comfortable with their sexuality. These women are no one's fool or plaything — unless they want to be. These female characters are not all, as some might think, deadly femme fatales. Certainly, Gene Tierney as the title character Laura couldn't be considered evil at all. She is a strong, self-reliant woman who is both sexy and intelligent. But she changes the hard-nosed sarcastic detective from a disconnected loner to someone who wants more in life. Thus she is "fatal" to his status quo.

Actresses Veronica Lake, Lauren Bacall and Jane Russell all played sexy, world-weary, strong, intelligent, female characters in film noir movies who were neither evil nor fatal. Yet, Lake clearly fulfills the femme fatale position in *This Gun for Hire* (1942) and *The Blue Dahlia* (1946) — both starring opposite actor Alan Ladd. Russell is a good but hardened-by-life club singer in the movies *His Kind of Woman* (1951) and *Macao* (1952) opposite actor Robert Mitchum, who, like Humphrey Bogart, became a standard in noir movie casting. The alluring Vivian in *The Big Sleep* (1946), played by Bacall, helps the detective Philip Marlowe, played by Bogart, and softens him. Her little sister is the bad femme fatale who is the cause of all of the trouble. This combination was repeated in the 1947 movie *Dark Passage*, in which Bogart plays an escaped convict wrongfully accused of murder. Bacall takes him in and helps him track down the real killer, a femme fatale named Madge. Once again, Bacall plays a smart, sexy, independent woman opposite Bogart, her leading man on screen and off, while Agnes Moorhead plays the story's typical evil femme fatale.

These are just a few examples of major good female characters essential to the noir plot and influential for the noir protagonist. As Aristotle said, stories are about people changing, sometimes for the better and sometimes for the worse. These women all change the hard-boiled loner protagonist who is swayed not only by their feminine charms. They are independent, sexy and intelligent, and certainly dress the part. Since the term "femme fatale" has been associated with the most powerful female character in film noir movies, we could recognize these characters as filling a category of "good femme fatales." These femme fatales are the catalysts for change, fatal to the status quo of the noir heroes. Sometimes such a femme fatale is the client who hires the PI, or the woman the main character seeks out because he is hired to find her or needs something from her. Other times they meet by accident. The femme fatale is neither innocent nor naïve, but rather worldly and hardened by life. She knows the score and how to play it.

So, in film noir there are several kinds of femme fatales, both good and bad. The bad femme fatales have given all female characters in noir an evil reputation, but there is a reason for that. The evil femme fatale will use her sexuality and intellect to manipulate others for her own personal gain or to maintain a position she has achieved by hiding her past. She will do anything necessary to anyone it is necessary to do it to, even if it is someone she has come to care for or has become romantically or sexually involved with. The character Brigid O'Shaughnessy from *The Maltese Falcon* is a sly, calculating woman who uses her charms and her intellect to get what she wants. She also will not hesitate to kill if that helps her reach her end goal. Mrs. Grayle (Velma) in *Murder, My Sweet* is another life-hardened woman who will do whatever she must to stay where she has worked so hard to get to. While the evil femme fatale will be the downfall of lesser men and will often influence the noir hero to make poor decisions, he will expose her for what she truly is and walk away – often leaving her to pay the price for her misdeeds. In *Dead Reckoning*, as the femme fatale whom our noir hero is taking in to the police turns a gun on him and shoots, he drives their car into a tree. He lives to hold her hand as she dies in the hospital.

To assume the femme fatale will always lead to the downfall of the male character ignores the reality of the very essence of the pulp mystery

novels that film noir grew out of. In these novels, the hard-boiled hero will turn on the evil femme fatale at the end, hardened and perhaps a bit more disillusioned with life than he was before he met her, but finishing what he set out to do and remaining good to his word.

For film noir anti-heroes, however, the evil femme fatale will often lead to their demise. In *The Postman Always Rings Twice* (1946), based on the James Cain pulp mystery novel, the young wife of the owner of a roadside diner convinces a drifter whom she starts an affair with to help her kill her husband. In *Out of the Past* (1947), based on the novel *Build My Gallows High* by Daniel Mainwaring (who was one of the few pulp mystery writers to actually write the screenplay for his own book), an ex-PI is called to do one last favor for a mobster he knew and ends up falling for the mobster's gal. The only way he can escape her grasp is through their ultimate demise.

Looking once again at the low-budget 1945 film *Detour*, we find one of noir's most unusual femme fatales – if she can even qualify as one. Vera, expertly played by Ann Savage, is neither sexy nor even the least bit likable, which makes her character unique among the femme fatale gallery. Another thing that sets her apart is her extreme low-class nature, street-smart upbringing and hard-edged manner of speaking. Generally, femme fatales are glamorous, sexy, mysterious and aloof. Not Vera. She's from the other side of the tracks and is as low as a class can get. Her voice is irritating and her fast talking and nasty glares make her all the more realistic and unattractive. When she twice attempts to turn on the sex appeal, she is rebuffed by Al, who wants nothing to do with her. She is a two-bit blackmailer who is more street-smart than Al, but is neither sophisticated nor highly intelligent. Her plan to pass Al off as the dead man to his relatives is so flawed and unworkable that it is the cause of their biggest argument and ultimately leads to her death and his ruin.

The 1950 movie *Sunset Boulevard* offers yet another unusual femme fatale. Interestingly, the film's co-writer/director Billy Wilder, who had made *Double Indemnity*, did not consider this film to be noir, rather a melodrama. But critics have classified it as noir due to its sarcastic voice-over narration, its stylistic cinematography by John Seitz (the same talented cinematographer of *This Gun for Hire* and *Double Indemnity*) and the fact that it begins with a corpse in a pool with the question of how it got there. The plot features

many of the noir themes, such as a disdain for the wealthy and the danger of the allure of easy money through unscrupulous means.

Set against the background of the inner workings of Hollywood filmmaking, *Sunset Boulevard* features a down-and-out screenwriter who, despite how much he despises her, becomes a kept man writing a screenplay for a wealthy faded silent film star who dreams of making a comeback. The well-past-her-prime Norma Desmond, played by actual famous silent film star Gloria Swanson, is neither sexy nor alluring. In fact, she is a demented character who seduces the screenwriter Joe, played by William Holden, with money, excesses of luxury and dreams of success. So here is a femme fatale who does not look, act or talk like the classic noir woman, good or bad. She's not sexually seductive, cunning or even intelligent, but rather overly dramatic and crazy. He instantly dislikes her but decides to use her, until he realizes he's becoming like her. Joe is another loser noir anti-hero and his involvement with Norma leads to his demise and her complete fall into insanity.

The film, a total A picture from the Paramount studios, was a box office hit and critical success. It was nominated for 11 Academy Awards, winning three, has been included in the National Film Archives and ranks 12th on the American Film Institute's list of the 100 best American films.

What all of these noir films seem to be saying is that an evil femme fatale, whether she causes the downfall of the male protagonist or not, is fatal to herself.

In *The Lady from Shanghai* (1948), based on the pulp novel *Before I Die* by Sherwood King, the femme fatale dies at the end as the noir hero, not a detective but an everyday man manipulated by her and her evil lawyer husband, literally walks away. The film is famous for its ending shootout scene in a house of mirrors. The femme fatale character, Elsa, was played by Rita Hayworth, opposite famous actor Orson Welles, who also rewrote and directed the film. One has to wonder how much of this ending was influenced by the fact that Hayworth was divorcing Welles during the shooting of the film. Elsa begins as a good femme fatale and then is revealed to be an evil femme fatale whom the hero – Welles, sporting a terrible Irish accent – literally walks away from as she cries out for him dying on the floor. Welles originally wanted her to commit suicide, but the Production Code office objected.

The rights for the book were already owned by Columbia Pictures, and William Castle (who would go on to become famous for his sensationalist marketing of low-budget horror films in the 1950s) was the assigned producer. Welles, who couldn't get a directing job in Hollywood after the disasters, both critically and at the box office, of his latest two films, approached Columbia chief Harry Cohn, desperate for cash to finance his play version of *Around the World in 80 Days*. Cohn gave Welles $50,000 for his play on the condition that he direct a film for Columbia. *The Lady from Shanghai*, starring Cohn's hit star Rita Hayworth, Welles' estranged wife, became that film.

The film was actually shot in 1946 but was so confusing and illogical that Cohn held up release of the film for a year, demanding many months of reshoots and even bringing in uncredited writer/producer Virginia Van Upp to fix the project. Among other problems, Welles had refused to shoot close-ups and had the ending funhouse shootout last for 20 minutes. Cohn brought in editor Viola Lawrence to recut the film and make sense out of it.

One has to wonder if this film, which failed critically and financially when released, could be more the product of the writer/director acting out his antagonism towards the female lead than an example of the typical portrayal of the female in film noir. After the film, Hayworth divorced Welles, which many have said he blamed on Van Upp.

Van Upp had worked with Hayworth several times before *The Lady from Shanghai*. She started as a screenwriter and really helped Hayworth with her career, writing the 1944 wartime musical *Cover Girl* as a showcase for Hayworth, which Gene Kelly basically directed without credit. (Interestingly, all of Hayworth's songs were actually sung by Martha Mears, who also sang the songs for Veronica Lake in *This Gun for Hire*.) Van Upp worked her way up to becoming a production executive at Columbia and produced perhaps Hayworth's most famous movie, the 1946 semi-noir film *Gilda*.

Because of complaints from the Production Code office, which consistently objected to the film's sexual content among other things, the story location for *Gilda* was moved from the USA to Buenos Aires, and centers on the dealings of a cold gangster running a casino, his right-hand man Johnny and the sexy independent woman whom he marries, Gilda, after he has told Johnny that no woman will ever come between their partnership in the casino. The story is told with a voice-over narration by the hard-boiled,

true-to-his-personal-ethics Johnny, complete with wit and sarcasm, and features noir standard themes of the past wreaking havoc with the present and characters not being what they seem, and also one of the most famous femme fatale characters in cinema. Missing from the noir story checklist is a murder and its detection, but instead there is the mystery of the past between Johnny and Gilda. The film could fall more into the area of gangster melodrama, but is missing the standard gangster shootouts, action scenes and heists normally associated with that genre. So noir is what it has commonly been associated with, as it is heavily character-driven.

The film was a truly female production, written by Marion Parsonnet and Jo Eisinger from a story by E. A. Ellington, and produced by Van Upp, who also carefully supervised almost all aspects of the production. It is said that Bogart was offered the lead male part but turned it down because he felt it was a supporting role in a female-centered movie and he was now an A-movie lead. The part went to Glenn Ford. Rudolph Maté was the director of photography, who also shot *Cover Girl* and did uncredited reshoots for *The Lady from Shanghai*. He would go on to become the director of the 1950 noir film *DOA* and was one of the few German refugee cameramen to have worked on a film noir movie. As is typical of noir, the film features a nightclub and illegal casino created through the fabulous art direction of Stephen Goosson and Van Nest Polglase, with sexy femme fatale costuming by Jean Louis.

Gilda is a sort of hybrid femme fatale, lurking between good and bad. While she is glamorous, sexy and strong-willed, she is also terribly mistreated by the two main male characters, both her casino owner husband and Johnny, with whom she once had a relationship and who is now assigned to keep watch over her. Her husband is a dangerous casino owner who treats her as a table winning and Johnny hates her because she left him some time ago. He still longs for her, as she longs for him, even as they hate each other. In one of the film's most famous scenes, they are in each other's arms telling each other how much they hate each other – then they kiss passionately. This insight as to how closely hate and lust are linked was certainly one of the darker concepts often displayed in film noir. To get back at Johnny and her evil husband, Gilda flirts with other men in front of them, disappears with strange men and even does a sexy song and dance that

almost turns into a strip tease in the casino (Hayworth's songs in the movie were actually sung by Anita Ellis). When her Nazi sympathizer husband is presumed dead, Johnny marries her but treats her even worse, out of loyalty to his boss and friend. She runs away but is dragged back. She laments, "You wouldn't think one woman could marry two insane men in one lifetime, now would you."

Gilda is neither evil nor a good girl. She taunts men and uses her sexuality for her own fun, power and revenge. But Hayworth also makes it clear in her exceptional performance that Gilda is also hurt, lonely and vulnerable. She truly wants love but is only offered lust. Ironically, Hayworth would complain in an interview that her personal love life often mirrored that of the character she was most famous for. She said men always thought they were going to bed with Gilda but found themselves waking up to Rita. Perhaps it was because the character Gilda is so complicated and nuanced that she intrigued audiences. The 1946 A-bomb test had the pin-up of Rita Hayworth on the bomb's nose and the atomic bomb was even named Gilda, which Hayworth was furious about. Perhaps Gilda, both the film noir character and the A-bomb, explains the slang word "bombshell" for a sexy woman.

While Van Upp only really produced one and a half noir films, both starring her friend Hayworth, she wasn't the only producer to add the female touch to noir. Joan Harrison began as Alfred Hitchcock's secretary and soon became the screenwriter of his 1941 hit gothic thriller movie *Rebecca*, for which she was nominated for an Academy Award. She wrote several more Hitchcock screenplays and then turned to producing with the 1944 noir film *Phantom Lady*. She later produced the 1946 noir films *Nocturne* and *They Won't Believe Me*. Harrison would go on to become the producer of the hit 1950s TV series *Alfred Hitchcock Presents*. So while in film noir stories women were strong forces to be reckoned with, women were making advances in a similar fashion within the wartime film industry and particularly in film noir.

Some film noir stories have a bad femme fatale and a good girl in the same story. The good girl offsets the power of the evil femme fatale, providing counterpoint in the story and doubt in the mind of the noir hero. In *Murder, My Sweet* and *Double Indemnity*, there are good stepdaughters who influence the male protagonists – good girls in opposition to the evil femme fatales, their

stepmothers. Both awaken the protagonists to better see the evil femme fatales for what they are. There is a good girl in *Sunset Boulevard* who tries to pull Joe out of his dependency and downward spiral into Norma's fantasy world. But as in *Double Indemnity*, her attempts are too late or too weak against the allure of the femme fatale. As mentioned earlier, *Dark Passage* also has a good and bad femme fatale. The appearance of the good girl next to the bad femme fatale is another example of how film noir did not always portray all women as evil.

Another often repeated good female character in noir is the loyal "gal Friday." Private eyes Sam Spade and Mike Hammer have Effie and Velda respectively, both secretaries who would do anything for them. In *The Dark Corner*, the private detective's loyal secretary Kathleen (played by actress Lucille Ball, who would become famous for her own screwball TV sitcom) plays an active role in helping to solve the case. These characters also appear in non-private eye noir films. In *Phantom Lady*, Kansas is a secretary who works to prove her boss' innocence and becomes the main character. While these are more standard "subservient" female character roles, what all of the female characters in these scripts share in common with the good femme fatales of noir is allure, strength, resourcefulness and independence.

It is interesting to note that many women worked as screenwriters in film noir and some female authors, such as Vera Casper, had their books made into noir movies as well. These women screenwriters and novelists were not writing misogynist stories, as Chartier, one of the French film critics, had mentioned about film noir. Rather, they were writing stories about strong, self-reliant women, as were their male writer counterparts. Some of the women in film noir were bad women, some good. But they were all their own and audiences loved them for it. This was the new post-war woman, down off the pedestal and on her own two feet. Whether she walked into the light or the shadows was totally up to her.

DOUBLE INDEMNITY (1944)

As discussed earlier, during the war years women worked in the factories, drove trucks and managed their lives without their husbands and boyfriends, who were overseas at war. They had to work and came home to an empty

50 THE FEMMES OF NOIR

Figure 4.1 Fred MacMurray and Barbara Stanwyck suspicious of each other in *Double Indemnity*
Paramount, 1944

room. The character Phyllis Dietrichson in *Double Indemnity*, based on the mystery novel by James Cain, is the archetypical femme fatale. She is a woman who doesn't have to work, lives in luxury and has a husband – albeit an older one – who isn't away possibly dying in the war. She has what the majority of women were missing and doesn't appreciate it. This is what made her evil in the eyes of the audience, which was preponderantly female.

It should be noted that in order to avoid the explanation as to why its two male lead characters were not fighting in Europe, the producers set the story in 1938. But this small fact is only mentioned briefly and easily missed by viewers, who saw no difference between that time period on screen and the world they were living in at the present, 1944.

Double Indemnity doesn't paint all women as evil. Proof is the inclusion in the story of the character of Lola, the stepdaughter good girl. What the story and film *Double Indemnity* does is paint a person who has what everyone else lacks and wants, yet is unsatisfied with it, as evil. As we've seen when looking

at the noir anti-hero, the person who refuses to appreciate what they have is bound for trouble. Bad things befall them. In this case both characters fulfill this character type. Walter is a success with a good job in the minds of the audience, not being forced to go fight on the blood-soaked beaches of a far-off war, and is even offered a promotion to assistant insurance investigator by Keyes, his friend at work. Keyes is the man whom he most admires and who will become his antagonist, for it will be Keyes who decides that the death wasn't an accident but murder and who begins the investigation.

Cain's sensational pulp mystery novel was first sent around Hollywood for bidding on the movie rights in 1935. Several studios were interested until the Production Code office issued a memo stating how immoral the book was and that they would never approve it becoming a film. The rights went unpurchased until 1943, when Paramount executive Joseph Sistrom bought the rights and assigned the film to Billy Wilder, who had just done the war movie *Five Graves to Cairo* as writer and director. Wilder's writing partner Charles Brackett hated the immorality of the book and refused to work on the screenplay with him. Cain was asked to co-write the screenplay but was working on another picture. So Sistrom, who read mystery novels and liked the novel *The Big Sleep*, suggested Raymond Chandler. Wilder read the book and liked the writing, so they called Chandler and invited him to the studio. Chandler, who was in his mid-fifties and educated in England, had never been to a film studio before. He wasn't exactly what Sistrom and Wilder were expecting either. Rather than looking like the typical movie idea of a writer, Chandler was described as looking like a stuffy college professor, smoking a pipe. Chandler saw an opportunity to make money and demanded $150 a week, and said that he would need a month. Wilder and Sistrom were taken back. Then Sistrom, who was known as a producer who was able to bark down everyone on their fees, informed Chandler that he would be paid $750 per week and be on staff for as long as it took to complete the film. For the studio this was a steal. When he returned from the weekend, Chandler handed in pages to Wilder and it became clear that he had no idea how to write a screenplay. Wilder also had to remind him that he was a co-writer and from then on Chandler had to report to an office at the studio's writer's building and spend the entire day working with Wilder. This went on for four months.

The two drove each other crazy. Everything Wilder did, Chandler disapproved of. Wilder would pace while Chandler smoked his pipe. Wilder would escape by going to the restroom frequently or taking phone calls, mostly from women, which irritated Chandler, who wasn't used to working with anyone. Wilder had a cane that he liked to carry about and often wore different hats in the office, which offended Chandler, who felt that wearing a hat indoors meant you didn't want to be with the person you were with – that you were about ready to leave. One day Chandler didn't come into the office and instead handed Sistrom a list of "offenses" he perceived from Wilder, such as not saying please and thank you. Wilder apologized and they went back to work. It is said that this became a recurring event.

Chandler had been a recovering alcoholic in AA. Wilder said working together caused Chandler to start drinking again. Wilder was the one who understood how to write a movie and was adept at dividing the story into filmable scenes, condensing the story, fleshing out the characters and even creating a new ending. Chandler's strength was his snappy dialog and writing the voice-over narration, which was Walter using a Dictaphone to confess – an idea that Wilder had and Chandler agreed on as his novels were all first-person narratives. It also allowed Chandler to do what he was best at: writing sarcastic inner monologs that revealed character and advanced the plot. Wilder wanted to retain as much of the dialog from the novel as possible, but Chandler insisted it wasn't written to be spoken out loud but as prose for reading. Wilder didn't understand that there was any difference. When they invited Cain in to discuss it, he agreed with Chandler, which Cain later said brought a smirk to Chandler's face. After the film was released, Cain would comment that Chandler greatly improved the novel's dialog.

Sometime later Wilder would say of his working relationship with Chandler that while they didn't get along, they worked well against each other. He felt it was more productive artistically if collaborators had different ideas and argued for them. One look at Wilder's film *Sunset Boulevard* and it is easy to see what he learned from Chandler. In turn, Chandler learned the craft of screenwriting from Wilder, and went on to make the most money he had ever been paid writing for Hollywood – although he would always insult it.

Casting proved more difficult than either Sistrom or Wilder thought it would be. Everyone turned down the parts, including George Raft – yet again. No one wanted to play such despicable immoral characters. Wilder approached Fred MacMurray, who had been playing light comedy roles, and he too refused. But Wilder kept after him day after day to take a chance and try stretching into a more serious character by taking on the murderous lead in *Double Indemnity*. Wilder's annoying persistence got to him and MacMurray finally accepted the role, confident that Paramount wouldn't let him tarnish his good-guy image and would therefore refuse to let him do it. But the studio executives weren't happy with how MacMurray had been negotiating his salary with them and thought letting him do this picture where he'd be a bad guy whom audiences would obviously hate would be teaching him a lesson. Later MacMurray would say that he never dreamed it would be the best picture he ever made. MacMurray played the part of womanizing insurance salesman Walter Neff with a bit of laid-back sleaze that helped his character become more of a criminal in waiting.

Sistrom now managed to get the movie upgraded to an A picture with the addition of MacMurray, and he and Wilder decided they needed an A-list actress. They wanted Barbara Stanwyck, who was one of the highest-paid actresses in Hollywood at the time. She too refused at first, saying she didn't want to go from playing heroines to an adulterous murderess. Wilder then asked her if she was an actress or a mouse. When she replied, "An actress, I hope," he challenged her to prove it and take the part. She did.

During filming, Wilder had Stanwyck play the part wearing a blonde wig. He thought blondes were sexier and more "loose." But two weeks into shooting he agreed with Sistrom that it looked terribly fake. The studio execs even complained, saying they paid for Barbara Stanwyck and got George Washington. It was too late into the shooting to change things, so Wilder told the studio chiefs that he wanted the character to look cheap and that the wig symbolized what a false woman she was. To make her character a little more acceptable to audiences, Wilder and Chandler changed the character of her husband from the average boring guy in the book into someone who was cranky and dislikable – someone audiences might understand why she would want out of the way.

Edward G. Robinson, who was known for starring in tough gangster parts, agreed to take the supporting role of insurance adjuster Keyes because he realized he was getting older and had to begin to adjust to taking interesting character parts if he wanted his career to continue. Wilder and Chandler expanded this role in the script from the book, making him a fast-talking, obsessive and intelligent detective figure.

The short 42-day shooting schedule went well, with highly respected cinematographer John Seitz, who shot Wilder's first film *Five Graves to Cairo* and the noir success *This Gun for Hire*, creating the shadowy look noir became known for. Wilder said they worked together perfectly to achieve the dark interiors, which contrasted with the bright LA exteriors. Instead of staying on the backlot, they shot many exteriors on location, which was made possible due to the new BNC camera and a more light-sensitive film from Kodak. This added more grittiness to the film.

Chandler visited the set and was kept on salary during the shooting just in case rewrites were needed. He appears as a background extra in one shot, sitting in a chair that MacMurray walks past in the insurance office.

During filming, some changes were made – one being the scene of the murder. The Production Code office objected to showing it on screen, so Wilder had Seitz just shoot a closeup of Phyllis as Walter kills her husband, which has been cited by many as demonstrating Wilder's great artistic directing. Another on-set change came about after they wrapped shooting the death scene at the train tracks and Wilder's car wouldn't start. It is said that he quickly ran back to the crew and cast and wanted to reshoot the shots of the murderous couple leaving the scene of the crime, this time with the car not starting. In the edit, Wilder dragged this out to become a high-tension moment, one that has been repeated in numerous films since. Also during the editing, Wilder decided to not use the ending they shot with Walter going to the gas chamber and instead ended the film a scene earlier, between just Walter and Keyes. Wilder admitted that the story was really about these two men, the father figure and the son who wanted to rebel and pull off the perfect crime. This change greatly pleased the Production Code office, which objected to the gruesomeness of the gas chamber scene.

Edith Head, who worked on *This Gun for Hire* along with cinematographer Seitz, designed Stanwyck's gowns and the wonderfully suspenseful music was composed by Miklós Rózsa, for whom this was only his second film.

Despite its tawdry story and immoral characters, the film opened to great reviews and equally great box office numbers. The film was nominated for seven Academy Awards – Best Picture, Best Director, Best Actress, Best Screenplay, Best Cinematography, Best Music and Best Sound Recording – but didn't win any. Ironically, the noir classic *Laura* won Best Cinematography that same year, but didn't have the typical noir-style imagery at all.

In 1981, screenwriter Lawrence Kasdan wrote and directed *Body Heat*, a tribute to *Double Indemnity*. The film is set in a heatwave in Florida, the noir anti-hero is a sleazy lawyer played by William Hurt and the femme fatale is a trophy wife played by Kathleen Turner. Ted Danson plays Hurt's friend, a local prosecutor, who fulfills the Keyes character role. With sultry cinematography by Richard Kline and a haunting score by John Barry, the film was both a critical and financial success. The movie, which has been classified as a great neo-noir, is more sensual than *Double Indemnity*, with nudity and sex scenes, and has a more pessimistic ending, all a reflection of the filmmaking time period. But it revived public interest in the alluring and cunning femme fatale and film noir.

Double Indemnity is often referred to as a prime example of the film noir style. Its visual look, dialog, voice-over narration, storyline and music all combine to create what is commonly thought of when one thinks of film noir.

5

DIRECTORS AND STUDIOS
A Noir Relationship

"I'm not kind, I'm vicious. It's the secret of my charm."

(Laura)

We've already talked some about the great work in noir of directors such as John Huston, Edward Dmytryk and Billy Wilder. How much influence directors had in creating the genre film noir has been the subject of many articles and essays. While director Alfred Hitchcock became known for his mastering of suspense thrillers, Frank Capri for his feel-good social commentary films and Ernst Lubitsch for his romantic comedies, no single director really became known exclusively for film noir. There were many significant directors who made major contributions to film noir, but all of them also made other great movies that were not noir. While today there are certain directors we widely recognize for their noir work, when the noir film *The Blue Dahlia* was released by Paramount, the publicity featured the film's stars Alan Ladd and Veronica Lake and the name of mystery writer Raymond Chandler. The director's name, George Marshall, virtually never appeared. By the time *The Blue Dahlia* came out, Marshall had already directed over 30 features and he would go on to direct many more major films, none being noir films.

During the studio system time period, actors, writers, cinematographers and directors worked on all kinds and all genres of films. A perfect example

is Howard Hawks, who was better known for directing Westerns during his lifetime but also directed one of the most famous noir films to be made in the late 1940s. That film was *The Big Sleep*. (More on this in Chapter 6.) Billy Wilder said that after directing *Double Indemnity* he was done with that kind of film and wanted to do other genres (although most recognize his film *Sunset Boulevard* as film noir). He went on to direct the famous comedy films *The Apartment* and *Some Like It Hot*. Diversity was a talent greatly admired within the studio system, especially among directors.

Also during the film factory years when film noir was born, like everyone else under contract, directors were asked and often assigned to work on a wide variety of genres. Some proved better at one genre than another. The studio head and the picture producers would often narrow down a list of directors they felt would be best for each project and make offers and a director's previous successes would often be taken into account when determining that list.

The director's job is without a doubt the hardest. They work with the actors, often ask for rewrites of the script, approve the sets and costumes, work on the shot list with the cinematographer, oversee the editing and work with the music composer: they direct the talents of all of the other artists working on the project. They are the conductor of the orchestra of cast and crew. Most conductors have neither written the score nor play the first violin. Film is a collaborative art form and the finished movie is a combination of contributions from a variety of very talented, hard-working artists all working under the leadership of the director.

On set, the director is really the only person who can talk with the actors, helping them to sculpt a performance that enlivens the characters from page to screen. Movies are not shot in order, but rather all of the scenes of the film in one location are shot together, so that the set can then be wrapped and replaced by a new one. So the director must remember and convey to the cast and crew what has and hasn't happened yet within the story, whether or not it has been filmed yet. They must steer the performances so that they have continuity between scenes that are shot at different times. They must know everything there is to know about the film's story, understand the story's theme and always consider how each scene will transition to the next. The director needs to have a vision as to how the finished product will

cut together in their head and plan for all of the shots that will be needed in the editing process. Everyone asks the director what they want for the film and works towards creating that. French film director François Truffaut said a director is someone who answers other people's questions a hundred times a day. It is a demanding, exhausting and often stressful job.

There is a widely repeated academic theory that German refugee directors, fleeing the Nazis and feeling a sense of alienation in America, highly influenced the creation of film noir and their stories. Directors Billy Wilder (*Double Indemnity*), Fritz Lang (*The Woman in the Window*), Robert Siodmak (*Phantom Lady*, *The Killers*) and Edgar Ulmer (*Detour*) all left Germany after the Nazis took power and came to the US. Michael Curtiz (*Mildred Pierce*), who was born in Germany, was already working in Hollywood by 1926 before Hitler rose to power. Joseph von Sternberg (*Macao*) was born in Austria but grew up in Brooklyn, New York City. Otto Preminger (*Laura*) was also Austrian but came to Hollywood before the war began because he was offered a job directing at 20th Century Fox by Darryl Zanuck. So some German noir directors just ended up in Hollywood on their own, not fleeing the Nazis. (Even more confusing is that several film noir textbooks name Edward Dmytryk as a German refugee, when in fact he was Canadian-born and started working in Hollywood as a production assistant when a teenager.)

German directors Ernst Lubitsch, William Wyler and William Dieterle fled Germany for the US and made many great movies, but none were noir films. Of course, some German directors may well have felt out of place and disillusioned in the US, with a sense of alienation. Perhaps those feelings attracted some of them towards film noir projects. But the film noir stories themselves were almost all pulled from popular fiction novels written by Americans and almost all of the screenwriters on these films were also American.

The newer directors without much clout often served time with the B-picture division and some new directors in Hollywood in the early 1940s were German refugees, such as Siodmak, Lang and Wilder. Wilder said it the best when interviewed about *Double Indemnity*:

> *"Well, there was this short story by James M. Cain. I didn't make it filled with angst or apprehensions or Nazi persecution. I just tried to*

dramatize, or Raymond Chandler and I, working on a screenplay, to emphasize what Mr. Cain had in mind. No, I honestly could not point my finger at any small incident, even in those pictures, which would reflect my background, and where I came from."[1]

While everyone's past has some effect on how and why they do what they do, a good film director will decide their approach based on the story being told.

As should be expected, many of the most significant noir films were directed by Americans. John Huston (The Maltese Falcon), Frank Tuttle (This Gun For Hire), Howard Hawks (The Big Sleep), Harry Hathaway (The Dark Corner), George Marshall (The Blue Dahlia), Delmer Daves (Dark Passage), John Cromwell (Dead Reckoning), Joseph Lewis (The Big Combo) and Edwin Marin (Nocturne) were just a few of the many talented American-born and -raised directors who contributed to film noir. Then there were the non-German European directors who made noir films, such as Jacques Tourmeur (Out of the Past), who was French-born but moved to the US in 1913 as a child, and John Farrow (The Big Clock, His Kind of Woman), who was Australian and came to the US in the 1920s.

Farrow directed a wide variety of film genres, but also directed more noir films than most of his contemporaries. At first working at Paramount, he directed The Big Clock, Calcutta and The Night Has a Thousand Eyes. Then he moved on to Howard Hughes' RKO, where he directed Where Danger Lives and His Kind of Woman. Farrow worked with a lot of the same people. He worked with cinematographer John Seitz, who had done Wilder's films, and art director Hans Dreier on all three noir films at Paramount. At RKO, he used the same actor, Robert Mitchum, as the lead in both noir films there. Farrow was good at working under the limited schedule and budgets of the B system. He rehearsed his actors more than usual, but did so while rehearsing the camera as well, so that he could shoot several pages of dialog, and sometimes action, in single long takes. Coverage, which is shooting the same action and dialog over and over from a variety of different angles, was not a luxury the B-picture productions were often afforded. So while in the bigger-budget films, directors could shoot the same scene over and over, allowing them freedom of choice during the editing process, in the B pictures many directors had to commit to shooting only what they knew they would eventually use. This was a way to save time and film, which saved

money. Directors like Farrow and Wilder who were good at this became popular B directors.

However, not all directors were easy to work with or economical. Some proved the opposite. But if the film made money or if it received critical acclaim (it didn't have to do both), the studio heads would keep the director under contract. And while directors often had the most creative control over their films, in the Hollywood film factories the production chiefs trumped everyone. Many noir films had winding roads leading to their release with many creative hands drawing the map. Sometimes the most influential ones were those of the studio chief as well as the film's director. A case in point was the bumpy ride of the highly acclaimed noir film *Laura*.

LAURA (1944)

Vera Casper was a playwright and novelist who had worked for a short time in Hollywood as a contract screenwriter. She wrote a play about a police

Figure 5.1 Dana Andrews in *Laura*
20th Century Fox, 1944

detective looking into the murder of a young successful high-society businesswoman, falling in love with the victim in the process. As playwrights do sometimes, she wanted to rework *Ring Twice for Laura* and a friend of hers recommended that she might work on it with a theater actor and director named Otto Preminger. Preminger was under contract at 20th Century Fox at the time, but had a falling-out with studio chief Darryl Zanuck, who had fired him from the 1939 movie *Kidnapped*. Casper met with Preminger and soon parted ways, saying there wasn't a single thing they agreed on. Casper rewrote the play into a serialized story that became a successful pulp mystery novel. Famous film actress Marlene Dietrich contacted her and said she wanted to star in a movie version of the book. So Casper set out to rewrite the novel as a screenplay, but then decided to do it as a play again first. After working with producers and directors and Dietrich, she decided to just sell the novel to Hollywood and let them deal with all of the headaches. Her agent only managed to get interest from two studios: MGM and 20th Century Fox.

While Zanuck was doing military service in the Signal Corps, Preminger's friend William Getz served as interim studio chief at 20th Century Fox. He brought Preminger back to direct the film *Margin of Error* while Zanuck was gone. Preminger remembered he had liked the twist of *Laura* and had Getz buy the rights as a property for him to produce and direct. Getz assigned mystery writer Jay Dratler to do a screenplay. But when Zanuck returned from service, he was angry that Preminger was back. He allowed Preminger to continue on the project as the film's producer but has been remembered for stating that he would never let Preminger direct again so long as he was at 20th Century Fox. That, however, quickly proved not to be the case. Zanuck hired screenwriters Samuel Hoffenstein and Betty Reinhardt to rewrite the script. Preminger, as the assigned producer, now was faced with finding a director and one after another turned the project down. Finally, Zanuck just assigned Rouben Mamoulian, who agreed because he didn't have any other project to work on at the time. As they began working on the preproduction for the film together, Mamoulian and Preminger didn't get along well. Zanuck had been a writer himself before working his way up to studio chief. He gave extensive script notes to Hoffenstein and Reinhardt and liked the story so much he elevated the project from a B picture to an A picture.

Actor George Raft turned down the lead detective part – making it a total of three hard-boiled tough guy parts that he rejected: *The Maltese Falcon*, *Laura* and *Casablanca*, which all became classics. While working on a different movie, actor Dana Andrews had been given the script by his director, who had turned down directing *Laura* but told Andrews that the part of the detective was perfect for him. Andrews went to meet Preminger, but Preminger told him he was wrong for the part, and that what Preminger was looking for was a more intellectual character type for the detective. Days later, Andrews was taking a break from shooting a scene for the other film he was in and ended up having a nice talk with Zanuck's wife, who was sitting outside watching her kid play. They talked about Andrews' career and how he wanted to move into more leading-man parts and how he had been interested in the detective part in *Laura*, but Preminger didn't feel he was right for it. Two days later Zanuck cast Andrews as the detective in *Laura*.

Zanuck wanted the studio's sex symbol Hedy Lamarr to play the title character Laura, but after several other female lead considerations, Jennifer Jones was assigned the role as part of her contract with David O'Selznick's studio, which stated she had to do one picture a year for Fox. On the first day of shooting, Jones failed to show up. She hated the script and even though Zanuck threatened to sue Selznick over breach of contract, she never came to the set. Newcomer model turned actress Gene Tierney was rushed into the part.

Preminger and Mamoulian wanted stage actor Clifton Webb for the snide lead male character Waldo Lydecker. But Zanuck wanted Webb to screen test for the part and Webb, who was performing in a production of *Blithe Spirit* in LA and was a recognized Broadway star, refused. Preminger sent a crew to film one of Webb's monologs from the play and showed the footage to Zanuck, who reluctantly agreed he was perfect for the part.

Filming began and cinematographer Lucien Ballard said that shooting was going so well everyone was enjoying themselves on set. After 18 days of shooting, Andrews remembers being called into Zanuck's office on a Saturday. On either side of Zanuck sat Preminger and Mamoulian. Zanuck had seen the dailies and hated the way the detective character was being played. He said he gave notes to the writers that the detective should be an everyday common working-class policeman, and not a super-intellectual

criminologist. Preminger said he agreed and had argued with Mamoulian about it – but Mamoulian said that directing the detective as an intellectual was Preminger's idea and one he had been against from the start. On the following Monday when Andrews walked on set, Preminger was the director. Ballard was replaced with the young cameraman Joseph LaShelle, who had filmed Webb's monolog for Preminger.

The cast wasn't happy. In fact, Andrews called his agent and tried to get removed from the picture. Other cast members complained about Preminger's method of working, saying he was very "German." Preminger reshot the scenes with the detective, making him more the way Zanuck had originally envisioned the character, and finished up whatever else was remaining. This was LaShelle's first big film so he was very careful with his lighting, taking much longer than Ballard did. Preminger also wanted to have a moving camera that would dolly in for closeups instead of having to cut to them, which required more setup and rehearsal time. Zanuck had repeatedly used *The Maltese Falcon* as an example in his script notes, a movie that used a lot of moving camera to slide in and out of close-ups, which possibly gave Preminger the same idea. All of this took a toll on the cast. Thankfully, the film was already laid out and set up by Mamoulian, which included the sets, costumes and even scene breakdowns, and Ballard claims that many scenes were never reshot and appear in the final movie as he and Mamoulian had filmed them, primarily all of the flashback scenes of Laura.

Contract studio musical composer David Raksin worked on the soundtrack. The novel mentioned a reoccurring song and so did the script. Preminger wanted to use Gershwin's song "Summertime," but Raksin thought it should be something original and more haunting. Preminger gave him one weekend to come up with something. By the Sunday night Raksin still didn't have anything he liked or he felt was workable. He read a letter he had received from his wife but hadn't opened for two days, which wasn't a happy one. Raksin said he placed the letter on his piano and started to play – and out came "Laura." Preminger liked the haunting theme and it became the centerpiece of the film. The *Laura* theme became so popular after the film's release that lyrics were written to it and it became a famous love song.

Raksin had even more input than just the famous musical theme. After a screening of a fine cut, Preminger and Zanuck considered cutting down the scene in which the detective walks around Laura's apartment all night, looking through her things and starting to fall for her. Dragging the scene out was originally Zanuck's idea, including the moment when he picks up a piece of her lingerie and then quickly drops it again. But Preminger and Zanuck now thought it went on too long and slowed the pace of the film. Raksin loved the scene and said he thought he could carry the scene with the music. The end result is a wonderful sequence that shows the audience the detective slowly falling in love with a dead woman through her belongings.

After the screening of the finished film, Zanuck is reputed to have said something to the effect of "Well, we missed the boat with this one." Zanuck hated the ending Preminger had filmed. He gave five pages of extensive notes to the writers and had an entire new ending written. He had Preminger bring back the cast and crew to reshoot it. When the new ending was screened, Zanuck and everyone else in the screening room liked most of it, except for the long-winded monolog given to Laura about what a liar the Lydecker character was. Preminger would later claim that they went back to his original ending, but in point of fact that wasn't the case. The ending in the released film is the ending Zanuck had dictated to the writers, but with the long monolog cut out. Another thing Zanuck cut out was the voice-over narration of both the detective and Laura that were originally in both the book and the screenplay. He felt it was unnecessary and too confusing to have multiple first-person narrations. In the finished film, only Lydecker's voice-over is heard.

Laura is well recognized as a true classic of the noir genre, reaching France in 1946. Andrews plays the hard-boiled cop in classic noir tradition: he has disdain for the wealthy and talks to everyone the same. The dialog, written by Jay Drafter, Samuel Hoffenstein and Betty Reinhardt, is snappy, witty and hard-edged and fits in with what constitutes noir dialog. Another film noir element is the voice-over narration, which conforms to the first-person narrative point-of-view of most of the pulp mystery novels that noir films were often based on. Laura is a strong-willed, independent woman who is also stylish and successful. Gene Tierney plays her with enough allure

and sophistication that audiences could see why so many men wanted her. While she shows some vulnerability, at the same time she is no one's fool or tool. She was the perfect image of the modern woman in wartime America, breaking with convention and being herself. This kind of character would come to typify the standard film noir female.

The sets by Lyle Wheeler and Leland Fuller and costumes by Bonnie Cashin are certainly in the noir style, created when Mamoulian was the director. Interestingly, *Laura* is lacking the more traditional film noir photography. There are no dark alleys, murky shadows or oblique camera angles. Many films shot before and at the same time as *Laura* had much more of the noir lighting and camera work in them, specifically the works of John Seitz in 1941 on *This Gun for Hire* and in the same year as *Laura*, 1944, on *Double Indemnity*. Preminger brought LaShelle in as cinematographer, and while *Laura* is beautifully shot, it is more a glamour Hollywood look than a film noir look.

Laura was nominated for five Academy Awards in 1944: Best Director (Otto Preminger), Best Cinematography (Joseph LaShelle), Best Supporting Actor (Clifton Webb), Best Art Direction (Lyle Wheeler and Leland Fuller) and Best Screenplay (Jay Drafter, Samuel Hoffenstein and Betty Reinhardt). LaShelle won for Best Cinematography. *Laura* really jump-started Preminger's career as a director.

In 1949, Zanuck would bring back the same successful team that made *Laura* to make *Where the Sidewalk Ends* (released in 1950), a project others had attempted and Preminger's brother was the agent for. Even though it was Preminger's idea to make the film and Zanuck bought it for him, giving him more free rein than on *Laura*, Preminger would claim to not remember it in various interviews years later. He was going through a divorce at the time of filming and was trying to get out of his contract with 20th Century Fox to become an independent producer/director. The film was a B picture, shot in three weeks in New York City.

Andrews plays a low-class police detective who accidentally kills a thug in self-defense while working on a murder case. The thug turns out to be the wife-abusing estranged husband of Tierney's character, who works as a fashion model and whose father gets arrested for the murder. Preminger

was brought back to produce and direct the film, written by Ben Hecht (who wrote the noir film *Cornered* and Hitchcock's *Notorious*) and based on the novel *Night Cry* by William Stuart. Preminger brought back cinematographer LaShelle and art director Wheeler from *Laura*, but the film bears virtually no resemblance to it. Instead of high society, the story of *Where the Sidewalk Ends* takes place in the low-class underbelly of life. Tierney actually has more of a supporting role and Andrews plays an angry hot-headed hero of questionable morals. While the reteaming of the two stars with the director was a publicity and marketing angle, the film failed at the box office and lost money.

As was the case with *Laura*, Preminger was said to be tyrannical on set, both rude and humiliating to his cast and crew – a reputation he seemed to enjoy owning. Andrews had developed a drinking problem and Tierney was fighting mental illness – her savior on set was her costume designer Oleg Cassini, who was also her husband. Both stars had survived working with Preminger in the past, thus having an advantage insofar as dealing with him over the other cast members. Once again Zanuck demanded reshoots and rewrites after seeing Preminger's edit.

While *Laura* is a prime example of many of the aspects of the classic film noir, *Where the Sidewalk Ends* is a good example of how noir changed in the 1950s. The victim Andrews' character accidentally kills is a down-and-out war-decorated ex-soldier, now a wife-abusing drunk who helps a low-life gambler gangster con wealthy men. Tierney's character loses her job because her father is arrested for a murder he didn't commit and has no savings. The attorney Andrews' character tries to hire with his life savings to defend the father turns the job down. There is no femme fatale, and virtually no other female character other than Tierney's and the owner of the low-class café they dine at, who serves as Andrews' surrogate mother figure – and who has some of the best lines in the film. Yet justice is served at the end, and Tierney's character does change the detective hero, who begins as a loner who does everything his own way. This is perhaps where its only similarity to *Laura* exists, even though both are noir. *Laura* was a great success with both the public and the critics, whereas *Where the Sidewalk Ends* was neither, despite it being the same studio, same cast, same director, same artistic crew and same hard-boiled crime genre.

NOTE

1 Silver, Alain, Porfirio, Robert and Ursini, James, *Film Noir Reader 3: Interviews with Filmmakers of the Classic Noir Period*, New York: Limelight Editions, 2002, p. 104.

6

THE NOIR CAST

"What's wrong with you?"

"Nothing you can't fix."

(The Big Sleep)

The HBO documentary *Casting By* opens with director Martin Scorsese saying, "More than 90 percent of directing a picture is the right casting." Getting the cast to bring the characters to life and make the situations real is one of the most important parts of directing. Everything else could really run by itself, if need be. No one other than the director can work with the actors. Without engaging actors with the right on-screen chemistry, audiences won't get seduced into the story, feeling as if it's real. But with the right cast, the viewer can emotionally connect to what is happening on screen. This is the talent any good actor brings to a picture.

The skill of an actor is to make things look real and spontaneous, not rehearsed and predetermined as all movies actually are. The challenges of acting for film are very different from those for the theater. On stage, the actors are far from the audience, whom they cannot even see in the blinding lights of the theater. But on a film set, the camera is often only a few feet away, surrounded by a small army of people including the director, cinematographer, camera operator, camera assistant, script supervisor and assistant director. A boom microphone bobs down from above as close as

possible. During the time that film noir movies were produced, lights were hot and bright and large crews were standing all around just out of the camera's view. Tuning all of this out while concentrating not only on the lines but also on the intent of the scene and the emotional moment of the character is an amazing skill. And on top of all that, the scenes of a film are almost always shot out of order, so for the movie actor there is no linear dramatic continuity as there is when they perform on a stage, beginning at the beginning of the story and ending at the end.

Noir is character driven. The mystery is secondary to the revelation of the characters, who are complicated and layered. Without good acting, the film becomes forced melodrama. So what makes any film truly successful in the long term, one that remains entertaining and involving years after it is made, is the actors' work.

Like the writers, directors, art directors, composers and cameramen of the classic noir films, the noir actors were employees of the studio. Everyone, from the producer down to the props person, was under contract at Fox, Warner Bros, MGM, Paramount, Universal, Columbia or RKO. Together the studios were putting out around 300 movies per year. They owned their own sound stages, backlots, warehouses of equipment, sets and costumes, as well as the talent that used them. While almost everyone was under contract, this didn't mean that the studio chiefs ruled with a dictator's fist. They offered their contract employees projects in the pipeline and allowed them to select projects they wanted to work on. But they could, and would, assign people to the films they felt were best for their career or for the box office – or just to get the thing made. Studio chiefs like Jack Warner and Darryl Zanuck were showbusiness experts and they had a tremendous amount of responsibilities and investments to worry about and one of their biggest investments was in their talent. They created the directors, producers, writers, cameramen and, more importantly to the public, movie stars of the day.

The Hollywood studios found their actors almost anywhere. They often hired people based on the visual – what kind of character they looked like – rather than on whether they could actually act or not. They figured they could always teach them to act. Sometimes they took people from the theater who had studied acting, but just as often they collected their players from

the ranks of models, singers and wannabes right off the bus who came to Hollywood to "make it."

While there were theater acting schools, there were no film acting schools in the 1930s and 1940s. The studios pulled actors and actresses from theater and radio, even nightclubs. When not shooting a picture, the actors were still being paid by the studio and they were assigned to take dance lessons, singing lessons, horse-riding lessons, elocution lessons and film acting lessons, which required much more subtlety and nuance than stage acting. The studios really did make their stars, which is why they felt they owned them. They taught them and trained them and picked the roles that were right for them and developed their fan base and created their career. But actors' contracts would expire and have to be renegotiated, and the bigger a box office draw they became, the bigger their demands; after all, they could just go to another studio. But before they became big, they had to work their way up – which often meant working in the studio's B pictures. These were the genre movies – the gangster films, the Westerns, the horror films – which sometimes didn't require the most nuanced acting to deliver the story. But then there were the mystery movies and the noir films, which usually did.

There were no real casting directors in the studios as there have been in the movie industry since the late 1950s. The studios had casting departments which had a roster of everyone under contract, grouped into A, B, bit-player, etc. From the list they would pull actors to fulfill whatever part was needed, based on the stereotype they were grouped into. Studio chiefs would often cast the stars of the film, sometimes against the wishes of the film's director and/or producer. Otto Preminger didn't want Dana Andrews for the movie Laura, but Darryl Zanuck gave him the lead, just as he put Gene Tierney in when the actress originally hired never showed up. Michael Curtiz didn't want Joan Crawford for Mildred Pierce but Jack Warner had her under contract and wanted his money's worth out of her. One can only wonder what both these great films would have been like without those powerful performances.

Billy Wilder, on the other hand, fought against the studio head office to get the actors he wanted for Double Indemnity. No one thought he could recruit two A-list actors for his assignment on a B picture with an amoral

story. But he was tenacious and knew he needed Fred MacMurray and Barbara Stanwyck, casting against their already established screen images, to make the film a success. He also knew that if he got two A-list actors, the studio would probably upgrade the film to an A picture – which they did. Edward Dmytryk also cast against type, hiring song-and-dance icon Dick Powell for the part of hard-boiled down-and-out PI Philip Marlowe in *Murder, My Sweet*. For both directors those risks were rewarded.

There was a war on and the casting options for male leads were becoming more and more limited, as many of Hollywood's heartthrobs were going off to non-combat military roles. Actors who may have been too short to be standard leading men, such as Powell, Alan Ladd and Humphrey Bogart, were still available. The war gave these actors an opportunity to play roles against type that they may not have been offered at another time. The dividends for the studios were very profitable. They now had actors who had been thought of as being limited to stereotyped roles fulfilling other needs, maximizing their investments.

Powell was signed in 1932 by Warner Bros because of his East Coast musical successes. As noted earlier, he became a successful actor in the extravagant Busby Berkeley musicals, appearing in five of them: *42nd Street*, *Gold Diggers of 1933*, *Footlight Parade*, *Gold Diggers of 1935* and *Gold Diggers of 1937*. His portrayal of hard-boiled private eye Marlowe in *Murder, My Sweet* changed his sweet screen image. Some critics complained that Powell was too pretty-boy soft to play such a part, but director Dmytryk wanted exactly that. Powell's performance of the down-and-out, seen-the-dirty-side-of-life PI is very different from Bogart's Sam Spade. His personification of Marlowe was a guy trying to be tough while not truly succeeding at it. Powell had the distinction of being the first actor to portray Marlowe on screen, whom he would also portray in a popular radio series from 1944 to 1945.

Immediately after that film's box office success, he starred in another noir film, *Cornered* (1945), also directed by Dmytryk and shot by the same cinematographer, Harry Wild. The trailer for the film declares "The New Dick Powell" and he plays an out-for-revenge ex-serviceman much tougher than his Marlowe character. Powell's character portrayals got even tougher and meaner with his next film *Johnny O'Clock* (1947), a gangster film in which Powell gets to play the heavy as a partner in an illegal gambling racket

who finds himself caught up in a murder by his partner, and (released in the same year) *Calcutta*, in which he plays a vengeful pilot who hates women. Powell reteamed with director Dmytryk as a noir anti-hero loser in the 1948 film *Pitfall*, and released the same year was the semi-noir film *To the Ends of the Earth*, in which he plays an obsessed Federal Agent tracking down the people responsible for killing a boatful of Chinese immigrants. Like any other contract player, Powell appeared in several other genre films, including war movies and comedies, but he never really returned to the musicals he had been so well known for before Dmytryk took a gamble and cast him in *Murder, My Sweet*. His last return to noir was in 1951 with the film *Cry Danger*, about an ex-con who was falsely imprisoned tracking down the true guilty party and discovering his wife was in on it all the time. While the story and characters are clearly noir, the production values have a rather standard 1950s blandness to them. His film noir persona got him the lead role in a long-lasting weekly NBC radio mystery drama, *Richard Diamond, Private Eye*. From 1949 to 1953, he was a Marlowe-style quick-witted private detective whom audiences loved, and several episodes even ended with an excuse for him to sing a little song. Powell would go on to be successful in the new medium, TV, becoming one of the founding producers of Four Star Playhouse. He died young, at the age of only 58, from cancer.

Actress Lizabeth Scott played the femme fatale opposite Powell in *Pitfall* and soon became known as "Paramount's Bacall," because of her strong facial features, sultry expressions and low voice. Like Bacall, she too had come from New York City, having appeared in several plays and having done some modeling. Scott was brought to Hollywood in 1944 as a discovery by Paramount producer Hal Wallis (who produced *Casablanca*) and gained a few smaller parts until she appeared in the melodrama *The Strange Lives of Martha Ivers*, starring Barbara Stanwyck and newcomer Kirk Douglas. There was only one scene between the actresses and it is said that Stanwyck didn't like the competition. After shooting finished, Wallis reshot some scenes to give Scott more closeups, and the critics and audiences liked her, even if co-star Stanwyck didn't. Her first true noir film was playing opposite Bogart in *Dead Reckoning* (1947). The producers originally wanted Rita Hayworth, but she was filming *The Lady from Shanghai* at the time. They offered it to Bacall, but she turned it down. So they got the

Figure 6.1 Lizbeth Scott with Humphrey Bogart in *Dead Reckoning*
Columbia Pictures, 1947

Bacall substitute, Lizbeth Scott. The film was a big hit and Scott moved on to a variety of roles in B pictures. She returned to noir in 1948 with Dick Powell in *Pitfall*.

The film's director Andre de Toth said:

> "I wanted Lizbeth Scott. I didn't want some blonde with big tits. You had to believe that this girl was real. Even if I took one of these oversexed types who could not act, it would change how the Powell character is drawn into the affair. Remember the point of the script was that he's just a middle-level insurance investigator. He's tired of his job, spending time in his little office with a drab secretary. So I could have made a different picture, with a prettier girl than Lizbeth Scott, and told the story of that girl, her problems; but that wasn't this movie. That would make it phony, if you cast it with Marilyn Monroe, a type like that. I needed somebody real."[1]

Scott's next noir was *Too Late for Tears* (1948), which gave her the protagonist role as a married woman who allows herself to become corrupted by greed and murder. Despite some saying this was perhaps Scott's greatest screen performance, the film bombed at the box office and sent its producer into bankruptcy. Her next noir was to be *The Big Steal* (1949) with Robert Mitchum, but she broke down on set and left the picture after three days. She eventually recovered from her chronic stage fright and went back to acting in both theater and films, becoming successful in many genres, but she never really returned to film noir.

Elisha Cook Jr became another face associated with film noir. Also coming to LA from the New York City stage, he appeared in bit parts in many films, and in noir first as the gunsel Wilmer in *The Maltese Falcon*, then small parts in *The Big Sleep*, *Phantom Lady*, *The Killing* and *I, The Jury*. He even returned to appear in *The Black Bird*, the 1973 comedy version of *The Maltese Falcon*. With his small size, street-smart mannerisms and way of speaking, Cook was good as the boy who tried to play tough, and was always able to gain the audience's sympathy. He was a standard stereotype character actor who worked on many studio pictures. Perhaps his most shining noir moment was as the obsessive jazz drummer in *Phantom Lady*.

William Bendix was another recurring studio player fulfilling the need for a blue-collar type. In the noir films, he alternated from bad guy to undercover cop in such films as *The Glass Key* with Alan Ladd and Veronica Lake, *The Dark Corner*, *The Blue Dahlia* also with Ladd and Lake, *Calcutta* with Ladd, and *The Big Steal* with Robert Mitchum, whom he also worked with in *Crossfire* and *Macao*. His plain looks, slightly overweight frame and working-class line delivery made him someone audiences could identify with as being a real person as opposed to a Hollywood star.

Often it was the chemistry of the cast that made a movie a box office and critical success. Nino Frank commented on the acting in the new "noir" films as being more authentic and having the ability to say so much in just a glance:

> *"These 'Noir' films no longer have any common ground with run-of-the-mill police dramas. Markedly psychological plots, violent or emotional action, have less impact then facial expressions, gestures, utterances*

> – rendering the truth of the characters, that 'third dimension' of which I have already spoken. This is a significant improvement: after films such as these the figures in the usual cop movie seem like mannequins."[2]

This kind of acting is what made actors like Bogart, Powell and Mitchum and actresses such as Bacall, Russell and Scott big hits with the viewing public. Like their directors, these noir cast members also regularly worked in many non-noir movies. At the same time, non-noir stars sometimes appeared in noir films, such as Joan Crawford, Barbara Stanwyck and Fred MacMurray, when the production was upgraded to an A picture. And while many actors and actresses appeared in a noir film early in their career, they often would not come back, such as Lucille Ball and William Holden.

When two actors had chemistry within the noir genre, the studio would often pair them up again. Alan Ladd and Veronica Lake were the same height and had similar subtle acting styles. They had chemistry on screen in *This Gun for Hire*, but were strictly business partners off screen. Ladd was dating his agent Sue Carol, whom producer Dick Blumenthal originally allowed to visit the set. But once she started showing up too frequently, he figured out they were an item and issued a memo telling the assistant director that Carol was no longer allowed on set. Lake was married to art director John Detlie at the time and had a young daughter at home. Filming was 9–5, weekdays only, with the exception of a few night scenes. The film's big success meant that Paramount now had a bankable film couple, for whom they even leaked totally made-up rumors of romance to the press. They were paired by Paramount on three more pictures together, two of which were the film noir features *The Glass Key* in 1942 and *The Blue Dahlia* in 1946. But in both, Ladd was upgraded to playing good guys instead of bad, as a result of his audience appeal on screen.

Actor Robert Mitchum and actress Jane Russell were another dynamic screen duo, appearing together in two noir films, *His Kind of Woman* (1951) and *Macao* (1952). They became good friends and actual neighbors, but never real-life lovers. Russell was discovered by Howard Hughes, who launched her sex symbol image in his RKO studio film *The Outlaw*. Although Hughes tried to seduce her, as he had tried with many of his actresses, Russell rejected his advances, as she was married to her high-school

Figure 6.2 Robert Mitchum, William Bendix and Jane Russell in *Macao*
RKO, 1952

sweetheart at the time and was somewhat religious. During a press conference after His Kind of Woman was released, a female reporter asked Russell, who was sitting on a set windowsill with co-stars Mitchum and Vincent Price, how she could claim to be a faithful Christian and wear such low-cut, form-fitting dresses. She replied that just because she was a Christian didn't mean she didn't have breasts. Mitchum laughed so hard he started to fall out the window but was caught by Price. Russell would go on to become a big musical star appearing in films with Bob Hope, who would often introduce her as "the two and only Jane Russell," and Marilyn Monroe, who is reported to have said that when Russell tried to introduce her to religion, she tried to introduce Russell to Freud. (An interesting side note is that Russell founded the World Adoption International Fund and found homes for thousands of orphans from across the world. She adopted two children herself.)

Robert Mitchum starred in a wide variety of films, but become very visible in his noir roles, to which he brought a very strong, yet subdued, persona and even a masculine vulnerability. His noir films without Russell

included *Crossfire*, *Out of the Past*, *The Big Steal*, *Where Danger Lives* and the remakes of *Farewell, My Lovely* and *The Big Sleep*.

Another big noir couple were Humphrey Bogart and Lauren Bacall, whose on-screen chemistry wasn't just an act. Their casting together made them both more popular with audiences and studios. While each did perform in films without the other, their most famous roles seemed to be as screen partners in which they "burned up the screen." Although it was their second film together, *The Big Sleep* was their first noir co-starring picture and would set the standard for noir sexual innuendo banter.

The Maltese Falcon had significantly changed Bogart's career. He had appeared in the 1937 Broadway production of *The Petrified Forest* as the gangster Duke who holds the diner hostage. When Warner Bros bought the screen rights as a vehicle for actress Bette Davis and actor Leslie Howard, Bogart ended up reprising the gangster role – after a bit of a fight. He became the go-to bad-guy character actor for the studio, playing many supporting roles in a variety of genres. He wasn't well liked because he spoke his mind and had a disgust for fakes and sham – which Hollywood was (and still is) full of. When George Raft turned down *High Sierra*, director Raoul Walsh agreed to try Bogart, who had become a drinking buddy to the film's writer, John Huston. That film led to him getting the part in *The Maltese Falcon*, Huston's first directorial job, also after Raft turned it down. That film changed Bogart's image from bad guy to hard-boiled, no-nonsense good guy – which seemed to be more a reflection of what he really was. This led Bogart to another B movie that would become world famous, *Casablanca*.

THE BIG SLEEP (1945, BUT RELEASED 1946)

In 1943, Howard Hawks, who became a director after being a studio writer at MGM, was on contract at Warner Bros and had become a close friend of the famous novelist Ernest Hemingway. He made a bet with the author that he could make a good film out of Hemingway's "worst book," *To Have and Have Not*. Hawks, William Faulkner and Jules Furthman collaborated on the script about a French fishing-boat captain and situations of espionage during the fall of France in 1940. To the novelist Faulkner, Hollywood was a paycheck. He once said Hollywood is a kind of purgatory, a place to which

Figure 6.3 Lauren Bacall and Humphrey Bogart in *The Big Sleep*
Warner Bros, 1946

it was necessary to come from time to time to do penance. Furthman had worked previously with Hawks on the film *The Outlaw* for Howard Hughes' RKO company. Hawks never received credit for directing that film and Hughes put his own name on.

Since Bogart had broken away from playing gangsters into playing hard-boiled heroes after *The Maltese Falcon*, Hawks thought he was perfect for the lead part in *To Have and Have Not*. Hawks insisted that a part be written for a young movie starlet he had been grooming: 20-year-old Lauren Bacall.

Bacall had been a model in New York City and Hawks' wife Slim saw her on the cover of the March 1943 *Bazaar* magazine. She urged Hawks to have Bacall take a screen test for *To Have and Have Not*. Hawks asked his secretary to find out more about her, but the secretary misunderstood and sent Bacall a ticket to come fly to LA for an audition. Hawks signed her to a seven-year contract and began to manage her career while Slim taught her how to act. Bacall became famous for what many called her smoky sensual growl of a

voice which made her lines all the more sexy in *To Have and Have Not*. Ironically, in the movie the Bogart character calls Bacall "Slim."

The film was a major hit, primarily due to the chemistry between Bogart and Bacall, and their legendary hard-boiled romantic moments together, such as when Bacall says to Bogart, "If ever you need me, just whistle. You know how to whistle don't you, Steve? Just put your lips together – and blow."

The film's success earned Bacall great reviews and launched her as potential star material for the studio. But it also made Bogart and Bacall an item off screen. This paring of an unhappily married, 45-year-old hard drinker, who never learned his lines until the morning of the shoot, with a sincere and dedicated 20-year-old actress did not sit well with Hawks or Slim. Slim tried to fix Bacall up with Hollywood heartthrob Clark Gable, but nothing came of it. To the relief of Hawks and Slim, Bogart and Bacall stayed apart after the filming ended. So on Hawks' next project, *The Big Sleep*, he thought it was safe to bring back the highly profitable box office chemistry of Bogart and Bacall, something the studio especially wanted.

Raymond Chandler was unavailable to write the screenplay for his own novel, as he was working on another picture. So Hawks brought back Faulkner to write the screenplay, but wanted a mystery writer to help. He had read the mystery pulp novel *No Good from a Corpse* and decided that the writer Leigh Brackett would be a good partner for Faulkner. He called Brackett's agent and asked for a meeting with Mr. Brackett, only to be told that Miss Brackett would be happy to meet him. Faulkner had decided that he and Brackett should divide up the book and write the scenes for each alternating chapter, turning them in to Hawks as they went. Brackett and Faulkner went to separate offices in the Warner writer's building and penned the entire film in eight days. They took entire sections and dialog from the novel, which made it easier and faster.

Before they started writing, Hawks had already given them his desired changes and omissions from the novel. He wanted to punch up the Vivian character's part, as that would be played by Bacall. So to make her more likable, she had to be changed to a nicer character who was only married once – not three times, as in the novel. He also wanted her in more scenes than in the book. To appease the Production Code office, other things had

to be changed: the blackmailer's pictures were no longer pornographic, drug use was lessened, homosexuality was removed and some of the more brutal moments omitted. Brackett's new ending of the story was dramatic and harsh.

Bogart read the script and objected to some lines he thought were too genteel for his character. He assumed they had been written by Brackett because she was a woman. When he went to request rewrites from her, she told him they were Faulkner's lines. Then she proceeded to make the dialog even more hard-boiled and tougher. As a result, Bogart nicknamed Brackett "Butch."

Shooting started in 1944. Chandler was invited to the set and thought Bogart was the perfect Marlowe and loved Brackett's new ending. But well into shooting word came from the Production Code office that the ending had to be changed. Since Faulkner had gone home to Mississippi, Hawks brought in Jules Furthman, whom he worked with on *To Have and Have Not* and together with Brackett they rewrote the ending and condensed and polished parts of the plot, which, due to all of the changes that were made to feature Bacall more and appease the censors, had become more and more confusing.

Bacall became nervous acting with Bogart again, fearful of her own feelings for him and afraid of his unpredictable and volatile wife. Her hands shook in a few scenes with Bogart when she lit a match or held a cigarette. Her character's unsuccessful resistance to falling in love with the Bogart character came across as so real on screen, because it was real. Working together again cemented their relationship and after the film, Bogart divorced his wife and married Bacall. Bacall later wrote in her memoirs that the making of the film was so much fun that Jack Warner sent a memo that read: "Word has reached me that you are having fun on the set. This must stop."

At one point during filming of the scene where the chauffeur is discovered dead, someone – most think it was Bogart – asked who killed him since it wasn't explained in the script. Hawks sent an urgent telegram to Chandler, who replied he didn't know himself; no one had ever asked him before. Chandler's method of getting over writer's block was to just kill off a character and introduce someone new – and worry about fixing it later. Apparently, the chauffeur's murder was something he had forgotten to

address in his own novel. So Furthman wrote in a few lines to try and tidy up the loose end.

Jack Warner admonished Hawks about all of the story confusion, delays (Bogart missed several days of work because of his drinking, brought on by his arguments with his wife) and even the cost of the telegram to Chandler. Hawks retaliated in a unique way. Whenever Warner sent someone down to the set to see what was going on, Hawks would stop all shooting and have everyone just sit around and wait for them to leave. The film became so behind schedule that it was rumored that Hawks would sometimes just rip pages out of the script to speed up production. By the time the film was scheduled to wrap, Hawks had shot less than half the screenplay. The main problem was his continual rewriting.

When the studio closed for the Christmas holidays, Hawks and Furthman shortened the script so that they could finish the film more quickly and economically, cutting whole scenes to free up sets and studio space needed by other films. The filming wrapped 34 days behind schedule. All of the changes made the mystery plot less and less decipherable. Hawks had decided that the film was really more about the characters than the mystery anyway. It was the adventures of the people, not the whodunit, that was the story. He hoped the actors would carry the film, since it wouldn't be the plot.

The cinematography was by Sidney Hickox, a well-seasoned cameraman who had filmed Bogart in his last gangster role, the 1942 picture *The Big Shot*. *The Big Sleep* was his first noir film, but his lighting was so well admired that he would be hired for the noir film *Dark Passage*, also starring Bogart and Bacall, and the noir-styled gangster film *White Heat*.

While the film was finished by 1945, Warner held the film back from release, as the war was coming to an end and the studio wanted to get out into the theaters all of the war-themed movies they had been filming first. This turned into a blessing in disguise. Bacall went on to a new non-noir film without Bogart and received lukewarm and even some poor reviews. Her agent, Charles Feldman, wrote a letter to Jack Warner, encouraging him to reshoot scenes of *The Big Sleep* in order to play up more of the great chemistry between Bogart and Bacall that made *To Have and Have Not* such a hit. He specifically named one scene in which Bacall shows up in Bogart's office wearing a horrible veil as needing to be reshot and rewritten. Warner

wanted the film to make money, so he agreed and hired Philip Epstein (one of the co-writers of *Casablanca*) to write a new scene and rewrite some of the others. Warner then brought back Bogart, Bacall and Hawks to reshoot and had to rebuild a few sets to match the shots. After the edit, virtually no one noticed that the actors had aged a year, sometimes between shots within the same scene.

The new scenes featured more screen time with Bogart and Bacall together and played up their on-screen chemistry. After a comment from Chandler about how much the actress playing the sexpot younger sister really stole the show, many of her shots and scenes were also cut. The film was finally released in 1946. At the preview, it is rumored Hawks told reviewers: "You're not going to know what to make of this picture. It holds out its hand for a right-turn signal, then takes a left."[3]

Brackett's ending, which Chandler liked, was that the younger sister Carmen confessed to the murder and was tricked by Marlowe to go out the cabin door and get shot by gangster Eddie Mars' men, who were waiting to kill Marlowe. That was changed during shooting so that Bogart's character could come across as less brutal and more compassionate. The revised movie was a big hit despite the fact that the scenes that were cut in the DA's office actually explained the entire plot very well. The new scene by Epstein was the restaurant scene in which Vivian and Marlowe talk about the horse races — considered a great sexual innuendo scene — giving the audience the same kind of hard-boiled romance that made *To Have and Have Not* such an audience pleaser.

In his rewrites Epstein succeeded in making Vivian Marlowe's equal in her wit and sarcasm. This shows a new direction that would become repeated in other noir films: having the good femme fatale be as clever as the noir hero. While in films like *Murder, My Sweet*, *Laura* and *Double Indemnity* the male protagonist has a fast sarcastic wit, *The Big Sleep* establishes the female lead as being able to dish back whatever clever comments get thrown at her. Bacall was the perfect actress for it, as she had a talent for being dry and aloof while also being alluring. Her portrayal of Vivian would become the model of the "good femme fatale" for many noir films, notably the Jane Russell noir films *His Kind of Woman* and *Macao*. Bogart and Bacall would go on to star in a number of other movies together in which Bacall continued to play

strong female characters who talked as tough as her male co-star. Of those movies, only *Dark Passage* would seriously be considered noir.

This equal-footing female character might be one of the biggest contributions *The Big Sleep* made to the noir genre. It demonstrated the independent thinking and intellect of the new postwar woman, as well as indicating that she could be a man's equal and no longer subservient. Like the noir hero, she said what she wanted to say, to whomever she wanted to say it to – something many in the movie-going audience, still mostly female, wished they had the courage to do.

NOTES

1 Silver, Alain, Porfirio, Robert and Ursini, James, *Film Noir Reader 3: Interviews with Filmmakers of the Classic Noir Period*, New York: Limelight Editions, 2002, p. 19.
2 Frank, Nino, "A New Kind of Police Drama: The Criminal Adventure," trans. Alain Silver, in Silver, Alain and Ursini, James, *Film Noir Reader 2*, New York: Limelight Editions, 1999, p. 15. (Originally published in *L'Écran Français* in August 1946.)
3 Lehman, David, *The Perfect Murder: A Study in Detection*, Ann Arbor: University of Michigan Press, 2001, p. 145.

7

NOIR THEMES

"Why don't you take that chip off your shoulder?"

"Every time I do, somebody hits me over the head with it."

(Macao)

In the previous chapters we already talked about some of the thematic elements within noir stories. Because the film noir movies were mostly B pictures, they were often under less scrutiny by both the Hollywood execs and the Production Code office – which still had plenty to say but often didn't follow through with the B pictures as much. The pulp stories explored risqué themes of sexual attraction, infidelity and drug addiction, but also – possibly even more risky to the political Production Code office – a dissatisfaction with the status quo and a distrust of both the upper class and the powerful. These were stories that the everyday American could identify with. America was at war and life wasn't all that rosy at home. Loneliness, depression and a feeling of doubt over how things were really going was the social and personal norm. The average Joe and Jane could identify with these stories.

But, as discussed earlier, these tales also fulfilled a greater need in the public psyche: a reassurance that sense could be made from chaos, that good triumphs over evil and that justice is served by the last reel. They may not all quite qualify as happy endings, but the good guys win and the bad guys get

punished. Many are bittersweet endings. Even with a finale where the main character dies or gets arrested, such as *Double Indemnity*, *This Gun for Hire* or *The Postman Always Rings Twice*, it is an ending that dispenses justice, with the antiheroes getting their due in the end. The classic noir films are not stories of injustice and good people coming to bad ends, which some writers about movies would qualify as film noir in years to come, but rather bad people coming to bad ends. In the stories that founded noir, bad decisions have deadly consequences. The theme could be considered to be that crime doesn't pay. But a deeper theme might be that when the main character gives up their ethics, they pay the ultimate price. Even characters with a dubious honesty must stay true to their own personal code of ethics. Sleazy PI Sam Spade even quips "Don't be sure I'm as crooked as I'm supposed to be." He might cheat with his partner's wife, but when it comes to the death of that same partner, even love won't stop him from turning in the culprit.

Many noir stories are of people who aren't what they pretend to be. In the detective films, often the PIs' own clients lie, such as in *The Maltese Falcon* and countless other films to follow. The PI exposes them for what they really are. In the non-detective noir stories, the main characters become threatened or in trouble if they are too easily accepting, as in *The Lady from Shanghai*. Perhaps this was a result of the war paranoia, or perhaps it was just a healthy disgust for shams and phonies, who were abundant and preyed on the poor, sad and lonely. These were cautionary themes saying one shouldn't believe everything one's told.

All of these dark stories have complicated plots full of twists, turns, lies and double-crosses. Sometimes hard to follow and confusing, they all somehow make sense at the end – at least to the protagonists. Often, within the private detective tales, the plots become so complicated that the enjoyment of the story isn't figuring out "whodunit" but rather becoming involved in the lives of these colorful characters who seem at home messing around in the dark underside of society.

French critic Jean-Pierre Chartier wrote in his 1946 essay "Americans Also Make Noir Films" for *La Revue du Cinéma* that in *Double Indemnity*

> *"as the guilty man is telling the story, there is no formal mystery; on the contrary, it is the psychological mechanism by which Walter Neff is*

> *dragged unrelentingly into the criminal action that unwinds before our eyes. The action doesn't spring from exterior causes – the seduction of [a] law-abiding young man by a calculating bitch, the appeal of the perfect crime, the gauntlet thrown down to the friend in charge of investigating fraud have a verisimilitude that draws us personally into this sordid tale."*[1]

During the war years, there was a lot of underside: a black market brought on by rationing and shortages due to the war, a fear of espionage and spies promoted through government propaganda, the police turning a blind eye to illegal gambling and prostitution, and the nagging question of how it was possible that so many rich people seemed to be so unaffected by the hardships of war.

The noir stories themselves involve violence, death and a healthy disrespect for the rich and powerful. What more could Jane and Joe Public want as a way to live out their inner frustrations with waiting for the war to end and happiness and prosperity to return?

The PI noir films highlight the theme that everything is connected. The PI usually becomes involved in what appears to be two separate cases that end up being connected. In *The Maltese Falcon*, Spade is hired to find Floyd Thursby by Miss Wonderly and hired to find the Falcon by Cairo, which are connected. In *Murder, My Sweet*, PI Philip Marlowe is hired to retrieve blackmailing photos and escort a man making a pay-off, which are also connected.

As discussed in the chapter about the noir anti-hero, a common theme exhibited in some noir films is that when faced with an opportunity to get away with something, you will always have to live (or die) with the consequences of your actions. If you make the unscrupulous choice (again, breaking a code of ethics) to take advantage of a situation that came to you by pure chance, bad things will happen to you. Some noir critics have called this the fall of the innocent man, a victim of circumstance to whom fate deals a raw hand. But it would be more logical to call these stories the fall of the opportunist, someone without the backbone or ethics to do the right thing. As discussed before, *Detour* is a prime example of this theme. The theme of many noir films could be simply stated as "deny temptation and

do the right thing, or else." Or "be happy with what you already have – it could be worse," such as in the films *Pitfall* and *The Woman in the Window*.

The Pretender (1947) is another Poverty Row noir film, produced and directed by W. Lee Wilder, Billy Wilder's lesser-known brother. Produced by WW Productions and written by Don Martin, the film is very low-budget, but features some nice cinematography from up-and-coming cameraman John Alton, who would go on to became a major 1950s noir cinematographer. The main character is an embezzling investment banker named Kenneth who decides to marry a client he's been stealing from in order to hide his crimes. The client, Catherine, turns him down as she is engaged to another man, so he hires a hitman to kill whoever is named as her husband in the papers. In another example of the noir cruel twist of fate, Catherine decides to break off her engagement and marry Kenneth instead. After they marry, he comes to the realization that he's hired his own killer. Here again, the opportunist is taught an ironic lesson. What goes around, comes around.

The 1947 film *They Won't Believe Me*, based on the short story by Gordon McDonell, is told in flashback in a courtroom trial. An adulterous husband ruins his wife's life and then runs away with his lover only to have her die in a car accident. The police assume the dead girlfriend is his wife, so he comes home with the plan to kill his wife and make it look like she died in that accident. But he discovers she's committed suicide. He dumps the body and takes up with a previous girlfriend he jilted. She secretly helps the police to arrest him for the suspected murders of both his wife and his girlfriend. Before the jury reads its verdict, he attempts to escape and is shot. After his death, the jury reads off their verdict: not guilty. The switch here is that the anti-hero is the one who is fatal to the female characters in the story. A common theme in noir films is that adultery leads to one's own demise, as in *The Postman Always Rings Twice* and *Double Indemnity*.

The 1950 film *DOA*, written by Russell Rouse and Clarence Green and based on a German film that was directed by Robert Siodmak, who would go on to direct a few film noir movies in America, presented a new theme in the film noir cycle that grew more common during the Red Scare period: total cynicism and unfairly becoming the victim of other people's games. The main character Frank steps into a police department and reports a murder: his own. He is dying from a poison and in flashback relates how

he tracked down who slipped it to him. Frank is a CPA who has come to the big city for a convention, leaving behind a sweet secretary who wants him to marry her. He goes on the prowl in one club after another, eyeing the dames and trying to pick up a sexy blonde when someone slips something into his drink. Through the long night search for his poisoner, he finally discovers that he notarized a shady business deal back home and is now being silenced, just in case.

A theme one could find in DOA is that those involved in big business are dishonest and so ruthless that they will kill over it. This theme also appears in The Big Clock and The Lady from Shanghai, as well as in This Gun for Hire. The guilty parties in these stories are big business owners who have no ethics. These themes were increasingly embraced in the later years of the film noir period. It would be easy to see this as a response to McCarthyism and the Hollywood blacklist, whereby innocent people suffered for just being in the wrong place at the wrong time.

DOA also shares a theme with other noir films in suggesting that there are dangers in going out on the town looking for a wild time. If Frank had only attended the conference and not gone to the nightclubs, trying to pick up the blonde, he wouldn't have been poisoned. This theme is also repeated in The Big Clock and Phantom Lady, as well as many noir films that followed. One might suspect that this was a theme the Production Code office liked, as it reinforced wholesome family values. The womanizer gets in bad trouble and sometimes dies. There are many hints in Double Indemnity that Walter Neff is a womanizer as well. In They Won't Believe Me, the womanizer dies in the end. In both The Big Clock and Phantom Lady, the man who flirts with a strange woman ends up accused of murder and his life is almost ruined, while in Pitfall and The Woman in the Window, the straying married man finds himself in potentially fatal danger. One could conclude that these noir themes are cautioning the male viewer to be more of a stay-at-home guy, which would have been popular with the majority of female audiences as well. The returning vet had seen too much action already during the war and perhaps was more ready to settle down. Perhaps these were tales that reflected a feeling of longing for the good old quiet life, a return to the prewar status quo.

After the war, more and more people moved to the cities for employment. The city was often the setting of the hard-boiled mystery fiction that

these films were based on. So it is no surprise that the city became the reoccurring motif and setting for most film noir movies. The city offers excitement and opportunities, but also is full of dark alleys, seedy clubs, criminals and loose women. Anything can happen in the big city, a place where dreams can be made or crushed and where people can be corrupted through ambition or desperation. Some might conjecture that film noir paints the city as evil, but it mostly portrays the city to be a crowded place full of lonely and often desperate people. The loner is a survivor in the city.

But noir stories weren't always confined to the city. *The Postman Always Rings Twice* takes place in a lonely roadside diner, while *Detour* mostly takes place on the road itself.

Another thematic story element of the noir screenplay is how the past affects the present. In *This Gun for Hire*, Raven has become a hardened killer because of his terrible childhood. In *Dark Passage*, the hero is out to clear his reputation and make up for mistakes he made along the way. Films such as *The Killers*, *Laura*, *Out of the Past*, *Dead Reckoning* and *The Dark Corner* are all about how the past affects the present. In fact, almost every murder mystery is about reconstructing what happened in the past, and the murder mystery is a primary element of the first film noir movies. Mrs. Grayle will always be Moose's Velma in *Murder, My Sweet*, no matter how rich she marries. Waldo Lydecker wants Laura to remain as she originally was when he helped "create" her.

Another part of this noir theme is that while the past will always be with you, you can't go back to it. This theme resonated with the postwar populace, many of whom yearned for what life was like before the war. In a way, many film noir movies say that the past is gone, that it often wasn't as good as we remember it and that if we try to revive the past, nothing good will come of it. In *Out of the Past*, a man in a nice comfortable life owning a gas station is pulled back to the dark, sleazy culture and people he had left behind, which destroys him.

Because noir films were mostly B pictures, they could sometimes get away with presenting very serious and almost controversial themes. As we've seen, they exploited sexuality and touched on homosexuality. But the most risky noir film in terms of theme may well have been the 1947

movie *Crossfire*, written by John Paxton and based on the novel *The Brick Foxhole* by Richard Brooks. Produced by Dore Schary and directed by Edward Dmytryk (who also directed *Murder, My Sweet*), the film is about a soldier who kills a man solely because he's Jewish and then tries to frame a fellow soldier who has come back from the war feeling useless and hating himself so much he doesn't even contact his wife, whom he feels won't even want him back. These were real issues: anti-Semitism and the mental anxieties facing returning veterans. This is a heavy-message film about hate and the effects of war on the returning soldiers, something producer Schary thought was dangerous to make while Dmytryk kept pushing for it. The book had the victim as a homosexual, but the Production Code office insisted it be changed. The film was very well received by critics and audiences alike and was nominated for five Academy Awards, including Best Picture.

Mistaken identity also became a recurrent thematic element in noir. This connected with the viewing public as so many people during and after the war (and still today) questioned themselves: who were they, how did they fit in and were they satisfied with who they had become? Many noir films address these concerns.

Sometimes a noir hero is innocently mistaken for something he's not – in which case his only escape is proving he isn't what they think he is. While this is often being wrongly accused as being a murderer, another common example is being mistaken for a detective or a fellow criminal, such as in the films *Macao* (1952) and *Red Rock West* (1993) respectively. In these films the noir hero isn't aware at first that he is being mistaken for something he is not. This reflects the theme that trouble can befall an innocent person who just happens to be in the wrong place at the wrong time. How he then approaches the situation is what determines if he is a noir hero or a noir anti-hero. The noir anti-hero deliberately takes on someone else's identity and pays the price for it, such as in *Detour*, whereas the protagonists in *Macao* and *Red Rock West* are noir heroes who help justice be served. Both suggest a moral that it is best if people are satisfied with being who they really are and don't try to pretend to be otherwise: to one's own self be true. One can see how this theme again might have been a reaction to McCarthyism's witch-hunting victimization of innocent people and the resulting Hollywood blacklist.

MACAO (1952)

Figure 7.1 Robert Mitchum being chased in *Macao*
RKO, 1952

Produced by RKO in 1951 for a 1952 release, the noir film *Macao* is not set in an American city but on an island off the coast of Hong Kong. But the story locations have the same crowded streets and shadows of New York City's or Los Angeles' Chinatowns. The story features themes of mistaken identity and people trying to evade their past. Also, typical in noir stories, many of the characters aren't what they seem to be.

Cast in the lead roles were Robert Mitchum, who had been in *Out of the Past* and some other noir films, and studio owner Howard Hughes' new protégée Jane Russell, whom he was promoting as a sex symbol. They were under contract at RKO and Hughes knew he had a winning combination after having them in the film noir audience hit *His Kind of Woman* a year earlier. They were equals, not only in height and stature but in sex appeal and wit, and the audiences loved their chemistry. So even though *His Kind of Woman* ended up losing RKO money, due to Hughes' reshoots, changing the actor for one character three times and hiring a

second director, Mitchum and Russell needed a second film together and *Macao* would be it.

At first Stanley Rubin, who was a screenwriter and had just won the first Emmy Award for producing a TV show, was given a contract to write and produce *Macao* from a short story by Bob Williams. But Hughes decided that the reteaming of Mitchum and Russell in their next film was too important a project to give to a first-time feature film producer so he broke the contract with Rubin and assigned veteran producer Alex Gottlieb to helm the film. Rubin stayed on and wrote the first few drafts, but then Bernard Schoenfeld came in to join him. Rubin said Schoenfeld wrote much better dialog then he did and really punched up the script. Five other staff writers were brought in at different times, as Hughes was someone who was always unsatisfied or making changes.

Hughes cast Gloria Graham, who had been nominated for an Oscar for Best Supporting Actress in the noir film *Crossfire* (which also had Mitchum in a supporting role), as the casino owner's sexy girlfriend. Graham had played opposite Bogart in the noir-esque thriller *In a Lonely Place* in 1950. Graham's character isn't fully explored or utilized in the film, although she plays an important role that is part good girl and part femme fatale. She becomes jealous of her gangster boyfriend's interest in Jane Russell's character. Not a particularly good or kind woman, she does things out of motivation to either get rid of her rival or get even. Graham plays the part with the perfect aloofness that befits a femme fatale, always remaining a bit mysterious and possibly dangerous. Her character seems subservient to the casino owner, but is revealed not to be, thus maintaining the noir view of the strong female.

Meanwhile, Russell's character is a woman who is neither totally honest nor evil herself. She also will do what she feels she must in order to survive. She wants to escape not only her past but also her present and thinks she may have found an opportunity to do so with Mitchum's character. Like the noir good femme fatale initially typified by Lauren Bacall's character Vivian in *The Big Sleep*, Russell's Julie Benson is strong, witty, self-reliant and no one's fool. The part was catered to her based in part on the success of the strong character she played opposite Mitchum in their previous film. Unlike Vivian in *The Big Sleep*, Julie is more proactive in controlling her destiny and prone

to being more aggressive. She is more of a wild cat, which makes her more actively sexy than Bacall's slow, simmering sultriness. She has mood swings and loses her cool, unlike Vivian or almost any other character Bacall would play. Unlike most noir femme fatales before her, Julie isn't wealthy or in the upper class. She's a poor working gal, and even a pickpocket, but she has style and elegance nonetheless. Her character is displayed in her gowns created by costume designer Michael Woulfe. Under Hughes' direction, the gowns emphasized her bust-line. Even her bathrobe is sexy and reveals a lot of leg, yet covers just enough to avoid the censors at the Production Code office, who specifically sent the production a memo about covering up the female anatomy at all times. The shimmering gown she wears during one of her club song numbers was made from meshed metal that weighed a great deal.

While both of the femme fatale characters in *Macao* are complicated, willful, sexy and resourceful, nether are presented as evil. So *Macao* is another example of how not all noir films display the female as deadly to the male. However, as is true of all major female characters in classic noir, they both cause changes to and influence the decisions of the male noir hero. Interestingly, rather than leading to the fall or death of the protagonist, in *Macao* both femme fatales lead to the fall of the antagonist.

Mitchum's character, Nick Cochran, also has a troubled past and, typical of the noir hero, is neither well-off nor successful. However, he is talented at surviving. Like the PI heroes of noir, he is a loner who has his own code of ethics and is no one's fool. He is witty and resourceful but also can be wrong or tricked. Keeping with a typical 1950s noir theme, he becomes a victim of mistaken identity and suffers for it. But also true to noir, once he is given the opportunity to quit the dangerous business he has fallen into and walk away, he presses on because of someone's death and his own feelings of an obligation to see things through. Unlike Philip Marlowe or Sam Spade, Mitchum's Cochran never loses his cool. He is the man everyone wants to be or be with. He takes things as they come and rolls with the punches (both figuratively and literally) but is both tough and tender when he wants to be or should be. These were admirable traits to both the male and female viewing audience and Cochran would be the kind of role Mitchum would become famous for.

Harry Wild, who had shot the noir films *Murder, My Sweet*, *Pitfall*, *They Won't Believe Me* and *Nocturne* (almost all for RKO), returned for this re-pairing of Russell and Mitchum, whom he had photographed in *His Kind of Woman*. Wild's cinematography is a standout in *Macao*, full of contrasts and shadows that keep the story grounded in its shadiness. Venetian blind patterns abound and light from a blinking sign illuminates the bad guy just as he looks down and catches a glimpse of Cochran hooking a ride with Julie. Particularly creative is his photography of the chase scene along the docks, shooting through fishing nets and his use of reflected water patterns on both people and set pieces. The entire film was shot on the RKO backlot, but a second unit of a director and a cameraman were sent to Hong Kong and Macao to film location footage to use as establishing shots and rear-screen projection.

Hughes didn't want to bring back the same director from *His Kind of Woman*, John Farrow, who had directed three noir pictures while at Paramount and whom he had replaced with Richard Fleischer to reshoot an entirely new climax and ending scene for *His Kind of Woman*. Instead, he brought in legendary director Josef von Sternberg, even though he hadn't directed anything in quite some time. Sternberg had been an acclaimed director in the early 1930s, often credited with making actress Marlene Dietrich into the famous Hollywood sultry sex symbol she became, directing her in such films as *The Blue Angel*. Hughes wanted that same sex appeal for his newest female star, Russell.

Sternberg decided he wanted to show a lot of racial diversity in the film, so he did extensive casting of Asians but also put a Sikh traffic officer in the film for some odd reason. Sternberg had a reputation for being pompous and arrogant. The cast hated working with him and he was disrespectful to the crew. On more than one occasion, cinematographer Wild became so angry he threw down his favorite hat and stomped on it or kicked over an apple box on set. One day Sternberg's treatment of the crew and Wild was so bad, Wild kicked over an apple box that Sternberg was standing on at the time. Mitchum, who had great respect for the crew and his fellow cast members, stood up to Sternberg. Sternberg would go to Russell and complain about Mitchum being difficult and then go to Mitchum and complain about Russell being beautiful but stupid. He didn't seem to realize that Mitchum

and Russell had become great friends on *His Kind of Woman* (and remained so throughout their entire lives). One of Sternberg's arbitrary rules was that no food or drink could ever be on set – even coffee and water. Finally, one day Mitchum brought in a picnic blanket and a basket. He threw the blanket down on the set, opened the basket and handed out sandwiches, candy bars and drinks to the entire cast and crew. Sternberg stormed over and yelled at Mitchum that he could be replaced. Mitchum answered, "No, you can be." Mitchum called Hughes and said, "Either he goes or I do." Hughes fired Sternberg and Nicholas Ray came in to direct the rest of the film.

As filming neared completion, Ray felt the last few scenes they had left to shoot needed some rewriting. So he would meet with Russell and Mitchum after shooting wrapped and they would come up with how the next scene should be rewritten. Then Mitchum would go back to his dressing room and rewrite the scene that they would film the next day. Mitchum never received any credit for his writing input.

After the final-cut screening, Hughes was unhappy with the film and wanted changes. He brought back the cast and hired Mel Ferrer, who had come in as a second director on several other Hughes-produced features, to direct the reshoots. Hughes bringing back the cast and hiring a new director wasn't new to the film's leading actors Russell and Mitchum, who had had the same thing happen to them on *His Kind of Woman* just a year earlier. Neither star would have fond memories of working on the film, which is unfortunate, as many believe their performances in *Macao* are among the best they ever did. Perhaps all of the on-set irritations helped them to enliven the personalities of their characters as world-weary, disillusioned loners who hope they have each other to depend on. But the film is significant in the noir chronology, as it truly cemented the laid-back noir hero that Mitchum would continue to play and that would make him as popular as the Bogart tough guy.

Interestingly, the Production Code office made numerous objections to language in the screenplay that was derogatory to Asians. Joseph Breen sent memo after memo demanding that lines with racist remarks be omitted from the film, which they were. So *Macao* is also notable as an example of how the Production Code office wasn't always about censoring on-screen violence and sex, but also prejudice.

NOTE

1 Chartier, Jean-Pierre, "Americans Also Make Noir Films," in Silver, Alain and Ursini, James, *Film Noir Reader 2*, New York: Limelight Editions, 1999, p. 23.

8

NOIR STYLE
Music, Costumes and Art Direction

"You see, I wanted to be a detective too. It only took brains, courage, and a gun . . . and I had the gun."
(My Favorite Brunette)

The Hollywood film factories were the providers of the nation's popular culture and mass movie-going was a favorite pastime of the era before TV. Film stars were the royalty of America and the movies introduced fashions, music and slang as well as reflecting the public's desires and fantasies. Noir films, like the films before and after them, never accurately reflected what the real world was like, but rather gave a stylized view of what it could be. Unlike the happy sparkly musicals of the Depression, noir reflected a more somber view, but it was as styled as any other film genre.

MUSIC

Jazz was the music of the day and most noir films incorporated elements of jazz into their soundtracks. Swing, bluesy ballads, horns and fast percussion were things that many composers would add to accent or punch up the excitement or emotion of a scene. Often a lone bluesy saxophone has been associated with film noir. Perhaps its haunting tenor echo reflects the walk

of the loner down the empty alley of his life. Jazz music and jazz clubs appear in many noir films, perhaps as they were perceived as being both exciting and risqué, much like the world of noir. *DOA* features a very long jazz club number and *The Dark Corner* even gives a screen credit to the jazz band playing in a club scene.

The nightclub song also became a frequent staple of the noir movie. *Detour* features a club song by the protagonist's girlfriend, who is almost never seen again. Sometimes the femme fatale was given an obligatory nightclub song by the Hollywood film factory producers, who wanted to maximize the entertainment value of their films for the movie-going public. Veronica Lake sings two numbers in *This Gun for Hire*,[1] Lizabeth Scott sings a torch song in a nightclub in *Dead Reckoning*, Lauren Bacall sings a sultry number in the illegal gambling club in *The Big Sleep*, Rita Hayworth sings a risqué song in the club in *Gilda* and a sweet song after the club closes,[2] and Jane Russell sings two numbers in both *Macao* and *His Kind of Woman*. Sometimes a film starlet's songs were sung by someone else and dubbed in. The lyrics of every song also had to be cleared by the Production Code office, which sometimes took offense to innuendo and requested changes. More often than not, the producers didn't make all of the requested changes, understanding that sexiness sells.

The studio contract composers lent a great deal to the texture and tone of any film, but especially in film noir. Music under the dialog can convey anger, sadness, loneliness, romance and tension. And every producer wanted his film to open with a grand musical score that let audiences forget their troubles and the life outside the theater and become immersed in an involving story experience. The fully orchestrated soundtracks of the noir films did exactly that. Some composers only did one noir film, some two, while others found themselves being called on several times to fill the studio need for sensational noir soundtracks. Victor Young composed the scores for *The Glass Key*, *The Big Clock*, *The Blue Dahlia* and *Calcutta*. Roy Webb did *Murder, My Sweet*, *Cornered*, *Crossfire*, *Out of the Past* and *They Won't Believe Me*. Miklós Rózsa created the music for *The Killers*, *Double Indemnity* and *Lady on a Train*. David Raksin composed the music for *Laura* and *The Big Combo*, while Max Steiner (the composer for *King Kong*) composed the scores for *The Big Sleep* and *Mildred Pierce*.

The film composer contributes greatly to the success of any movie. The opening title theme helps to set the tone of the picture and often includes a melody that will be repeated throughout the film. But these talented musical artists also create recurring themes for the different characters and often different locations within the story as well. These musical cues subliminally help orient the viewer. Sometimes a theme will be repeated but in a different tempo or key, thus adding a new feeling to the scene. Film scores add tension, quicken the pacing, establish emotion and amplify the action. Music is also used to help establish a time and place setting and as a transition device, allowing the story to flow from one scene to the other.

In *Laura*, Raksin's musical originality makes an otherwise slow scene of the detective snooping around Laura's apartment into a bittersweet scene of a loner falling in love with a woman he has never met. He repeated the theme often, sometimes slow and romantic, other times faster and louder to punch up the tension. *Laura* would never have been as great a success without his creative contributions.

Rózsa set the pacing of *Double Indemnity* with his grand opening title theme, conveying to the viewer a feeling of doom. He defied the old Hollywood standards and the head of Paramount Studio's music department by creating music that was dissonant and harsh rather than romantically melodic. He used violins to create a "theme of conspiracy, a nervous kind of motif"[3] that begins when Walter first visits the Dietrichson home, one that is repeated throughout the film at various times as he and Mrs. Dietrichson plan the murder. Rózsa believed that the music in a film should support and underline the drama, and that the story should dictate the style of music, a goal shared by all film score composers. He also believed in the importance of silence. Deciding when there should be no music is almost as important as deciding what kind of music should be heard and when. For *The Killers*, Rósza established a musical motif to cue the audience in to when the killers were around. His creative contributions to the art of cinema were well recognized within Hollywood. Rózsa won the 1945 Academy Award for his soundtrack for the famous Alfred Hitchcock suspense thriller *Spellbound*, which came out between *Double Indemnity* and *The Killers*, winning against himself as he was also nominated that year for his work on *Lost Weekend* and *A Song to Remember*. Rózsa would go on to win two more Oscars and several nominations until doing

his last film score, for the film noir parody *Dead Men Don't Wear Plaid* starring Steve Martin, in 1982.

COSTUMES

The fashion of the war years wasn't very elaborate for the everyday working woman or man. There was rationing and the factories were working overtime, fulfilling the needs of the war effort rather than catering to the fashion desires of the public. But that didn't mean that women, the primary movie-goers in the US when film noir started, didn't dream about dressing up and being fashionable. The noir woman allowed them to do that vicariously, with elegant, tasteful yet sexy gowns often designed by costume designer Edith Head.

Head's designs were sleek and form-fitting, with a hint of revealing skin either in the high slit on the long skirt or the narrow, deep V neckline. She not only took great care to tailor them to each individual actress but also used them to highlight their best physical assets with elegance. Rarely did Head dress her femmes in anything too girlish or frilly. One can see how she pioneered the style of the femme fatale in the gowns for Veronica Lake in *This Gun for Hire*, a look that is not shared by the femme fatale in *The Maltese Falcon* before it.

The clothing someone wears is like a book cover: it gives the viewer an idea of what's inside. Miss Wonderly in *The Maltese Falcon* is well dressed, but not very sexy. Costume designer Orry-Kelly dressed this character who keeps changing both her name and her story in clothes that make her look like she is trying too hard to look sophisticated. She is nothing more than a small-time swindler and conwoman, and her costumes help the audience doubt what she tries to pass herself off as. His costuming for the Peter Lorre character, Joel Cairo, clearly conveys to the viewer Cairo's eccentricities and his lack of masculinity. Yet he still appears as a person who is successful at whatever he chooses to do and someone to be reckoned with. Sam Spade's attire is simple but serious, true to his character, and the thug Wilmer is instantly recognized by viewers as a low-class, not very smart gun for hire. Orry-Kelly's work helps clue the audience subliminally into each character's background, as is the intent of all movie costume design. Orry-Kelly would

go on to design costumes for almost every studio and a wide variety of stars, including the women's wear for both Tony Curtis and Jack Lemmon in Billy Wilder's *Some Like It Hot*, which won him his third Academy Award.

As previously mentioned, Edith Head won more Academy Awards than any other person in the history of motion pictures. Head decided that for the noir films her female characters would showcase their independence and comfort with their own sexuality through their outfits. The style she started in *This Gun for Hire* was different from that of Orry-Kelly's design for the con artist femme fatale of *The Maltese Falcon*. Head's designs were more risqué and tantalizing, often running the risk of the wrath of the Production Code office. But the stylish sexiness of Veronica Lake in *This Gun for Hire*, *The Glass Key* and *The Blue Dahlia* is different than the almost sleazy sexiness of Barbara Stanwyck in *Double Indemnity*. The murderess Mrs. Dietrichson is a rich married woman, as opposed to the "good femme fatale" characters that Lake played in her noir films. While Head dressed Lake glamorously, she dressed Stanwyck more like she wants to have an affair. There is something about Head's designs for Stanwyck's character that helps visually convey to the viewer a sort of snobby conservative sexiness. Head would also design the costumes for the noir classics *The Big Clock*, *Sunset Boulevard* and the 1947 noir comedy *My Favorite Brunette*, and ended her extremely long and prolific career in film with the Steve Martin/Carl Reiner film noir parody *Dead Men Don't Wear Plaid* in 1982.

As we discussed in Chapter 7, costume designer Michael Woulfe created sexy outfits for Jane Russell's character in *Macao* that convey to the audience that she knows how to use her sexuality to get what she wants, but in a way that also conveys that she is neither high-class nor a tramp. The costumes for Robert Mitchum's character allow him to look a little down on his luck, yet honest. Meanwhile, the costumes for the gangster boss are almost too refined, showing him as someone trying too hard with a sort of arrogance of wealth. His girlfriend is draped in gowns that always make her mysterious and alluring – perfectly befitting her conflicted yet soft-spoken character.

The dresses of the noir femmes reflected their personality as much as their desires, which were often shared by a large portion of the movie-ticket-buying base. These fashions were an escape from the drudgery of working in a factory and never having the time, money or clothing to go out

on the town. Women were doing masculine jobs and wanted to be reminded of their femininity, and the wardrobe of the noir woman did that. These gowns made the women who wore them powerful, alluring, sophisticated and sexy.

There seemed to be a motif of making some characters look the opposite of their character type in a number of noir films. In *The Postman Always Rings Twice*, the femme fatale first appears in white – a commonly assumed symbol of innocence. Costume supervisor Irene Lenz dressed Lana Turner in a form-fitting shorts-and-top combo. In *Mildred Pierce*, Mildred's daughter Veda, who fulfills the role of femme fatale for Mildred, also first appears in white. This motif of dressing the dangerous female in white was also used in *Body Heat*, the 1981 modern noir tribute to *Double Indemnity* written and directed by Lawrence Kasdan and costumed by Renié Conley, which introduces actress Kathleen Turner playing the femme fatale in a low-cut white dress on a windswept boardwalk at night, beautifully photographed by cinematographer Richard Kline. Miss Wonderly doesn't look like a murderess when she hires Spade and Archer, and the fastidiously stylish and well-dressed Waldo Lydecker in *Laura* doesn't look like a killer either. Mrs. Grayle in *Murder, My Sweet* doesn't look like a low-class thug's dame. In these instances, costumes are means of deceiving the audience as well as the story's protagonist into feeling one way for a character who turns out to be quite the opposite. In the wonderful 1988 seminal noir cartoon hybrid *Who Framed Roger Rabbit*, written by Jeffrey Price and Peter Seaman and based on the Gary Wolf novel *Who Censored Roger Rabbit?*, cartoon femme fatale Jessica Rabbit (voiced by Kathleen Turner, who played the femme fatale in *Body Heat*) says, "I'm not a bad woman, I was just drawn that way" (animation artists Russell Hall and Richard Williams are credited with drawing her, inspired by the look of noir actresses Veronica Lake and Lauren Bacall). That looks can be deceiving is a common caution echoed in film noir.

For the male protagonist, especially in the private eye films, the standard costume became the trench coat. Used extensively as a raincoat for soldiers in the trenches during the First World War, its use in film noir might have been a way for the costume designer to show that the protagonist was indeed an everyday man. It wasn't too stylish or expensive, and the fedora was a standard male accessory, again an everyman accoutrement. Bogart

dressed in both in *The Maltese Falcon* and *The Big Sleep*, as did Alan Ladd in *This Gun for Hire*, Dick Powell in *Murder, My Sweet* and Robert Mitchum in *Out of the Past*. The trench coat and fedora soon became the standard attire of film noir and the movie PI. Even Harrison Ford wore them in the 1982 sci-fi neo-noir *Blade Runner*.

ART DIRECTION

Hollywood art directors had the amazing ability to make a gourmet feast out of table scraps and leftovers. Movies then, as now, were primarily shot on sound stages. The art director of a picture would design the sets needed for the film: everything from the layout of the walls to the furniture, wallpaper, carpets and lamps. Art directors are well versed in art history, especially architecture and interior design. Their job is to interpret the script into visual elements that clue the viewer into the story's time and place, as well as the character. The environment that the person inhabits tells a lot about their personality. A room's décor as well as furnishings and how neat or messy it is reveals a lot to the viewer and is used consistently in filmmaking as a visual storytelling tool. Art directors will draw from the screenplay their ideas on how to display the character's personality as well as their social standing and upbringing.

During the time of the studio film factories, and especially for film noir, the art director had to understand how colors, textures and patterns would read on black-and-white film. Color provides the eye with natural contrast. But once color is removed, everything turns into a shade of gray. How these shades play off each other, creating contrast and texture, is a particular skill of the Hollywood art director. Thus, besides being artists, art directors had to understand scenic painting as well as construction. They also needed to understand how lenses worked and their field of view. Some sets were three walls, some two and some only one wall. Some sets were built in forced perspective, such as Carl Wyle's design for the airstrip scene in *Casablanca* where everything in the background was scaled down to look further away. Everything in the movies is fake; art directors make it look real.

The elegance of Waldo Lydecker's apartment in *Laura*, designed by art directors Lyle Wheeler and Leland Fuller, quickly reveals to the viewer what

type of man this character is. The high ceilings and tall windows with tasteful drapery tell the audience this character is rich and particular for a man. The furnishings are expensive and elegant as well. Almost all of the sets in *Laura* are opulent and refined. Wheeler designed the opposite feeling for the rooming-house apartment of the victim in *Where the Sidewalk Ends*. He created a room with faded, peeling wallpaper, chipped molding and outlines on the wall where pictures once hung, all to telegraph to the viewer how low this character has fallen. In fact, almost all of the settings in this film were working-class, revealing the social standing of the characters.

Wheeler gained a reputation for being able to repurpose used sets for other films by artistically redesigning them through repainting, decorating and minimum construction changes. Thus, he was ideal for the B-picture division. The quality of Wheeler's work was first recognized by the Academy when he won the Best Art Director Oscar for *Gone with the Wind*, for which he designed the sets and a series of magnificent glass matt paintings the camera would shoot through. After his wonderful work on *Laura*, Darryl Zanuck made him chief art director at 20th Century Fox. He won five Oscars and was nominated 17 times – one of which for *Laura*, which he shared with Fuller. Fuller was nominated for six Oscars.

At Paramount, art director Hans Dreier, who came to Hollywood in 1923, worked his way up from the silent films to become head of the art department at the studio during the birth of noir. Dreier worked on over 500 films – everything from Westerns and horror films to comedies and thrillers. Schooled as an architect in Germany, he became known for a look of continental style and elegance, but was well skilled in creating any look that the screenplay required – always crafting sets that helped reveal time and place, backstory and character. Dreier worked a lot with his fellow German immigrants, namely on the comedies of Ernst Lubitsch, the dramas of Josef von Sternberg and the eclectic variety of director Billy Wilder, designing the sets for the noir films *Double Indemnity* and *Sunset Boulevard*, the latter for which he won an Academy Award. He won two other Oscars and was nominated 20 times. Dreier can be said to be one of the founders of noir art direction, as he designed many of the earliest noir films, such as *This Gun for Hire*. He went on to develop the looks of such noir classics as *The Blue Dahlia*, *Calcutta*, *The Big Clock*, *The Glass Key*, *Dark City* and others. As supervising

art director at Paramount, Dreier gained a reputation for allowing his team of fellow art directors to have a more free hand in their work than at other studios, which attracted some other great designers to his projects. Among them was Albert D'Agostino.

New York City-born D'Agostino was another influential art director in the noir look. He started at Universal in the 1930s doing different genres including B-picture horror films, such as *The Werewolf of London*, *The Raven*, *The Invisible Ray* and *Dracula's Daughter*. He then worked at Paramount and RKO doing a variety of films. When producer Val Lewton started the RKO horror division, he recruited D'Agostino to design their first film, *Cat People*, in 1942, which initiated a long-lasting relationship between D'Agostino and director Jacques Tourneur. Together they would do a number of horror and thriller films at RKO. D'Agostino's success at designing mysterious surroundings for the horror films prompted Lewton, who had become the head of the entire B-picture division, to ask him to do RKO's first noir film, *Murder, My Sweet*. D'Agostino created the dingy private detective offices of *Murder, My Sweet* and *Cornered*, as well as high-class apartments, and proved skillful at redecorating the streets and alleys on the studio backlot. He would go on to create effective designs for many noir films including *Crossfire*, *Out of the Past* (with Tourneur), *They Won't Believe Me*, *The Big Steal*, *Strange Bargain*, *Where Danger Lives*, *His Kind of Woman* and *Macao*, all for RKO, where he eventually became the studio's supervising art director. D'Agostino worked on over 350 movies, including films for Alfred Hitchcock and Orson Welles, and was nominated for five Academy Awards, none of which were for noir films.

MY FAVORITE BRUNETTE (1947)

By 1947, the style of film noir, although not called that yet in the US, was so well known by the movie-going audience that famous comedian and comedy actor Bob Hope's newly formed production company, Hope Enterprises, parodied it for its first production. *My Favorite Brunette* was written by Edmund Beloin (who was one of the writers of the noir comedy *Lady on a Train*) and comedy screenwriter Jack Rose. The film was directed by Hope's regular collaborator Elliot Nugent. The film features all of the trappings of classic noir, beginning with Hope as a wrongly accused man about to be

Figure 8.1 Bob Hope and Dorothy Lamour in *My Favorite Brunette*
Paramount, 1947

executed for murder. As he smokes his last cigarette given to him by a guard, he tells his story to reporters and thus begins the flashback film with typical noir voice-over narration. Hope's character is a baby photographer longing to be a detective like the tough private eye in the office next door. When that PI goes on vacation, Hope gets mistaken for him by a femme fatale who doesn't at first tell the truth (played by long-time Hope co-star Dorothy Lamour). All of the film noir standards are present: a hero who puts himself in danger over a dame, mistaken identity, a lying sexy femme fatale (who then turns out to be a good girl), a complicated mystery plot, murder, the police not believing the hero, and ruthless criminals. While everyone else in the film plays it like a straight noir, Hope is the one who adds the comedy, playing his well-known screen persona of a bumbling wannabe with elements of light slapstick.

Noir actor Alan Ladd makes a cameo appearance in the film as Hope's PI next-door neighbor and actor Peter Lorre (from *The Maltese Falcon*, *The Mask of*

Dimitrios, Casablanca and other films) appears as the dangerous heavy who is studying to become an American citizen. Lorre's career had been failing but he was the perfect choice for the menacing thug. Lon Chaney Jr, who had become bitter over being relegated to horror roles, also had his career sliding away when he was cast in the film as the not-so-bright muscleman. Paramount had been making most of Hope's comedy films and became the co-producer/distributors of this one.

To get the recognized hard-boiled detective look and feeling for the film, Hope imported the entire artistic team from the highly successful noir film *The Blue Dahlia*, made only a year before. He hired Lionel Lindon as cinematographer, Hans Dreier as art director and Edith Head as costume designer. Head created a 14-carat gold gown for Lamour made out of gold-plated cloth from the Paramount stock. Dreier created the dingy offices common to noir, but also found exterior locations in San Francisco and at the Crocker Mansion on Pebble Beach to flesh out the look of the film.

Parody only works when the viewer instantly knows what is being made fun of. *My Favorite Brunette* was a big box office success, clearly demonstrating that audiences recognized the genre being lampooned through its style and that they enjoyed Hope throwing in his usual antics to make fun of it.

NOTES

1 Veronica Lake's singing was dubbed in by Martha Mears.
2 Rita Hayworth's singing was dubbed in by Anita Ellis.
3 Silver, Alain, Porfirio, Robert and Ursini, James, *Film Noir Reader 3: Interviews with Filmmakers of the Classic Noir Period*, New York: Limelight Editions, 2002, p. 169.

9

NOIR IMAGERY
Lighting and Cinematography

"Shoots me with my own gun, that's what gets me."
*(*The Big Combo*)*

The visual look of noir films, created by talented Hollywood film factory-taught cinematographers, was to the eye what jazz was to the ear and noir gowns were to female stars. It was exciting, risqué and often unpredictable, especially in the terms of what the standard Hollywood movies had always looked like. Rather than the more typical soft, high-gloss, glamorous look, these films featured gritty high-contrast images, filled with hard shafts of light through windows, downward puddles of light surrounded by darkness, stark silhouettes and faces in half-shadow. This new visual motif was the direct result of the stories the noir films were based on. The pulp mystery stories were often set in dark alleys, sleazy nightclubs, forgotten back roads and lonely offices in a shady part of town.

In the documentary *Cinematographer Style*, 110 cinematographers all say the look of any film is determined first and foremost by the script: what is happening within the story, what is happening within the characters and what is happening within the scene. The deep shadows, the stark contrasts, the window patterns and the blinking neon light effects of film noir were

appropriate for these mysterious stories that took place at night, in alleyways, back streets, empty docks and dim nightclubs. It would be virtually impossible to shoot a film noir movie any other way.

The cinematographer is the creative artist behind the lighting and the camera framing. It is his job to create the images that the director wants and that service the story best. During discussions in pre-production about the overall film's look and feel, the director and the cinematographer will come up with a shot list for every scene in the movie. That list is then used by the production manager and assistant director to determine how many days will be needed and what will be shot on which day. On set, after the director has the actors do a run-through, known as a blocking rehearsal, the actors and director leave the set while the cinematographer lights the scene, which can take over an hour. A director's time is very valuable and is put to better use talking with the actors about the scene, meeting with the costume designer, looking over the next set and talking with the assistant director about the schedule.

Meanwhile, the cinematographer works with the electricians and grips, placing lights, determining contrast ratios and adding shadows and highlights by using the stand-ins for the actors on set. At the same time, the camera crew is rehearsing any camera moves and focus pulls. Last, the cinematographer will fine-tune the framing of the shot, asking the set decorators to move that lamp in a little, slide that rug over, raise that painting a bit, until he composes the exact frame he thinks serves that moment in the story the best. Once finished, the assistant director recalls the actors and director back to the set. Now they rehearse and the director will often look through the viewfinder to watch what the cinematographer has created. Minor changes will be made to lighting and framing, the director will give notes to the actors and then the assistant director calls "Cameras up."

One has to keep in mind that back when the noir films were made, they were all shot on black-and-white negative 35mm film. There were no digital cameras and no monitors, so there was no way to see the actual photographed image until 32 hours later, when the film came back from the lab and dailies were watched in a screening room after the end of the next day's shooting. Only the cinematographer, after years of experience, knew what the final image would actually look like. And there were times even he wasn't sure.

A major development that had a significant effect on creating the look most associated with film noir was Kodak's new film stock. In 1938, Kodak introduced four new black-and-white 35mm film stocks which had finer grain and were more light-sensitive. Of these, the one used most by Hollywood A-picture productions was 1231 Plus-X Panchromatic film stock with an ASA (ISO) of 80, which was double the light sensitivity of the stock that had been used by Hollywood years earlier. But many of the lower-budget and B-picture productions were using the new and much faster Super-XX, which had an ASA (ISO) of 120, three times the sensitivity to light. Both of these film stocks allowed cinematographers a greater range in contrast, with deeper blacks, while also allowing them to use fewer lights. This meant moving faster, which meant doing more setups per day – the requirements of the B-picture divisions from which most noir films emanated. On *The Big Clock* (1947), director of photography John Seitz and director John Farrow managed to shoot 5–6 pages per day and finished shooting two days ahead of schedule. Most Hollywood A-productions thought they were successful if they managed 2–3 pages per day. Seitz and Farrow completed their film in only 35 shooting days.

Also, in 1940, a year before *The Maltese Falcon* was released, Kodak released its new Fine-Grain Release Positive 1302, which all movie theater exhibit films were printed on. It was this combination of new film stocks that allowed both the capture and projection of high-contrast images and a greater grayscale dynamic range to produce the look that has become the stereotypical film noir style. But it wasn't just the faster, better dynamic range film stock that allowed cinematographers to move faster and light more creatively; it was also the technological improvements in film cameras and lighting units.

The standard Hollywood movie camera before the war was the 35mm Mitchell. To shoot dialog scenes, a large blimp housing was required to be placed over the camera to silence the sound of the camera mechanics. The blimp made the camera heavier and more bulky, thus harder to move and difficult to place at unusual angles. It also meant that a considerable amount of time was wasted each time a lens was changed or the camera needed to be reloaded with film (one roll of film would only last for 15 minutes of footage). The big camera revolution came at the same time as the film

stock revolution, 1938, when Mitchell introduced the BNC, the Blimped News Camera. This was the first self-blimped movie camera, which made the camera easier to move and faster to set up and change both lenses and reels of film. It also made the camera easier to take on locations and allowed the camera to be put in more creative places and angles. This camera became the workhorse of the Hollywood film studios.

A common cinematic feature of film noir movies is longer takes, where the camera dollies from wide shot to closeup or vice versa without a cut. This shooting style allowed the crew to cover more pages per day, as it eliminated other camera setups. This was greatly needed for the shorter shooting schedules assigned to the B pictures. Also, the moving camera creates more dynamic images by adding movement to scenes that are basically just two people talking. These smooth camera dolly moves keep the viewer visually interested and invested in the story, while are also often used to focus the viewer's attention on a specific person's expression or a significant object or reflection. The BNC made this easier for the cinematographer to accomplish.

In 1935, the Mole-Richardson lighting company introduced the solar spot lighting units, bringing relatively smaller and more portable tungsten Fresnel lights (2kW, 1kW and 650W) into the workplace of the film studio, which had been dependent on large, bulky and electricity-draining arc

Figure 9.1 The Mitchell BNC
Courtesy Mole-Richardson

Figure 9.2 The Mole-Richardson solar spot light
Courtesy Mole-Richardson

lights and 5kW lights up until then. These new units allowed the cameraman to light faster and place the units in almost any position.

Necessity is the mother of invention, and constraints are often the inspiration for artistic originality. The war effort had put rationing into effect and the studios were being asked to use less film, which was made of silver and the explosive nitrate. The B pictures had smaller budgets and shorter shooting schedules, which required their cinematographers to do more with less – both in terms of time and money. All of these technical advancements allowed cinematographers to do just that and at the same time gave them greater creative freedom that served the requirements of the

noir story. Since they had to shoot more pages per day, they didn't have the time to minutely light the entire set and fill in the muddy areas of the image. Allowing parts of the screen to go dark created more mystery, while also taking less time to light and obscuring unfinished parts of the set or backgrounds. The new motion picture film stock could not only hold the contrast, but also, since it needed less light, allow cinematographers to use smaller, lower-wattage units. These lights could be moved and powered faster than the older lights and put in places that didn't need a lot of extra rigging, thus saving time and manpower.

Lighting isn't just necessary to get enough exposure to photograph the image. The cinematographer uses lighting as a major storytelling tool. Lighting relates the time of day, sets the mood, can focus the attention of the viewer on one area of the screen over another, produces an illusion of reality, adds modeling to the actors and provides a feeling of depth to the two-dimensional image on the screen. The fear of the dark is primal – a fear of the unknown. The noir cinematographers used darkness and shadows to create the feelings of mystery and danger. The more side-lit a subject, the more mysterious the visual moment. The more contrast between the lightest part of the screen and the darkest, the more dangerous the moment felt. The more hard edges of the lighting noticeable on screen from patterns and visible shafts of light, the more hard-boiled the story felt to the viewer. The combination of Kodak's new film stocks, which held darker blacks, and the new Mole-Richardson small lighting units, which were easier to manipulate, allowed the noir cinematographers to accomplish all of this.

Another factor that probably led to the shared look of film noir movies was the American big-city upbringing of the talented cinematographers who authored the images. Harry Wild was one of the most prolific noir cinematographers and truly deserves much of the credit for establishing the noir look. He created the cinematography on such noir films as *Murder, My Sweet* (1944), *Cornered* (1945), *Nocturne* (1947), *They Won't Believe Me* (1948), *Pitfall* (1949), *The Big Steal* (1949), *Strange Bargain* (1949), *His Kind of Woman* (1951) and *Macao* (1952). Wild shot more noir films than any single director directed.

Wild was born and raised in New York City. Having grown up surrounded by the visuals of the shafts of light created by the sun streaking between

buildings, the patterns of fire escapes across the sidewalks and elevated L trains across streets, and the stark silhouettes created by streetlights against high city walls at night. Wild brought these images with him to Hollywood and used them in his approach to lighting the noir stories. Arthur Edeson, who shot *The Maltese Falcon* (as well as the noirish *Casablanca* and *The Mask of Dimitrios*), and Sidney Hickox, who shot *The Big Sleep* and *Dark Passage*, were also born in New York City.

Perhaps more than anyone, Chicago-born John Seitz needs to be recognized as the true author of the imagery that became the noir look with his work on the noir classics *This Gun for Hire* (1942) and *Double Indemnity* (1944), which really established the standard shadowy noir imagery. He went on to create the lighting and visual compositions for *Calcutta* (1947), *The Night Has a Thousand Eyes* (1948), *The Big Clock* (1948) and *Sunset Boulevard* (1950). The reviews of the last two films even mentioned him when the movies were released. Seitz began his career in the Hollywood studios as a lab technician, learning how far one could push the negative and get a quality picture. He worked his way up to becoming a highly-regarded cinematographer, shooting many of the famous Rudolph Valentino silent feature films. Seitz was a risk-taker and did things other cinematographers rarely did. He used window patterns throughout *This Gun for Hire* and *Double Indemnity*, allowing the characters to move in and out of shadow, just as their characters do story-wise. Hollywood studio chiefs wanted their money's worth out of their stars and almost always insisted they be photographed glamorously and in full light. Seitz ignored that and dared to do what the story needed rather than what the studio's star marketing department wanted.

Seitz was assigned to work with writer Billy Wilder on his second movie as a director, the war film *Five Graves to Cairo*, for the same reason Arthur Edeson was assigned to shoot *The Maltese Falcon* for first-time director John Huston. The studios wanted insurance that the shooting days would have usable footage, so it was standard practice to assign highly experienced cinematographers whenever they had new directors. In the oral history record of the Academy of Motion Picture Arts & Sciences, cinematographer Lothrop Worth recalled a conversation he had with Wilder, who confessed to him that on "[m]y first picture as a director, I knew nothing about camera angle, etc. I don't now. I leave it up to the cameraman."[1]

What Wilder did ask of Seitz during their first film together was to make things "dark." Seitz did, to the point that one day the footage came back totally black. Not many cinematographers would have taken such a chance. Teaming up again when Wilder was assigned to make *Double Indemnity*, he told Seitz he wanted everything to be more realistic looking. When he told Seitz that he liked the way light looked filtering in through the windows in a dusty room, Seitz had the prop department throw metal filings in the air to give the image a dusty, stuffy feeling. He wanted to cloud the image just as Walter Neff's mind was becoming clouded over right and wrong.

Seitz was always pushing the edge and thus was often nervous on set. Wilder said that during the filming of *Double Indemnity* Seitz wore a hat that he would pull down over his eyes as the scene was shot, which greatly distracted Wilder. Wilder claimed he made the decision not to work with Seitz again because he was distracting and made Wilder too nervous when the camera rolled. But Wilder did work with Seitz on two more films, including *Sunset Boulevard*, which was hailed for its great cinematography. Seitz was nominated for seven Academy Awards, including for all of the films he worked on with Wilder.

Just as the American city was the backdrop for the film noir stories, so was it the inspiration for the lighting. Interestingly, while many noir stories are set in LA, the lighting doesn't make it look like southern California at all – a place full of bright sun, low buildings and virtually no rain. Instead, the images are full of shadows and shafts of light that would come from tight streets between tall buildings. There are many rain-glistened streets in noir and back alleys, which again are not prevalent in LA. Noir made almost all of its cities visually resemble San Francisco, Chicago and New York City, no matter where the films were actually set. The fact that almost all of the original noir cinematographers were born and raised in big cities can't be ignored.

Some film scholars have suggested that German Expressionism had a influence on the imagery and lighting of film noir, based on the idea that European-born directors, such as Billy Wilder and Otto Preminger, brought with them German Expressionism to film noir. But a growing number of film scholars have recently refuted that theory. Expressionism was a turn-of-the-century into early 1920s European art moment that was defined by

Figure 9.3 The Scream by Edvard Munch: German Expressionism

being anti-realistic. Its trait was distorting the image to produce emotion, as typified by the painting *The Scream* by Edvard Munch.

In interviews, both Wilder and Preminger strongly disputed the influence of German Expressionism on their films. When author Cameron Crowe asked in *Conversations with Wilder* if the lighting in his films was influenced by German Expressionism, Wilder answered, "No."[2] He said he had asked Seitz

for newsreel realism. In a different interview, Wilder was quoted as saying about Double Indemnity that everything was meant to support the realism of the story. That is the opposite of Expressionism, defined as being anti-realism, distorting it for emotional effect. Preminger, when asked a similar question in Film Noir Reader 3, dismissed the concept, saying that cinema was a realistic medium and that its photography had to be real.[3]

In the early 1940s, 20 years after the German Expressionist movement, when noir films were first being made, America had its own popular artistic movement which was the exact opposite of Expressionism, that of stark realism seen in the works of Reginald Marsh and Edward Hopper. What could typify the look of film noir better than Hopper's famous 1942 painting Nighthawks? Hopper's paintings evoked a sense of loneliness and isolation in the surrounds of the city. The paintings featured shafts of light and streaks of shadows. They told stories that revealed the inner thoughts of their subjects, just as the lighting and composition of the film noir cinematographer did. And like the film noir cinematographers, these painters were from the big American city.

The first noir films that displayed the imagery later commonly associated with noir were The Maltese Falcon (1941), the directorial debut of American John Huston with cinematography from well-established and award-winning New York City-born cinematographer Arthur Edeson, and This Gun

Figure 9.4 Nighthawks by Edward Hopper: American Realism

for Hire (1942), directed by American Frank Tuttle and shot by Chicago-born John Seitz. So in the formative years of film noir, the directors and the cinematographers were not in fact European, but American. If one looks at two films shot by Seitz, This Gun for Hire and Double Indemnity, the lighting and camerawork are very similar; both hard-boiled mystery stories called for similar hard-boiled mystery looks. Seitz had already established that photographic look he used in Double Indemnity for Wilder three years earlier in This Gun for Hire for Tuttle.

Under the tight budgets and short shooting schedules that were the norm for B pictures, the look that became synonymous with film noir was much more influenced by the necessity of shooting quickly, the invention of faster-speed film, lighter cameras and smaller lights, and the artistic suggestions of the stories themselves than by any foreign art movement or individual director's personal history.

By the 1950s, block booking was over and the Poverty Row production companies were churning out genre films as fast as the theaters would buy them – often underselling the Hollywood studio pictures. Crime films were easier to make than dramas or comedies, especially ones with lots of night scenes in lonely places, because the producers didn't need extras or elaborate sets. A few lights could go a long way if you didn't mind a lot of shadows – which were ideal for the subject matter. These crime stories often didn't require nuanced acting or great timing, both things that dramas and comedies rely on. If there was enough action, audiences could forgive mediocre acting and plot holes.

The 1950s witnessed the Red Scare and the war against communism in Korea. Movies were escapism. There was also a new movie-going public: the children who were born before the Second World War but were too young to be greatly affected by it at the time. Now they were teenagers and young adults who didn't understand their parents' desires for things to be like they used to be. The music was changing, the fashions were changing and so were the movies. Was noir changing as well?

Not all crime films made in the 1950s were film noir, and many that weren't have been erroneously labeled as such. Made much faster and cheaper than the studio B pictures in the 1940s, many of the 1950s films lacked the noir look established by the great noir cinematographers. Frontal

flat lighting was fast and cheap and became common in a lot of the 1950s low-budget crime films, including many of the Mike Hammer movies. These films were shot in black and white, not because it suited the story, but because it was just cheaper than color film. This attitude of cheapness on the part of producers and impatience on the part of directors often degraded the imagery, not just photographically but also in art direction and costuming.

One cameraman who refused to allow the image to suffer was John Alton, whose dedication to the style of the noir film can be best seen in *The Big Combo* (1955), written as an original screenplay by Philip Yordan and directed by Brooklyn-born Joseph Lewis.

THE BIG COMBO (1955)

The Big Combo marked the first production of Theodora Productions, which was owned by actor Cornel Wilde and his wife, Jean Wallace, and co-produced by Security Pictures, Inc., headed by Philip Yordan and producer Sidney

Figure 9.5 Jean Wallace runs through shadows in *The Big Combo*
Allied Artists, 1955

Harmon. It was based on a short story by Yordan, who had offers from several low-budget independent film companies to make a film out of it. The film was originally slated to be shot in color but was shot in black and white due to budget constraints. Wilde cast his wife as the rich socialite girlfriend of the mobster whom she has a submissive obsession with. The script and film are examples of how the non-majors were desperately trying to push the risqué envelope in order to gain audiences and become a favorite of the new line of independent theaters. Block booking was over and teenagers with cars and the young adult audience were a growing financial market.

Joseph Lewis came on as director. He had started his career as an editor at several Poverty Row production companies and worked his way up to becoming a B-movie director. By the 1940s, he was directing musical Westerns at Republic Pictures and later directed almost every genre the low-budgets were putting out, including cheesy sci-fi, war, romance, thriller and crime films. One of his low-budget B-picture crime films was a modern Western take on Bonnie and Clyde titled *Gun Crazy*, which wasn't the most successful at its time in 1950, but gained cult status in the 1960s and 1970s when he was "rediscovered" by film critic Paul Schrader (who called it noir even though it is lacking every noir film trait). By the 1950s, he was directing television and he retired in the 1960s.

Actor Jack Palance was originally cast as the lead in the film, but was making so many demands that the day before the camera rolled the producers fired him and quickly got a copy of the script to actor John Conte on a tennis court. The next day, he was on set.

John Alton had been making a reputation for himself in Hollywood as a cameraman who believed that cinematography was more of an art. He even wrote the first true book on cinematography, titled *Painting with Light*, in 1949. Although born in Hungary, Alton had been working at MGM since 1924 and had come up through the Hollywood camera department ranks, learning from the best of them, including legendary cinematographer James Wong Howe. He shot a number of Poverty Row B pictures but then was brought into MGM to do some big-budget films with director Vincente Minnelli, including the end ballet sequence in the film *An American in Paris*, which won him a shared Oscar in 1951. By the time he shot *The Big*

Combo, he had gained a reputation for being a little "problematic," which might explain why he moved back into shooting the low-budget B pictures. His work on *The Big Combo* really represents everything noir strived to be, especially during the Red Scare period. The world was one full of shadows and the lines between black and white were drawn hard, but also really jagged.

The story itself was also representative of the new times. The hard-nosed hero detective has a stripper as his on-again-off-again girlfriend – a sign of his male weakness and an acceptance that some good girls are forced to do unsavory jobs to make ends meet. Like the noir PI heroes who preceded him, the film's detective becomes obsessed and is fallible to the point of getting beaten up. But he also becomes infatuated with a femme fatale – in this case, a high-society woman who's slumming it as the sexual pawn of a ruthless gangster. He will do whatever it takes to bring down the gangster and save the dame – for himself.

There are many things in the film that pushed the Production Code office to its limits – including a subtly implied homosexual relationship between two thugs and an off-camera sex scene where Lewis focused the camera only on the face of the female star, Jean Wallace. After viewing the "kissing scene," Wallace's husband Wilde, the film's co-star and co-producer, was furious with Lewis. The Production Code office demanded that the scene be removed for being vulgar – at which point Lewis asked them why. It was just a scene of the gangster kissing his mistress and then disappearing below camera. What did they think he was doing? Lewis told the Production Code office they were the ones with the vulgar minds, as he shot the scene staying on her face. The scene stayed in the film, but the producers had the editor dissolve out of the actress's suggestive expression very quickly.

Another feature of the film often referred to by critics is the creative way Lewis showed the brutality of the execution, when the victim's hearing aids are removed and he is gunned down in complete silence – no sound at all in the film (something that would be imitated later in the modern film *The Road to Perdition*). The harshness of *The Big Combo* reflected the new hard reality of the Red Scare period of the 1950s and pushed the envelope as to what movies could and couldn't get away with – all in the

name of getting audiences away from the TV and back into the theaters. It also marked the beginning of the end of the power of the Production Code office, which was becoming more and more sidelined by the non-majors. The new independent B-picture producers seemed to be happier when the Production Code office had a problem with their films, as they knew they would gain box office attention with the new generation of movie-going audiences.

For film noir, The Big Combo shows a dramatic change in how the genre would begin to view its female characters. The femme fatale is more of a victim and less of a strong independent character than her predecessors were. The good girl character is a stripper who gets killed by mistake. The new conservative "family" values of 1950s America were warping film noir and putting the woman back in her "place." The woman who dies isn't evil, she's immoral. The femme fatale character who lives turns from a weak woman who lusts for a bad boy into a good girl who loves a good guy.

Cinematographer John Alton said "There is no better opportunity for such realistic lighting than in mystery illumination."[4] He felt that lighting should be realistic, that the lighting in a mystery or a melodrama should come from a logical motivated light source: a lamp, a street light, a neon sign through a window, a lit cigarette, etc. He then would allow the shadows to go very dark, since the less someone sees on screen in full light, the more mysterious the image. Shadows provide drama and The Big Combo has plenty of shadows. At the same time, Alton was dedicated to the idea that all women should always look glamorous on screen. The opening sequence in which Susan runs away from the thugs hired by her gangster boyfriend is a perfect example of Alton's mix of stark contrast and female star glamour. They stop her under a street light and the background almost melts away into blackness, while Susan still looks elegant. Alton's ending shot is famous for its film noir imagery of silhouettes in a foggy night, lit by a single beacon of light from afar – although there is low-intensity fill light in the foreground.

The cinematography in The Big Combo is a revision of the noir imagery. Its contrasts are deeper with richer blacks and even starker visuals than the classic noir films. Even the camerawork and lighting were reflections and products of their time.

NOTES

1 Worth, Lothrop, oral history record, Academy of Motion Picture Arts and Sciences, Hollywood, CA.
2 Crowe, Cameron, *Conversations with Wilder*, New York: Alfred Knopf, 2001, p. 53.
3 Silver, Alain, Porfirio, Robert and Ursini, James, *Film Noir Reader 3: Interviews with Filmmakers of the Classic Noir Period*, New York: Limelight Editions, 2002, p. 93.
4 Alton, John, *Painting with Light*, New York: Macmillan, 1949, p. 45.

10

NOIR SPEAK
Dialog and First-Person Narrative

"Look up 'idiot' in the dictionary. Know what you'll find?"

"A picture of me?"

"No! The definition of the word 'idiot', which you f—ing are."

(Kiss Kiss Bang Bang)

DIALOG

Throughout this book I've listed the screenwriters of each film. Screenwriting is an art in and of itself, even when the script is an adaptation. While the majority of noir movies had plots and characters taken directly from their source book or story, the screenwriters had to create screen dialog. As noted earlier, Raymond Chandler was proven right when he argued with Billy Wilder that the dialog in a novel doesn't work for a screenplay. It's meant to be read rather than spoken. So besides condensing the mystery story down from around 200 pages to under 90 for a screenplay, the Hollywood staff writers had to also create dynamic dialog that furthered the plot, revealed character and added to the pace and rhythm of each scene. Like everyone else, most writers were under contract at a studio. They reported to work every day, went into their office and worked on a screenplay either alone or

very often with another studio writer off whom they could bounce ideas and dialog.

Just as a spoonful of sugar makes the medicine go down, so does humor make the hard-edged, dark view of life seem all the more palatable and enjoyable. While the film noir story is dark, these tales of deceit, murder and sometimes redemption are spiced with sarcasm, wry wit, wisecracks and sardonic wordplay. The style and even some of the original lines from these movies have worked their way into the American language culture. "Live fast, die young and have a good-looking corpse" comes from Daniel Taradash and John Monks Jr's screenplay for *Knock on Any Door* (1949), based on the pulp novel by Willard Motley.

Chandler's private eye character Philip Marlowe is the very image of the noir protagonist, never giving a straight answer; sarcasm, dark wit and hard-boiled talk are his natural state of being. Chandler wrote in his essay "Murder Is My Business": "He talks as a man of his age talks – that is, with rude wit, a lively sense of the grotesque, a disgust for sham, and a contempt for pettiness."[1] The screenplays from his novels took many lines straight from his books, such as this exchange from *The Big Sleep*:

VIVIAN: "I don't like your manners, Mr. Marlowe."

MARLOWE: "I don't mind if you don't like my manners. I don't like them myself. They're pretty bad. I grieve over them on long winter evenings."

Sarcasm is Marlowe's trademark. Here is a man who has seen a lot of the underside of life. He has become accustomed to dishonesty, while he himself remains honest and straightforward. His sarcasm is more than merely an interesting characterization; it is a display of his strength and a symbol of how he treats all people equally. His hard edge is softened by his continual ability to find something humorous to say, making the audience appreciate and identify with him. Although just a working-class Joe, he is smart and has a fast wit. Sometimes his sarcasm has a ring of friendship to it, such as at the beginning of *The Big Sleep*, when he first meets his extremely wealthy new client, the general, a man he clearly likes:

GENERAL: "How do you like your brandy, Mr. Marlowe?"

MARLOWE: "In a glass."

This retort brings a smile to the suffering general's face and he instantly likes Marlowe. No one talks to him like that. Now he feels he knows Marlowe is a man to be trusted with the delicate matter of his family being blackmailed.

Later, we can only admire and wish we were half as fast and had a fourth as much nerve as Marlowe when he's faced with dangerous men, such as the gangster gambling king Eddie Mars. Marlowe's sarcasm gives him the strength to be defiant and hold onto his ethics. When Eddie finds Marlowe snooping around a dead man's home, Eddie insists Marlowe tell him what job he's working on and for whom. Even when Eddie offers to pay him, Marlowe refuses to break the private eye code of ethics. Marlowe then defiantly turns the questioning on Eddie:

> MARLOWE: "How come you had a key?"
>
> EDDIE: "Is that any of your business?"
>
> MARLOWE: "I could make it my business."
>
> EDDIE: "And I could make your business my business."
>
> MARLOWE: "Oh, you wouldn't like it. The pay's too small."

Chandler carried this art of sarcasm and wit over into his screenplay work with Billy Wilder on *Double Indemnity*. While Wilder didn't get along with Chandler, he credited him with writing the best dialog and creating the sardonic feel of *Double Indemnity*. James Cain even commented that Chandler had improved the dialog from the original novel. What Chandler had done was to add sardonic humor. Even in the downwardly spiraling tale in which our protagonist dies at the end, humor is wedged in, often courtesy of other characters in the script, in the form of sarcasm –

> DIETRICHSON: "No man takes his wife along on a class reunion. That's what class reunions are for."

and hard-boiled wordplay –

> KEYES: "They've committed a murder and that's not like taking a trolley ride together where each can get off at a different stop. They're

> *stuck with each other. They've got to ride all the way to the end of the line. And it's a one-way trip, and the last stop is the cemetery."*

and flirtation –

> PHYLLIS: *"Mr. Neff, why don't you drop by tomorrow evening about 8.30? He'll be in then."*
>
> WALTER: *"Who?"*
>
> PHYLLIS: *"My husband. You were anxious to talk to him, weren't you?"*
>
> WALTER: *"Yeah, I was, but I'm sort of getting over the idea, if you know what I mean."*
>
> PHYLLIS: *"There's a speed limit in this state, Mr. Neff. 45 miles an hour."*
>
> WALTER: *"How fast was I going, officer?"*
>
> PHYLLIS: *"I'd say around 90."*
>
> WALTER: *"Suppose you get down off your motorcycle and give me a ticket."*
>
> PHYLLIS: *"Suppose I let you off with a warning this time."*
>
> WALTER: *"Suppose it doesn't take."*
>
> PHYLLIS: *"Suppose I have to whack you over the knuckles."*
>
> WALTER: *"Suppose I bust out crying and put my head on your shoulder."*
>
> PHYLLIS: *"Suppose you try putting it on my husband's shoulder."*
>
> WALTER: *"That tears it."*

Chandler's influence on Wilder becomes clear when one looks at the hard-edged lines for Wilder's shared screenplay of *Sunset Boulevard*, first written in 1948 but finally filmed and released in 1950. When down-and-out screenwriter Giles first meets the faded actress Norma Desmond, he spouts:

> GILES: *"You used to be in pictures. You used to be big."*
>
> NORMA: *"I am big. It's the pictures that got small."*

And when she throws him out, he retorts:

> GILES: "Next time I'll bring my autograph album along, or maybe a hunk of cement and ask for your footprints."

Although often considered the best, Chandler wasn't the only pulp mystery writer penning hard-boiled dialog. It seemed to come with the territory. And it became a standard in film noir:

> KATHERINE: (looking over her shoulder) "I've never been followed before."
>
> BRAD: "That's a terrible reflection on American manhood."
> (The Dark Corner: *Jay Dratler and Bernard Schoenfeld*)

> NICK: "Why don't you take that chip off your shoulder?"
>
> JULIE: "Every time I do, somebody hits me over the head with it."
> (Macao: *Bernard Schoenfeld and Stanley Rubin*)

> VERA: "Life's like a ball game. You gotta take a swing at whatever comes along before you wake up and find it's the ninth inning."
> (Detour: *Martin Goldsmith*)

> LYDECKER: "Why did you have to photograph her in that horrible condition?"
>
> DT. MCPHERSON: "When a dame gets killed, she doesn't care about how she looks."
> (Laura: *Jay Dratler, Samuel Hoffenstein and Betty Reinhardt*)

> BAILEY: "You're like a leaf that the wind blows from one gutter to another."
> (Out of the Past: *Daniel Mainwaring*)

> SUSAN: "He was a lady killer. But don't get any ideas – I ain't no lady."
> (Nocturne: *Jonathan Latimer*)

> HAMMER: "What's the matter? Were you out with a guy who thought 'No' was a three-letter word?"
>
> (Kiss Me Deadly: A. I. Bezzerides)

> MILDRED: "Friendship is a lot more lasting than love."
>
> WALLY: "Yeah, but not as entertaining."
>
> (Mildred Pierce: Ranald MacDougall)

> VELMA: "You know, this is the first time I've ever killed anyone I knew so little and liked so well."
>
> (Murder, My Sweet: John Paxton)

Several screenwriters got their start writing the B-picture noir films. Bernard Schoenfeld was a playwright who was brought to Hollywood because the studios liked hiring writers from the theater and radio, knowing they had experience writing dialog that tells a story. Schoenfeld began his career in Hollywood writing the screenplays for *Phantom Lady* and *The Dark Corner*. He would go on to become a successful TV writer, with credits including *Alfred Hitchcock Presents* from 1956 to 1960. John Paxton started his career writing the screenplays for *Murder, My Sweet*, *Cornered*, *Crack Up* and *Crossfire*, the latter earning him a nomination for an Academy Award. Chandler's first screenplay was *Double Indemnity* and Leigh Brackett wrote *The Big Sleep* as her second screenplay (with her last being the first draft of *Star Wars: The Empire Strikes Back*).

FIRST-PERSON NARRATIVE

The hard-boiled pulp mysteries were often told in first-person narrative. The reader was able to be inside the main character's head, getting his insight and perspective on what was going on. Chandler really started the flippant, witty and sardonically humorous approach to the internal dialog the protagonist has with the reader. This framing device proved to be as successful with movie audiences as it had been with readers, so it was carried into the movies made from the popular stories. First was *Murder, My Sweet*, based on Chandler's book *Farewell, My Lovely*. The writers came up with

the idea that Marlowe is retelling the tale to police officers, thus launching us into the flashback narrated adventure.

In his 1946 essay "Americans Also Make Noir Films" for La Revue du Cinéma, French film critic Jean-Pierre Chartier wrote:

> *"The narrator of* Murder, My Sweet *is a private detective . . . [It] is no ordinary crime drama where from scene to scene more of the mystery is revealed: the script is not a whodunit designed to draw the viewer into guessing the outcome, it aims not to intrigue, but to create an atmosphere of fright. Precisely because we don't understand them, we sense the menace of unknown dangers."*[2]

The pull of the protagonist's first-person voice-over narration works on the viewers because they feel like they are in the main character's shoes, experiencing only what he (or she) is experiencing as it happens, rather than having an omniscient view, seeing things that happen in various locations at the same or different times that the main character has no knowledge of. The audience is as surprised, confused, disappointed, scared and humored as the lead character. This storytelling device instantly makes the viewers identify with the protagonists and feel for them.

While Laura only has a touch of voice-over narration, Double Indemnity fully employs it to great effect, allowing the viewers to identify with and even root for a murderer. Many noir films followed suit, including Detour, The Postman Always Rings Twice, Mildred Pierce, The Killers, Out of the Past, Dead Reckoning, The Big Clock and DOA. Even Bob Hope's 1947 parody of the PI noir genre, My Favorite Brunette, opens with him telling the tale from a cell awaiting his execution, and continues with joking irreverent voice-over narration throughout the film.

As with noir dialog, noir narration has sardonic wit. The sardonic humor in Sunset Boulevard flows at a steady pace in Giles' voice-over narration, such as near the end, when Giles' body is floating in the pool after Norma shoots him:

> *GILES: "The poor dope! He always wanted a pool. Well, in the end, he got himself a pool . . . only the price turned out to be a little high."*

NOIR SPEAK 133

That same style of sardonic narration is common to many other noir films:

> *NEFF'S VOICE: "Only what I didn't know then was that I wasn't playing her. She was playing me, with a marked deck, and the stakes weren't any blue and yellow chips. They were dynamite."*
>
> *(Double Indemnity)*

> *WALTER: "In this life, you turn the other cheek and you get hit with a lug wrench."*
>
> *(Impact)*

First-Person Camera (Subjective Camera)

The first-person narrative was so popular for mystery stories that two noir films tried to take the concept further, by having the viewer be the protagonist. The story would be told with the use of a "subjective" camera, whereby the camera, and thus the audience, would be the main character. The first was the 1947 MGM production of the Raymond Chandler novel *Lady in the Lake*. Famous actor Robert Montgomery wanted to try directing and he liked Chandler's books and the mystery films made from them. His idea was to film the entire story from the point of view of the main character, PI Philip Marlowe, using a subjective camera. Montgomery thought seeing only what Marlowe sees would endear the audience to the main character. Chandler hated the idea, but producer George Haight had hired him to write the screenplay. Eventually he quit and had no say over the production. Staff studio writer Steve Fisher came on to condense Chandler's 220-page screenplay into a 106-page screenplay. One has to wonder if Chandler had written so much deliberately to thwart the production. He had been writing in Hollywood for a while now and knew full well that screenplays for these B pictures were 90 pages long. Chandler hated the subjective camera concept so much he refused to take credit as one of the screenwriters.

The production was problematic. Instead of being able to cut and do retakes or closeups to cover mistakes, the cameramen had to shoot entire scenes in long continuous takes – like a theater performance. The big studio

camera had to be moved around and choreographed and the actors had to always look into the lens, which was something they had extensive training never to do.

Instead of drawing the viewer in, the gimmick actually distances the viewer from the main character, making us always aware that we are in fact watching a movie. It becomes irritating to watch and doesn't allow us to feel for the character. The film was a critical failure and financially did only a little better than breaking even.

The second attempt to use a subjective camera was made the same year, 1947, in the Warner Bros' production of *Dark Passage*, based on the pulp novel by David Goodis. Director Delmar Daves wrote the screenplay so that the first 30 minutes would be mostly shot with a subjective camera from the point of view of the main character, who is wearing bandages across his face after plastic surgery. Unlike *Lady in the Lake*, there are scenes that are not from the point of view of the main character. In these scenes, which are shot from other perspectives, the camera is always positioned so that its field of view does not include his face. Eventually, the main character is revealed to be Humphrey Bogart after his plastic surgery bandages come off and the film continues, shot in the usual objective camera manner. The cinematographer was Sidney Hickox, who shot *The Big Sleep* only a few years before, also with Bogart. While this production was more commercially successful than *Lady in the Lake*, this may have been due to the fact that it starred Bogart and Lauren Bacall, who had become Hollywood's hottest couple, rather than because it used a more limited subjective camera.

KISS KISS BANG BANG (2005)

Hard-boiled slang and sarcasm are what make a movie a noir film and allow audiences to recognize the more modern film noir entries for what they are. A prime example is a noir movie that, like *The Maltese Falcon*, allowed a screenwriter to try to become a director,

Kiss Kiss Bang Bang, produced by Joel Silver in 2005, was written by screenwriter Shane Black and loosely based on the Brett Halliday mystery novel *Bodies Are Where You Find Them*. Brett Halliday was a pen name of novelist Davis Dresser for his series of popular detective pulp novels featuring the

Figure 10.1 Robert Downey Jr and Val Kilmer in *Kiss Kiss Bang Bang*
Columbia Pictures, 2005

PI Michael Shayne in the 1940s through the 1960s. Black had become famous for writing the film *Lethal Weapon*, and then went on to write other action films such as *The Last Boy Scout* and *The Long Kiss Goodnight*. *Kiss Kiss Bang Bang*, which he wrote because of his love of Raymond Chandler and his desire to contribute to film noir, marked a directorial debut for Black. The film features great modern noir cinematography by Michael Barrett and a wonderful soundtrack by John Ottman and contains all of the classic attributes of film noir. It is told with the flippant voice-over narration of the protagonist Harry, a small-time crook who is mistaken for an actor and flown to LA to be in a movie. Played by Robert Downey Jr, our noir hero allows himself to be mistaken yet again, this time for a private eye by a "good femme fatale," and gets involved in two murders. The film includes standard noir themes such as a total disrespect for the rich, deception, the past catching up to people and, like most good PI noir films, two cases that become intertwined, demonstrating how everything is connected. As was common with the classic noir films, the movie is more about the relationships between the characters than the actual mystery plot, which – again as is typical in film noir – is convoluted and hard to follow.

But the film breaks a lot of new ground for noir, including breaking the fourth wall with voice-over narration that reminds the viewers that they are indeed watching a movie, introducing flashbacks and even rewinding material. Also our hero becomes the unwanted partner of the very successful Hollywood celebrity private detective Gay Perry – who

happens to be gay – (played by Val Kilmer), thus making a noir film into a buddy action-comedy movie.

What Black also did with his screenplay was have the hero try to be the noir tough guy, but fail. The gay PI is tougher, yet they are both in way over their heads. As Black said in an interview, "Every time they try to do something, they get slapped down by reality."[3] The tough narrator can't even tell his own story right, messing it up and going back to correct himself. True to noir, our hero gets beaten up, but then the film even goes further with him getting his finger cut off – twice.

The dialog is noir sarcasm on speed. Both Harry and Gay Perry trade barbs with fast wit and flippant comments. They become equals, and reluctant partners. While most noir heroes are more often soft-spoken, these two talk at high-speed chase level. This elevates the film to a place where the danger can still be real but offset by the humor.

Moderately successful at the box office, *Kiss Kiss Bang Bang* received mixed reviews. But it did launch Black's directing career and led him to write and direct the extremely successful *Iron Man 3* movie, also starring Robert Downey Jr. *Kiss Kiss Bang Bang* demonstrates the enduring power of film noir and its continued allure for audiences and filmmakers.

NOTES

1 Chandler, Raymond, *The Simple Art of Murder*, New York: Ballantine Books, 1977, p. 20.
2 Chartier, Jean-Pierre, "Americans Also Make Noir Films," in Silver, Alain and Ursini, James, *Film Noir Reader 2*, New York: Limelight Editions, 1999, p. 22.
3 Black, Shane, interview, *Showbizjunkies*, 30 April 2013. Available at: www.youtube.com/watch?v=m4LC6FtfL1Y (accessed 28 April 2016).

11

NOIR'S REBIRTH AND NEO-NOIR

"You can't bluff someone who's not paying attention."
(House of Games)

NOIR'S REBIRTH

As film noir became more and more a product of the ultra low-budget Poverty Row companies in the latter 1950s, the stories became more brutal and fatalistic. The female characters became more and more dependent on the male characters, displayed most clearly in the Mike Hammer PI films. Female empowerment was served a severe setback and noir was corrupted into more of a sensationalist crime film, rather than a character-driven story of mystery. Many film scholars have said that Orson Welles' 1958 movie *Touch of Evil*, written by Welles and based on the book *Badge of Evil* by Whit Masterson, marked the end of film noir. Perhaps this is because *Touch of Evil* forsook almost everything that classically made film noir into film noir, other than its bold artistic black-and-white cinematography by Russell Metty. Gone are such staples as the sarcastic dialog, the everyday loner protagonist who treats everyone the same and the strong independent female character. In their place come corrupt policemen and victimized women. Sadism and sensationalism were distorting classic noir into a different kind of pessimistic crime film. But noir wasn't dying out, only sleeping.

The 1970s introduced film studies into academia, quickly followed by essays on every genre imaginable. Film noir became a hot subject and for a good reason. As during the time period of classic film noir, the United States was involved in a foreign war with a sense of endless casualties: Vietnam. While the Second World War was a noble war fighting an evil enemy (the Nazis), the Vietnam conflict was generally considered by the public to be a pointless war with innocent victims – both in the Asian villages and within the American armed forces filled with drafted young men. It should come as no surprise that film noir would have a rebirth at this time. Pessimism and even nihilism were gripping the country and therefore Hollywood could gain audiences by offering something that had a similar outlook. The new noir films embraced a darker outlook than the classic noir films.

Hollywood tried to make noir a light-hearted mystery with the 1969 production of *Marlowe*, written by Stirling Silliphant, who wrote the screenplay for the classic police film *The Heat of the Night*. Based on Raymond Chandler's novel *The Little Sister*, the film was set in contemporary LA, starred actor James Garner as Marlowe and was directed by the appropriately named Paul Bogart. Bogart had been a TV director and was making his feature film debut. Doing a crime film after the recent assassinations of both Martin Luther King and Robert Kennedy, Bogart wanted to minimize any violence. This caused disagreements between director and writer. The resulting light-hearted PI version in a rather bright LA was not much of a success and gained poor reviews – but it did lead to the popular TV series *The Rockford Files*, starring Garner as a wise-cracking PI who always gets beaten up, which ran from 1974 to 1980. This widely successful TV show featured a reinvented Marlowe for modern times. Perhaps TV-viewing audiences wanted more humorous escapism than movie theater audiences, who were gravitating towards harder-edged stories that reflected the uncertain times. After all, the news was on TV.

Klute (1971) was written by Andy and David Lewis and directed by Alan Pakula, with Donald Sutherland as the PI and Jane Fonda as the prostitute femme fatale – and with great cinematography by Gordon Willis. This neo-noir film shares the classic noir themes of a disrespect for the wealthy and a venture into the underbelly of society. Drugs and sex play major roles in the story, as they did many times in the earlier noir films. The film was widely

acclaimed and won Fonda an Academy Award for Best Actress. The film was full of mistrust and uncertainty, a feeling to which the audiences of the war-weary 1970s could relate. The film doesn't end happily, even though the bad guy ultimately pays the price for his actions. Our good femme fatale says in a voice-over how she might never be able to trust men again or have a normal life. This feeling – of never being able to trust the government again or have what past generations would call a "normal" life – was shared by male and female movie-goers alike. Even though it has a contemporary setting, the film succeeds as a modern noir film, where both *Marlowe* and *The Long Goodbye* didn't.

The Long Goodbye (1973) was written by Leigh Brackett, who co-wrote the screenplay for *The Big Sleep* in 1946. She was tasked with making the story contemporary by producer Elliott Kastner, for a project to be directed by Brian Hutton. But she had problems with the story. *The Long Goodbye* was one of Chandler's last novels, in which his private eye character Marlowe was sadder and more introspective. In the story Marlowe is betrayed by an old friend and nothing goes right. And nothing went right for Brackett, who hated her own first script. Hutton then left the project and Brackett had time to rethink her approach. When director Robert Altman came onto the project, he told Brackett that he saw Marlowe as not just a loner, but a real loser. That's when Brackett felt she knew what to do with the script. Altman said he felt the only way to update the story was to have it be "Rip Van Marlowe" – that the character has woken up in the 1970s where there is no longer a place for him. He is neither hard-boiled nor hard-edged, but is a loner with a cat and certainly takes a beating. Brackett said, "A man like this hasn't got an edge. He gets kicked around. People don't take him seriously. They don't know what he's about and they don't care. So instead of being a tough guy, Marlowe became a patsy."[1]

Marlowe was downplayed by actor Eliott Gould as a loser PI. The cinematography by Vilmos Zsigmond, who used a film-processing technique called post flashing to desaturate and wash out the color and contrast, deliberately plays against the noir visual standards, giving the viewer the feeling of the oppressive heat of summer in LA. The story is radically changed and while he solves the case, this Marlowe – unlike Chandler's Marlowe – takes revenge by shooting the man responsible for all of his misery, something a true noir

hero would never do. This was Altman and Brackett's modern update of noir: that no one cares about ethics in the 1970s, even the good guys, and that in life one may need to be more ruthless in order to survive emotionally.

When the film was released, Jay Cocks wrote in his review for *Time* magazine:

> "Altman's lazy, haphazard putdown is without affection or understanding, a nose-thumb not only at the idea of Philip Marlowe but at the genre that his tough-guy-soft-heart character epitomized. It is a curious spectacle to see Altman mocking a level of achievement to which, at his best, he could only aspire."[2]

The film did terribly at the box office and was pulled from distribution. The producers felt it was a mistake to have promoted the film as a mystery, so they re-released it with a new ad campaign as a black comedy/drama. The same film, uncut, was reviewed by Vincent Canby, of the *New York Times*, as "an original work, complex without being obscure, visually breathtaking without seeming to be inappropriately fancy."[3] Despite other good reviews from Roger Ebert and from Pauline Kale in the *New Yorker*, the *New York Times* listing it in its Ten Best Films for that year, and new-wave cinematographer Zsigmond being awarded the National Society of Film Critics prize for Best Cinematographer, the anti-noir film continued to suffer at the box office and never really gained an audience.

Chinatown (1974) was written by Robert Towne, who won the Academy Award for Best Screenplay for the film, which was directed by Roman Polanski. It starred Jack Nicholson and was beautifully lensed by John Alonzo. Set in 1930s LA, the film also eschews the noir standards but still remains noir itself. Private investigator J. J. Gittes runs a successful agency with employees, which goes against the struggling loner everyday man version of the classic noir PI. He is also a publicity hound and a good businessman – yet he does have a certain code of ethics and certainly a healthy disrespect for the wealthy. Like the classic noir hero, he takes a beating, and is lied to and misled, but still solves the case. His femme fatale does lie to him, but turns out not to be evil at all, but a victim whom he feels the need to protect. But again in keeping with the 1970s time period's

pessimistic outlook on life, the wealthy get what they want and the innocent victim loses despite our hero's efforts. Like the Vietnam War, it was all for nothing.

The Drowning Pool (1975) was based on the hard-boiled 1950s PI mystery novels of Ross McDonald (the main pseudonym of crime author Kenneth Millar), with Paul Newman as sardonic PI Lew Harper. Newman's wife Joanne Woodward played the wealthy femme fatale. Walter Hill was first hired to write the screenplay, which was rewritten by Tracy Wynn and Lorenzo Semple Jr. Hill would go on to become a well-known director, his second feature being the 1978 neo-noir crime film *The Driver*, which would be remade in 2014. Cinematographer Gordon Willis, who had filmed *Klute*, shot the film, which was directed by Stuart Rosenberg. But the film is more of a 1970s detective movie than a classic noir film. While Harper is witty and affable, it is still contemporary in both its settings and visuals. The film was a sequel to the 1966 movie *Harper*, based on McDonald's novel *The Moving Target*. Written for the screen by William Goldman (who would go on to become one of the most famous screenwriters in modern Hollywood), that film was more of a tribute to the Bogart films and even starred Lauren Bacall as a woman searching for her missing husband who hires the private eye Harper, played by Newman.

Farewell, My Lovely (1975) starred noir standard hero actor Robert Mitchum playing a much older, wiser and more world-weary Marlowe. The film stayed closer to Chandler's novel than the 1941 film *Murder, My Sweet* and was moderately successful. It was produced by the same two producers of Altman's *The Long Goodbye*, but this time they were trying to revive the classic film noir look, characters and storyline. Dick Richards, who grew up reading Chandler's novels and loved them, was hired as the director. Richards came from TV commercials and wanted this film to be "pure Chandler." He convinced the producers to let him do the film as a period piece instead of giving it a contemporary setting. He wanted John Alonzo to shoot it based on his great work on *Chinatown*. Alonzo used Fuji film instead of Kodak, which gave the visuals more pastel saturated colors. Richards kept changing dialog, which Mitchum didn't take well to. Keeping up with the times and the appetite of 1970s producers and audiences for sensationalism (and a reason why it couldn't be shown on TV), some gratuitous nudity was thrown

in and one character was changed into a lesbian whorehouse madam. The good stepdaughter was removed and the film implies that Marlowe sleeps with the femme fatale Mrs. Grayle, which he doesn't do in either the book or the first movie. Many Chandler enthusiasts hated the film, as they felt it corrupted the Marlowe character, the same as they felt about *The Long Goodbye*. While *Time* magazine called the film "soft-boiled" in its review, *Farewell, My Lovely* was successful in reviving the film noir genre and introducing it to a new generation.

The Big Sleep (1978) brought Robert Mitchum back as Marlowe three years later and three years older, but this time in London in the 1970s. The film wasn't well liked by noir lovers and Chandler fans because it wasn't American enough and Marlowe was now 60. Ensuring that it was a movie that challenged what could be shown on TV at the time, the film explicitly included pornography, homosexuality and nudity. The film lacked the edge of both the 1946 version and the 1975 *Farewell, My Lovely*. The film received mixed reviews and wasn't much of a hit.

In 1982, *I, the Jury* was remade, and was most notable for using the new 500 ASA high-speed Kodak 35mm film, which could get an image under New York City streetlights shot by cinematographer Andrew Laszlo. The film stayed true to the essence of Mickey Spillane, featuring a good amount of nudity, sex and violence.

Along with the rebirth of noir came the rebirth of noir parodies. In 1947, the successful film comedian Bob Hope made a parody of film noir, *My Favorite Brunette*. In 1978, renowned comedy playwright and screenwriter Neil Simon took his shot at the genre with the film *The Cheap Detective*, a parody of the Bogart films starring actor Peter Falk. 1982 saw the release of *Dead Men Don't Wear Plaid*, the Carl Reiner/Steve Martin comedy that intercut Martin and other cast members into scenes from famous noir films, while *Who Framed Roger Rabbit* added famous cartoons mixing with live action for one of the most inventive noir parody films ever made.

In 1981, Walt Disney Pictures bought the screen rights to the book *Who Censored Roger Rabbit?* by Gary Wolf, about a world in which cartoon characters live and work alongside real people. Robert Zemeckis heard about it and approached Disney, wanting to direct. They turned him down based on the failures of his last two feature films and instead approached Terry Gilliam.

Disney added Steven Spielberg's company Amblin as a producing partner and the project gained momentum. Gilliam dropped out during the development stages and Spielberg convinced Disney to hire Zemeckis to direct, based on his now recent successes *Romancing the Stone* and *Back to the Future*. Jeffrey Price and Peter Seaman were brought in to write the screenplay, which changed the cartoon characters into film movie stars instead of newspaper comic-strip characters as in the book. Inspired by the film *Chinatown*, they added the public transportation conspiracy plot based on LA's true history. During production, the film spiraled over budget, first from $30 million to $40 million, then to $50 million, due to its elaborate animation and compositing. Disney president Michael Eisner considered shelving the project, but was convinced to keep the production going by Disney studio chief Jeffrey Katzenberg. The live-action sequences were filmed on VistaVision cameras, which shot running the film horizontally through the camera, allowing wide-screen image capture, which compounded the expense. Effects were created in England and in LA and by George Lucas' company Industrial Light & Magic.

In 1988, when the film was finished, Disney execs were very worried about the "adult" content, especially the sexy femme fatale cartoon character of Jessica Rabbit, voiced by Kathleen Turner, who had played the femme fatale in the 1986 neo-noir film *Body Heat*. So they released the film under their Touchstone banner. The film was the second-highest-grossing movie of 1988 and received international acclaim.

And as mentioned earlier, the modern noir *Kiss Kiss Bang Bang*, written and directed by Shane Black, hit theaters in 2005 and, while receiving mostly good reviews, only barely made back its budget.

NEO-NOIR

By the mid-1970s and into the 1980s, neo-noir films began becoming popular. These could be defined as films that prominently use many of the prime elements of film noir, but with updated themes, content and styles absent from the classic noir films of the 1940s and 1950s.

The 1974 movie *Night Moves*, written by Alan Sharp and directed by Arthur Penn, starred Gene Hackman as an unhappily married private eye who takes

on the case of a missing teenage daughter to escape his wife. While receiving mostly good reviews, the film wasn't considered to be a big success financially. The 1977 film *The Late Show* was written and directed by screenwriter Robert Benton, undertaking his second directorial project. It was produced by Robert Altman, the director of *The Long Goodbye*, and starred Art Carny as a senior citizen PI who gets back into the business after his ex-partner is killed. Very successful both critically and at the box office, this humorous neo-noir earned Benton an Oscar nomination for Best Original Screenplay. Both *Night Moves* and *The Late Show* are more lighthearted than traditional noirs, with the latter being essentially a comedy. What is interesting is that both feature more mature protagonists with personal "baggage" – not what one would expect in a typical private eye movie.

As previously mentioned, screenwriter Lawrence Kasdan's directorial debut was *Body Heat*, his 1981 version of *Double Indemnity*. Also in 1981, *The Postman Always Rings Twice* was remade, starring Jack Nicholson and Jessica Lange. The film was beautifully shot by Swedish cinematographer Sven Nykvist, who brought back the imagery of noir. Filled with raw sexuality and graphic sex scenes, the film didn't receive great reviews, panned as being overacted, and was not a box office success. In 1984, the 1947 noir classic *Out of the Past* was remade as *Against All Odds*, starring Jeff Bridges and Rachel Ward. In 1987, the 1948 noir film *The Big Clock* was remade as *No Way Out*, starring Kevin Costner and Sean Young. In 1988, the 1950 noir film *DOA* was remade, starring Dennis Quaid and Meg Ryan.

The late 1980s also ushered in a new brand of private eye detective fiction to the big screen. *8 Million Ways to Die* (1988) brought mystery author Lawrence Block's PI Matt Scudder to the screen, with a screenplay co-written by Robert Towne (who wrote *Chinatown*) and Oliver Stone. The film was the last picture made by director Hal Ashby, starred Jeff Bridges and introduced actor Andy Garcia to the movie-going public. *The Singing Detective* (1986) was a six-part BBC TV series written by Dennis Potter about a mystery writer named Marlow hospitalized with a crippling chronic skin and joint disease. He escapes into his fantasy world, which Potter based on the noir classic *Murder, My Sweet*, living the adventures of a nightclub-singing private eye. The series was extremely successful and was brought to Hollywood, first by director Robert Altman with Dustin Hoffman as the lead. That and several

other attempts failed to materialize until Mel Gibson's film company picked up the rights and made the film in 2003, written by Potter and starring Robert Downey Jr. The film bombed at the box office and with most critics.

In 1995, *Devil in a Blue Dress* brought Walter Mosley's hard-boiled African-American PI Easy Rawlins to the screen, portrayed by actor Denzel Washington. It was written and directed by Carl Franklin, whose first film was the 1992 neo-noir movie *One False Move*. This was a breakthrough for film noir, as it finally embraced a hero of color. The film was well received and won cinematographer Tak Fujimoto a National Society of Film Critics award for his color noir photography. Unfortunately, it never earned back its budget.

Writer/director brother team Joel and Ethan Coen's first film was the 1984 loser neo-noir movie *Blood Simple*, in which everything spirals out of control for their characters. While the film – shot by cinematographer Barry Sonnenfield, who would go on to shoot several more of their films before becoming a director himself best known for *Men in Black* – only did moderately well at the box office, it was highly acclaimed critically and established the Coen brothers as a new voice in cinema. They would go on to make their own anti-noir films such as *The Big Lebowski* and *The Man Who Wasn't There*, and their highly acclaimed neo-noir film *Fargo*.

Their 1998 film *The Big Lebowski* is a black comedy story featuring a loser stoner played by Jeff Bridges, who is mistaken for a wealthy man someone wants dead – a typical mistaken identity noir setup. He then gets incompetently involved in paying off a kidnapping, as in *Farewell, My Lovely*. While the story elements are obviously taken from classic film noir, the film visually is not noir and the dialog is classic Coen brothers. There are subplots and tangents that have nothing to do with the mystery. This takes the film further away from noir as they don't tie in to the main story, which is a noir standard. So the film is more of a humorous modernized satire of noir.

With the new century came two neo-noirs that are homages not to the classic noir films of the 1940s but the neo-noirs of the 1970s and specifically *The Long Goodbye*. The 2014 neo-noir film *Inherent Vice*, written and directed by Paul Thomas Anderson and based on the mystery novel by Thomas Pynchon, is a stoner comic drama detective movie set in the 1970s. While it gained some good reviews, most viewers found it frustrating to sit through due to

the constant mumbling of lead actor Joaquin Phoenix and a convoluted and contradictory plot. The film alternates between outright comedy, with scenes featuring Martin Short, and serious drama. The film gained Anderson an Oscar nomination for Best Adapted Screenplay, but never really made back its budget.

Writer/director Shane Black came back to his buddy action comedy roots with the 2016 neo-noir film The Nice Guys, a private eye mystery set in 1977. At the time of writing, the film is still on major release and doing well both financially and critically. Like Inherent Vice, the film is art-directed and shot to look and feel like a 1970s neo-noir film. Black said this film, like his previous noir Kiss Kiss Bang Bang, was inspired by the works of mystery writer Brett Halliday. But unlike Halliday's PI Mike Shayne, the detectives in The Nice Guys aren't superior at their jobs, which makes it a fun ride. Also, Black's talent for writing noirish sarcastic dialog makes the film stand out against Inherent Vice.

HOUSE OF GAMES (1987)

David Mamet is a Tony Award and Pulitzer Prize-winning playwright who came to writing movies with the 1981 remake of a classic film noir,

Figure 11.1 Lindsay Crouse and Joe Mantegna in *House of Games*
Orion Pictures, 1987

The Postman Always Rings Twice. This star vehicle version wasn't nearly as noirish as the original and didn't fare that well at the box office. Mamet's second screenplay was the noir-influenced courtroom drama *The Verdict*, which revived actor Paul Newman's career and was directed by Sidney Lumet. It seems only fitting that his directorial debut would be a film noir screenplay of his own writing. *House of Games* has many of the standard noir motifs, such as hidden motives, a disrespect for the wealthy, the uncertainty of who to trust and the allure of venturing into the underbelly of society.

What truly makes *House of Games* a major milestone in film noir is how Mamet re-envisions noir dialog. In classic noir, talk is fast and staccato with clever wit and sarcasm. It is hard-boiled. Mamet takes the noir speak and transforms it into literary theater – from which Mamet originates. True to the genre, it remains fast and witty and full of noir slang. But Mamet makes it more mannered, more intellectual, more stylized. It becomes prose.

While the film's storyline, visuals and tone are classic noir, Mamet updates the genre for the mid-1980s, giving it something fresh and original. Another aspect that makes *House of Games* so important to the noir lineage is Mamet's inversion of the male and female as the noir protagonist and the femme fatale. In the city of the 1980s, many women became career-oriented professionals. The rich, successful professional woman was no longer something unusual or special but an accepted part of American culture. In US society, feminism had made major inroads and feminists were demanding that women be treated the same as men in the workforce. The Equal Rights Amendment was passed by Congress in 1972, but was defeated in 1982 by heavy campaigning by conservative religious groups. Nevertheless, the 1980s saw the first female Supreme Court justice, the first female astronaut and the first woman to be part of a major presidential ticket. Perhaps it was also time to have a female noir anti-hero loser, a woman who has a moment to make a decision as to whether to break her code of ethics or not? Herein lies Mamet's most significant contribution to the noir genre.

Mamet's neo-noir hero is a wealthy female psychologist and the author of a famous self-help book. She steps into a noir underworld of con artists and dangerous criminals. She becomes fascinated with them and with the fast-talking, artful con artist who will become her male femme fatale. He provides something lacking in her life of success and luxury: excitement

and thrills. Like the male noir loser protagonists who came before her, she bends her own ethics and gets involved in something highly questionable until things get out of hand and the lies add up. True to noir, the guilty pay the price at the end, but Mamet also adds the more modern take on noir reflected in *The Long Goodbye*: sometimes things end on a rather ambiguous note, creating a grey area of what constitutes a "good" ending.

NOTES

1 Clark, Al, *Raymond Chandler in Hollywood*, Beverly Hills: Silman-James Press, 1996, p. 188.
2 Cocks, Jay, "A Curious Spectacle," *Time*, 9 April 1973. Available at: http://content.time.com/time/magazine/article/0,9171,903961,00.html (accessed 28 April 2016).
3 Canby, Vincent, "For *The Long Goodbye* a Warm Hello," *New York Times*, 18 November 1973.

12

CROSS-GENRE NOIR AND NOIR INFLUENCE

"No, bulls would gum it. They'd flash their dusty standards at the wide-eyes and probably find some yegg to pin, probably even the right one. But they'd trample the real tracks and scare the real players back into their holes, and if we're doing this I want the whole story. No cops, not for a bit."

(Brick)

Film noir has had a profound influence on American movie-making. Its style and story themes have transcended time and even genre. There have been many films that have merged noir with other film genres, with both great and questionable success.

The 1982 movie *Blade Runner* is a futuristic noir film, which features a loner sort of PI who hunts down replicants (human androids) and extinguishes them. Based on the novel *Do Androids Dream of Electric Sheep?* by sci-fi writer Philip K. Dick, the screenplay was first written and pitched to producers by screenwriter Hampton Fancher but rewritten into its noir version by David Peoples after Ridley Scott joined the project as the director. Dick had hated the first draft but liked the rewrites and felt it better reflected his story and his view of a dark, dystopian future. Scott had originally turned

down the project but joined it after leaving the slow-moving production of Dune. The film owes much of its futuristic noir visuals to production designer Lawrence Paull, art director David Snyder and cinematographer Jordan Cronenweth. The film had many setbacks and problems during production, including the producers' re-editing the film down from Scott's overly long original version and adding voice-over narration, which both Scott and lead actor Harrison Ford hated. The film was recut twice and has two different "director's cuts." Critics recognized the film for its wonderfully evocative visuals, but it was mostly panned as being too slow and relying too heavily on special effects, which were all non-digital. While the film looks noir and has a loner hero, it is lacking any real characterization, which was the true foundation of the noir story. This may also have been one of the reasons for the film's poor commercial success, although it has since become a cult classic.

The 1987 film *Angel Heart* takes noir into the realm of horror with a story written and directed by Alan Parker and based on the novel by William Hjortsberg. The horror/noir mix had proven successful in the 1974 TV series *Kolchak: The Night Stalker*, about a Chicago reporter who investigates mysterious murders committed by supernatural creatures. In *Angel Heart*, a down-and-out New York City PI is hired by a mysterious client to find a famous jazz musician who has gone missing. His search takes him to the occult underground of New Orleans and many dead ends. He slowly discovers that the missing man has sold his soul to the devil and his client is none other than Lucifer himself. There are even more twists and, just like any good noir story, the plot is hard to follow, but the character's journey keeps the audience interested. The horror/noir combination genre would be repeated in the 1991 HBO movie *Cast a Deadly Spell*, a totally tongue-in-cheek story set in 1948 with a noirish PI named H. Philip Lovecraft (after the famous horror writer) hired in a world where magic, witches and monsters are the norm.

Red Rock West is a 1993 neo-noir film that crosses genres with the postmodern Western. Directed by John Dahl and written by him and his brother Rick, the story features a loner, loser noir protagonist mistaken for a hitman. It features a femme fatale, lies and double-crosses and some very fun classic noirish moments. It is a low-budget film starring Nicholas Cage and Dennis Hopper that was well received at film festivals and then picked

up by Columbia TriStar for cable distribution. Later it became a popular arthouse cinema feature.

The 1996 film *Playing God*, written by Mark Haskell Smith and directed by Andy Wilson, features actor David Duchovny of the successful sci-fi TV series *The X-Files* and actress Angelina Jolie in an action/adventure neo-noir about a plastic surgeon stripped of his medical license who is forced to patch up a gangster and falls for his girlfriend. It includes the witty sarcasm and loner main character as well as the seductive femme fatale, but the film didn't do well at the box office or with most critics.

BRICK (2006)

The 2006 movie Brick, written and directed by Rian Johnson, is a homage to film noir set in a modern high school. The loner detective character is a street-savvy high schooler who can't be corrupted, always trying to stay out of view of the demanding vice-principal, the police force in this setting. He sets out to solve the mystery of a dead girl by interacting with crooks and dames in the forms of high-school bullies and drug pushers, and popular girls. The dialog is a modern take on noir slang and sarcasm with some unique flourishes thrown in.

Figure 12.1 Joseph Gordon-Levitt finds the body in Brick
Focus Features, 2006

Johnson grew up watching film noir movies and loved the novels of Dashiell Hammett, including *The Maltese Falcon*. He wanted to make his own film noir and wrote the screenplay, setting it in a high school. He commented that "it was really amazing how all the archetypes from that detective world slid perfectly over the high-school types."[1] He spent seven years pitching his script and finally decided to make it himself, raising money from his family and their associates. He rehearsed with his cast for three months before shooting the film, which he completed in 20 days. The film was admitted to the Sundance Film Festival where it won a Special Jury Award for Originality of Vision. Focus Films picked up the rights and distributed the film, which was made for around $500,000 and grossed over $3 million worldwide. Johnson went on to make the feature films *The Brothers Bloom* (2009) and *Looper* (2011), which both display his form of sarcastic noirish dialog.

NOIR'S CONTINUED INFLUENCE

Writer/director Brian De Palma was very influenced by film noir, as seen in his movies *Dressed to Kill*, *Body Double*, *Femme Fatale*, *The Black Dahlia* and *Passion*. He, more than any other writer/director, infused the erotic thriller with noirish elements. Quentin Tarantino is another writer/director who showed heavy noir influence in his early success, most obviously in *Pulp Fiction*, but Tarantino favored violence over eroticism.

David Lynch's *Mulholland Drive*, Christopher Nolan's *Memento*, Michael Mann's *Collateral* (written by Stuart Beattie), Robert Rodriguez's *Sin City* (based on a graphic novel by Frank Miller) and Curtis Hanson's *LA Confidential* (based on a book by mystery writer James Ellroy) are all films that are heavily influenced both visually and story-wise by the classic noir traditions. Other films that display a noir influence would include *Two Days in the Valley*, a black comedy ensemble neo-noir; *Feeling Minnesota*, a low-class loser neo-noir; *The Mexican*, an incompetent lovers neo-noir; *The Blue Iguana*, a feds-in-Mexico neo-noir; and *Grosse Pointe Blank*, a romantic comedy neo-noir.

The influences of film noir have been felt worldwide as well. There have been British, French, Italian and Japanese neo-noir films, to name just a few countries that have embraced it. But the noir influence is evident even in

non-noir films. Tough dames, sarcastic dialog and different stories that all connect are all movie conventions that seemed to have started with film noir.

What makes a film "noir" is a hard question to answer. Many people have widely varying opinions. Some have said film noir was a movement, some a cycle, some a style and some a genre. Its definition seems to change with the publication of every new academic study on the subject. Some writers will classify a film as being noir solely based on who directed it. Some seem to feel that any film that was made during a certain time period, was shot in black and white and has a pessimistic outlook on life is noir. Sometimes films that just have noir-influenced imagery have been called noir.

Historically, film noir came about as a result of Hollywood tapping into the popular hard-boiled crime fiction that was written not for the cultured but for the masses. It was the ideal market-tested resource for the studios, which were profit oriented and needed to sell movie tickets to make the payrolls of the tens of thousands of people who worked in their offices and backlots. And as audiences gravitated to theaters playing these films, the studios wanted to make more and more of them – and so did the independent film companies looking to turn a buck and get noticed. Noir films became stepping stones for awards and career moves.

No matter how one decides to consider what it is or isn't, film noir is an American invention, even though it was named by the French. As such, the tradition and its influences on visual storytelling live on in American popular culture. Perhaps it's because Americans love to root for the underdog, the loner who beats the odds, that noir gained such popularity with audiences then – a popularity it continues to retain now. And even if that loner comes away with nothing, or if he even dies at the end, at least he learns from his mistakes, which is something we all wish we could and would do.

NOTE

1 Tobias, Scott, "Rian Johnson," *The Onion*, 19 April 2006. Available at: https://en.wikipedia.org/wiki/Brick_(film) (accessed 28 April 2016).

APPENDIX
Notable Noir and Neo-Noir Films

There are, of course, many more noir and neo-noir films than are listed below, especially the many rather bad ones made in the 1950s by the Poverty Row companies. I have also not included every modern noir or neo-noir film. I have mostly listed the films discussed in the book and a few I wish I had. They are listed here in chronological order.

The Maltese Falcon, 1941
This Gun for Hire, 1942
The Glass Key, 1943
Murder, My Sweet, 1944
Laura, 1944
Double Indemnity, 1944
Phantom Lady, 1944
The Woman in the Window, 1945
Mildred Pierce, 1945
Lady on the Train, 1945 (screwball comedy noir)
Detour, 1945
Cornered, 1945
The Postman Always Rings Twice, 1946

The Big Sleep, 1946
Nocturne, 1946
The Dark Corner, 1946
The Killers, 1946
Gilda, 1946
The Blue Dahlia, 1946
The Brass Doubloon, 1946 (from Raymond Chandler's novel The High Window)
The Unsuspected, 1947
Dead Reckoning, 1947
They Won't Believe Me, 1947
Dark Passage, 1947
My Favorite Brunette, 1947 (parody noir)
The Pretender, 1947
Lady in the Lake, 1947
Out of the Past, 1947
Crossfire, 1947
The Lady from Shanghai, 1948
Pitfall, 1948
The Big Clock, 1948
The Night Has a Thousand Eyes, 1948
Too Late For Tears, 1949
Sunset Boulevard, 1950
DOA, 1950
Where the Sidewalk Ends, 1950
Where Danger Lives, 1950
His Kind of Woman, 1951
Macao, 1952
Pick-Up on South Street, 1953
I, the Jury, 1953
The Big Combo, 1955
Murder Is My Beat, 1955
Kiss Me Deadly, 1955
Klute, 1971
The Long Goodbye, 1973
Chinatown, 1974

Farewell, My Lovely, 1975

The Drowning Pool, 1975

Body Heat, 1981

Blade Runner, 1982 (sci-fi noir)

Dead Men Don't Wear Plaid, 1982 (parody noir)

Blood Simple, 1984

House of Games, 1987

Angel Heart, 1987 (horror noir)

Who Framed Roger Rabbit, 1988 (live-action/cartoon noir)

Red Rock West, 1993

Playing God, 1996

Kiss Kiss Bang Bang, 2005

Brick, 2005 (high-school noir)

BIBLIOGRAPHY

BOOKS

Alton, John, *Painting with Light*, New York: Macmillan, 1949

Beach, Christopher, *A Modern History of Film Style: Cinematographers, Directors and the Collaborative Process*, Oakland: University of California Press, 2015

Behlmer, Rudy, *Behind the Scenes*, Hollywood: Samuel French Trade, 1990

Biesen, Sheri, *Blackout: World War II and the Origin of Film Noir*, Baltimore: Johns Hopkins University Press, 2005

Chandler, Raymond, *The Simple Art of Murder*, New York: Ballantine Books, 1977

Clark, Al, *Raymond Chandler in Hollywood*, Beverly Hills: Silman-James Press, 1996

Crowe, Cameron, *Conversations with Wilder*, New York: Alfred Knopf, 2001

Gardner, Dorothy and Walker, Katherine, *Raymond Chandler Speaking*, London: Allison & Busby, 1984

Grobel, Lawrence, *The Hustons*, New York: Cooper Square Press, 1989

Hirsch, Foster, *The Dark Side of the Screen: Film Noir*, New York: Da Capo Press, 1981

Hogan, David, *Film Noir FAQ*, New York: Applause Books, 2013

Keating, Patrick, *Hollywood Lighting from the Silent Era to Film Noir*, New York: Columbia University Press, 2010

Lehman, David, *The Perfect Murder: A Study in Detection*, Ann Arbor: University of Michigan Press, 2001

Lyons, Arthur, *Death on the Cheap: The Lost B Movies of Film Noir*, New York: Da Capo Press, 2000

Martin, Leonard, *The Art of Cinematography*, New York: Dover Press, 1971

Myers, David, *A Girl and a Gun: The Complete Guide to Film Noir on Video*, New York: Avon Books, 1998

Pappas, Charles, *It's a Bitter Little World: The Smartest Toughest Nastiest Quotes from Film Noir*, Cincinnati: Writer's Digest Books, 2005

Pratley, Gerald, *The Cinema of John Huston*, New York: A. S. Barnes, 1977

Schoenfeld, Bernard, *Macao*, New York: Fredrick Ungar, 1952

Server, Lee, Greenberg, Martin and Gorman, Ed, *The Big Book of Film Noir*, New York: Carroll & Graf, 1998

Silver, Alain and Ursini, James, *Film Noir Reader*, New York: Limelight Editions, 1996

Silver, Alain and Ursini, James, *Film Noir Reader 2*, New York: Limelight Editions, 1999

Silver, Alain and Ursini, James, *The Noir Style*, Woodstock: Overlook Press, 1999

Silver, Alain and Ursini, James, *Film Noir: The Directors*, New York: Limelight Editions, 2012

Silver, Alain and Ward, Elizabeth, *Film Noir: An Encyclopedic Reference to the American Style*, Woodstock: Overlook Press, 1979

Silver, Alain, Porfirio, Robert and Ursini, James, *Film Noir Reader 3: Interviews with Filmmakers of the Classic Noir Period*, New York: Limelight Editions, 2002

Thompson, Peggy and Usukawa, Saeko, *Hard-Boiled: Great Lines from Classic Noir Films*, San Francisco: Chronicle Books, 1995

ARTICLES

Canby, Vincent, "For *The Long Goodbye* a Warm Hello," *New York Times*, 18 November 1973

Cocks, Jay, "A Curious Spectacle," *Time*, 9 April 1973. Available at: http://content.time.com/time/magazine/article/0,9171,903961,00.html (accessed 28 April 2016)

"*I, the Jury*, Spillane Whodunit, Is Transformed in 3-D to Screen at Criterion Theatre," *New York Times*, 22 August 1953. Available at: www.nytimes.com/movie/review?res=9E03E5DB153EE53BBC4A51DFBE668388649EDE (accessed 28 April 2016)

"Review: *I, the Jury*," *Variety*, 31 December 1952. Available at: http://variety.com/1952/film/reviews/i-the-jury-1200417488/ (accessed 28 April 2016)

Schager, Nick, "Review: *Kiss Me Deadly*," *Slant Magazine*, 2006. Available at: https://en.wikipedia.org/wiki/Kiss_Me_Deadly (accessed 28 April 2016)

Stafford, Jeff, "*This Gun for Hire*," *Turner Classic Movies*. Available at: www.tcm.com/this-month/article/444686%7C436785/This-Gun-for-Hire.html (accessed 28 April 2016)

Tobias, Scott, "Rian Johnson," *The Onion*, 19 April 2006. Available at: https://en.wikipedia.org/wiki/Brick_(film) (accessed 28 April 2016)

OTHER SOURCES

IMDB website

Marian Library, Academy of Motion Picture Arts and Sciences

TCM Movie Database

Wikipedia

YouTube

INDEX

20th Century Fox (studio) 59, 61, 62, 66, 106

Alonzo, John (cinematographer) 27, 142, 143
Altman, Robert (director) 141–142, 146
Alton, John (cinematographer) 33, 34, 88, 122, 123, 125
American Realism 120
Andrews, Dana (actor) 61, 63–64, 65, 66, 67
Angel Heart (movie) 152
Astor, Mary (actress) 12, 14

Bacall, Lauren (actress) 26, 35, 42, 73, 74, 76, 78, 79–83, 93, 94, 100, 104, 135, 143
Ballard, Lucien (cinematographer) 63–64
Barry, John (composer) 55
Bendix, William (actor) 75, 77
Big Clock, The (movie) 19, 30, 60, 89, 100, 103, 106, 113, 117, 133, 146

Big Combo, The (movie) 60, 100, 111, 122–125
Big Lebowski, The (movie) 147
Big Sleep, The (movie) 6, 42, 51, 58, 60, 69, 75, 78–84, 93, 100, 105, 128, 132, 135, 141, 144
Black Mask, The (magazine) 2
Black, Shane (screenwriter/director) 135, 137, 145, 148
Blade Runner (movie) 105, 151
block booking 3, 121, 123
Block, Lawrence (author) 146
Blood Simple (movie) 147
Blue Dahlia, The (movie) 57
BNC camera (Mitchell camera) 13, 54, 114
Body Heat (movie) 55, 104, 145, 146
Bogart, Humphrey (actor) 10, 11, 12, 14–15, 26, 27, 35, 42, 47, 72, 73, 76, 78–83, 93, 96, 104, 135
Bogart, Paul (director) 140
Brackett, Charles (screenwriter) 51
Brackett, Leigh (screenwriter) 80–81, 83, 132, 141–142

166 INDEX

Bredell, Woody (cinematographer) 22
Breen, Joseph 7, 96
Brick (movie) 151, 153–154

Cain, James (author) 2, 6, 22, 23, 29, 31, 44, 50, 51, 52, 59–60, 129
Casper, Vera (author) 22, 49, 61–62
Castle, William (producer) 46
Chandler, Raymond (author/screenwriter) 2, 6, 17–19, 24, 25, 26, 27, 32, 51–54, 57, 60, 80, 81, 82, 127–131, 132, 134, 136, 140, 141, 143
Chartier, Jean-Pierre (critic) 2–3, 7, 49, 86, 133
Cheap Detective, The (movie) 144
Chinatown (movie) 27, 142–143, 145, 146
Coen brothers (screenwriters/directors) 147
Cohn, Harry (studio head) 46
Columbia Pictures (studio) 15, 31, 46, 70, 136, 153
Conley, Renie (costume designer) 194
Cook Jr, Elisha (actor) 5
Cornered (movie) 19, 67, 72, 100, 107, 116, 132
costumes 4, 37, 58, 64, 66, 67, 70, 94, 102–105, 109, 112
Crawford, Joan (actress) 23, 71, 76
Crossfire (movie) 25, 75, 78, 91, 93, 100, 107, 132
Curtiz, Michael (director) 59, 71

D'Agostino, Albert (art director) 107
Dahl, John (screenwriter/director) 152
Dark Corner, The (movie) 18, 49, 60, 75, 90, 100, 131, 132
Davis, Bette (actress) 11

Dead Men Don't Wear Plaid (movie) 102, 103, 144
Dead Reckoning (movie) 19, 35, 43, 60, 73, 74, 90, 100, 133
Detour (movie) 32, 44, 59, 87, 90, 91, 100, 131, 133
Devil in a Blue Dress (movie) 147
Dietrich, Marlene (actress) 62, 95
Dmytryk, Edward (director) 25–26, 27, 57, 59, 72, 73, 91
DOA (movie) 47, 88–89, 100, 133, 146
Double Indemnity (movie) 6, 7, 18, 22, 29, 31–32, 44, 48, 49–55, 58, 59, 66, 71, 83, 86, 88, 89, 100, 101, 103, 104, 106, 117–118, 120, 121, 129, 132, 133, 134, 146
Dratler, Jay (screenwriter) 30, 62, 131
Dreier, Hans (art director) 60, 106–107, 109
Drowning Pool, The (movie) 143

Edeson, Arthur (cinematographer) 13–14, 117, 120
Expressionism (art movement) 118–120

Farewell, My Lovely (book/movie) 24, 27, 78, 132, 143, 144, 147
Farrow, John (director) 60–61, 95, 113
Faulkner, William (author/screenwriter) 6, 22, 78, 80–81
Frank, Nino (critic) 2, 7, 20, 75
Fuller, Leland (art director) 66, 105–106
Fuller, Samuel (director) 2, 35

Garner, James (actor) 140
Gilda (movie) 46–48, 100

Glass Key, The (movie) 6, 75, 76, 100, 103, 106
Greenstreet, Sydney (actor) 13, 14, 15

Halliday, Brett (author) 135, 148
Hammett, Dashiell (author) 2, 6, 11, 12, 15, 17, 18, 154
Harrison, Joan (producer) 48
Hawks, Howard (director) 58, 60, 78–83
Hayworth, Rita (actress) 45, 46, 48, 73, 100
Head, Edith (costume designer) 37, 55, 102–103, 109
Hickox, Sidney (cinematographer) 82, 117, 135
His Kind of Woman (movie) 26, 42, 60, 76–77, 83, 92, 95–96, 100, 107, 116
Hoffenstein, Samuel (screenwriter) 62, 65, 66, 131
Hope, Bob (comedian/actor) 8, 23, 53, 77, 107–109, 133, 144
Hopper, Edward (painter) 120
House of Games (movie) 139, 148–150
Hughes, Howard (studio head) 60, 76, 79, 92–96
Hurt, William (actor) 55
Huston John (screenwriter/director) 11–15, 26, 57, 60, 78, 117, 120

I, the Jury (movie) 33, 75, 144

Jones, Jennifer (actress) 63

Kasdan, Lawrence (screenwriter/director) 55, 104, 146
Killers, The (movie) 59, 90, 100, 101, 133
Kiss Kiss Bang Bang (movie) 127, 135–137, 145, 148

Kiss Me Deadly (movie) 9, 34, 132
Kline, Richard (cinematographer) 55, 104
Klute (movie) 140, 143,
Kodak film 13, 38, 54, 113, 116, 143, 144

Ladd, Alan (actor) 36, 37, 38, 42, 57, 72, 75–76, 105, 108
Lady from Shanghai, The (movie) 45–47, 73, 86
Lady in the Lake (movie) 134–135
Lady on a Train (movie) 22, 100, 107
Lake, Veronica (actress) 36–38 42, 46, 57, 75–76, 100, 102, 103, 104
Lamour, Dorothy (actress) 108–109
Lang, Fritz (director) 59
LaShelle, Joseph (cinematographer) 64, 66–67
Late Show, The (movie) 146
Laura (movie) 7, 20, 22, 42, 55, 57, 59, 61–67, 71, 83, 90, 100, 101, 104, 105, 106, 131, 133
Lenz, Irene (costume designer) 104
Lewton, Val (producer) 4, 107
Lindon, Lionel (cinematographer) 109
Long Goodbye, The (movie) 141, 143, 144, 146, 147, 150
Lorre, Peter (actor) 10, 102, 108

Macao (movie) 26, 42, 59, 75, 76, 83, 85, 91–96, 100, 103, 107, 116, 131
McDonald, Ross (author) 143
MacMurray, Fred (actor) 50, 53, 54, 72, 76
Mainwaring, Daniel (screenwriter) 44, 131
Maltese Falcon, The (movie) 1, 6, 7, 10–15, 18, 20, 27, 43, 60, 63, 64, 75, 78–79, 86, 87, 102,

103, 105, 108, 113, 117, 120, 135, 154
Mamet, David (screenwriter/director) 148–150
Mamoulian, Rouben (director) 62–64, 66
Marlowe (movie) 140
Marshall, George (director) 57, 60
MGM (studio) 23, 31, 62, 70, 78, 123, 134
Mildred Pierce (movie) 22–23, 59, 71, 100, 104, 132, 133
Mitchum, Robert (actor) 26, 27, 42, 60, 75–77, 92–96, 103, 105, 143, 144
Mole-Richardson (lighting manufacturer) 38, 114–116
Monroe, Marilyn (actress) 27, 74, 77
Moorhead, Agnes (actress) 42
Mosley, Walter (author) 147
Munch, Edvard (painter) 119
Murder, My Sweet (movie) 3, 6, 7, 17, 20, 23, 24–28, 43, 48, 72, 73, 83, 87, 90, 91, 95, 100, 104, 105, 107, 116, 132, 133, 143, 146
My Favorite Brunette (movie) 8, 99, 103, 107–109, 133, 144

Newman, Paul (actor) 143
Nighthawks (painting) 120
Night Moves (movie) 145
Night Stalker (TV series) 152
Nocturne (movie) 20, 48, 60, 95, 116, 131

Orry-Kelly (costume designer) 102–103
Out of the Past (movie) 4, 60, 78, 90, 92, 100, 105, 107, 131, 133, 146

Paramount Pictures (studio) 3, 17, 35, 36, 45, 50, 51, 53, 57, 60, 70, 73, 76, 95, 101, 106, 107, 108, 109
Parker, Alan (screenwriter/director) 152
parody 8, 15, 22, 102, 103, 109, 133, 144
Paxton, John (screenwriter) 19, 24–25, 27, 91, 132
Phantom Lady (movie) 6, 21, 22, 48, 49, 59, 75, 89, 132
Pick-Up on South Street (movie) 2, 35
Pitfall (movie) 2, 30, 31, 73, 74, 88, 89, 95, 116
Postman Always Rings Twice, The (movie) 6, 31, 44, 86, 88, 90, 104, 133, 146, 149
Potter, Dennis (screenwriter) 146
Poverty Row 8, 32, 35, 88, 121, 123, 139
Powell, Dick (actor) 3, 24, 25–27, 72–74, 76
Preminger, Otto (director) 59, 62–67, 71, 118, 119, 120
Production Code office 6, 11, 22, 31, 35, 37, 39, 45, 46, 51, 54, 55, 80, 81, 85, 89, 91, 94, 96, 100, 103, 124–125

Raft, George (actor) 12, 20, 52, 63, 78
Raksin, David (composer) 64–65, 100, 101
Ray, Nicholas (director) 96
Red Rock West (movie) 91, 152
Reinhardt, Betty (screenwriter) 62, 65, 66, 131
Richards, Dick (director) 143
RKO (studio) 4, 20, 24, 26, 60, 70, 76, 77, 79, 92, 95, 107
Robinson, Edward G. (actor) 54
Rózsa, Miklós (composer) 55, 100, 101–102

Russell, Jane (actress) 26, 42, 76–78, 83, 92–93, 95–96, 100, 103

Schary, Dore (producer) 17, 37, 91
Schoenfeld, Bernard (screenwriter) 93, 131, 132
Scott, Adrian (producer) 24, 25
Scott, Lizabeth (actress) 35, 73–75, 76, 100
Scott, Ridley (director) 151–152
Scream, The (painting) 119
Seitz, John (cinematographer) 37, 38, 44, 54, 55, 60, 66, 112, 117–118, 119, 121
Singing Detective, The (TV series/movie) 146
Siodmak, Robert (director) 59, 88
Sistrom, Joseph (producer) 51–53, 55
Spillane, Mickey (author) 9, 33–34, 144
Stanwyck, Barbara (actress) 50, 53, 55, 72, 73, 76, 103
Steiner, Max (composer) 100
Sternberg, Joseph von (director) 59, 95–96, 106
Sunset Boulevard (movie) 18, 44–45, 49, 52, 58, 103, 106, 117, 118, 130, 133

They Won't Believe Me (movie) 41, 48, 88, 89, 95, 100, 107, 116
This Gun for Hire (movie) 7, 29, 36–39, 42, 44, 46, 55, 60, 66, 76, 86, 89, 90, 100, 102, 103, 105, 106, 117, 121
Tierney, Gene (actress) 42, 63, 65–67, 71
Too Late for Tears (movie) 35, 75
Toth, Andre de (director) 2, 74
Touch of Evil (movie) 139
Tourneur, Jacques (director) 60

Towne, Robert (screenwriter) 142, 146
Trevor, Clair (actress) 26
Turner, Kathleen (actress) 55, 104, 145
Turner, Lana (actress) 32, 104
Tuttle, Frank (director) 37, 60, 121

Ulmer, Edgar (director) 32, 59
Universal Pictures (studio) 4, 11, 70, 107

Van Upp, Virginia (screenwriter/producer) 46–48

Wallis, Hal (producer) 12, 13, 73
Warner Bros Studios (studio) 1, 4, 5, 10, 11, 12, 13, 14, 15, 23, 31, 70, 72, 78, 79, 135
Warner, Jack (studio head) 11, 12, 14, 15, 22, 70, 71, 81–83
Webb, Clifton (actor) 63–64, 66
Webb, Roy (composer) 100
Welles, Orson (actor/director/screenwriter) 45–46, 107, 139
Wheeler, Lyle (art director) 66, 67, 105–106
Where the Sidewalk Ends (movie) 66–67, 106
Who Framed Roger Rabbit (movie) 104, 144–145
Wild, Harry (cinematographer) 20, 26, 72, 95, 116–117
Wilder, Billy (screenwriter/director) 6, 18, 32, 44, 51–55, 57, 58, 59, 60, 61, 71, 103, 106, 117–118, 119, 120, 121, 127, 129–130
Wilder, Lee (director) 88
Willis, Gordon (cinematographer) 140, 143

Woman in the Window, The (movie) 6, 30, 31, 59, 88, 89

Woolrich, Cornell (author) 2, 6, 21, 22

Woulfe, Michael (costume designer) 94, 103

Wyle, Carl (art director) 105

Young, Victor (composer) 100

Zanuck, Darryl (studio head) 59, 62–65, 66, 67, 70, 71, 106

Printed in Great Britain
by Amazon